PAUL GAUGUIN

Publishing Director: Paul ANDRÉ
Collaborator: Tatyana MORDKOVA
Translator: Ashkhen MIKOYAN
Designer: Stanise TRAVERS
Layout: DES SOURIS ET DES PAGES

Printed by Sager in La Loupe (France)
for Parkstone Publishers
Copyright 3rd term 1995
ISBN 1 85995 141 4

PAUL GAUGUIN

Mysterious affinities

Texts

Anna BARSKAYA
Asya KANTOR-GUKOVSKAYA
Marina BESSONOVA

PARKSTONE PUBLISHERS, BOURNEMOUTH
AURORA ART PUBLISHERS, ST. PETERSBURG

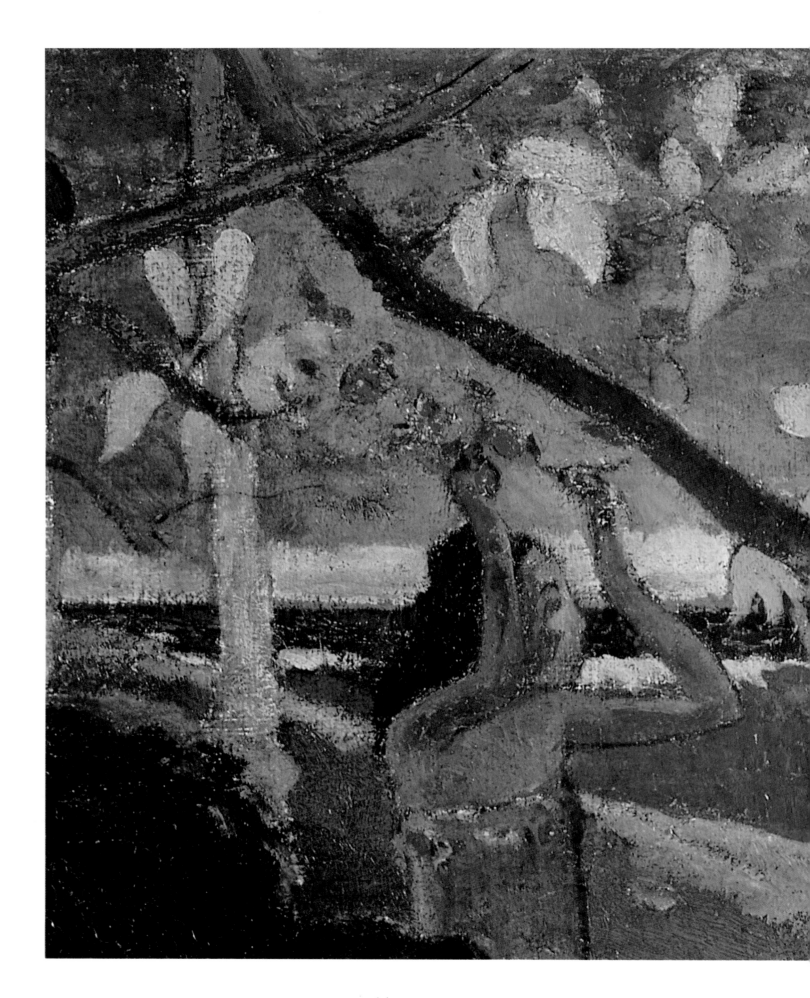

CONTENTS

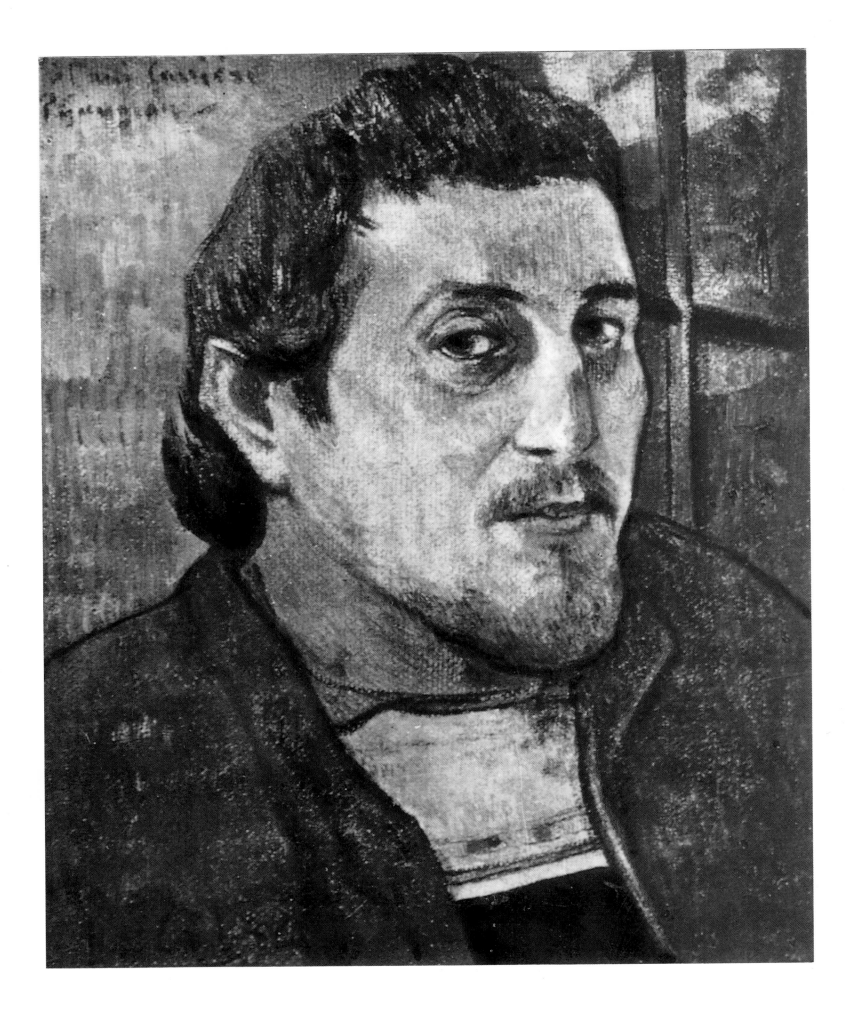

Oâ€‚N MAY 8, 1903, having lost in a futile and fatally exhausting battle with colonial officials, threatened with a ruinous fine and an imprisonment for allegedly instigating the natives to mutiny and slandering the authorities, after a week of acute physical suffering endured in utter isolation, an artist died who had devoted himself to glorifying the pristine harmony of Oceania's tropical nature and its people. There is bitter irony in the name given by Gauguin to his house at Atuona — "Maison du Jouir" (House of Pleasure) — and in the words carved on its wood reliefs, *Soyez amoureuses et vous serez heureuses* (Be in love and you will be happy) and *Soyez mystérieuses* (Be mysterious).

After receiving the news of the death of their old enemy, the bishop and the brigadier of gendarmes — the pillars of the local colonial regime — hastened to demonstrate their fatherly concern for the salvation of the sinner's soul by having him buried in the sanctified ground of a Catholic cemetery. Only a small group of natives accompanied the body to the grave. There were no funeral speeches, and even an inscription on the tombstone was denied the late artist as an undeserved honour. In his regular report to Paris the bishop wrote: "The only noteworthy event here has been the sudden death of a contemptible individual named Gauguin, a reputed artist but an enemy of God and everything that is decent."[1] It was only twenty years later that the artist's name appeared on his tombstone, and even that belated honour was due to a curious circumstance: Gauguin's grave was found by a painter belonging to the Society of American Fakirs. Half a century passed since Gauguin's death before his memory was finally honoured by France thanks to the efforts of the marine painter Pierre Bompard who designed a monument to the artist and supervised its construction and erection. No one remembered Gauguin's wish to lie under his own sculpture, the *Oviri*. However, good or bad, the monument, financed by the Singer sewing-machine company, remains the only material evidence of Gauguin's stay at Hivaoa, the island which witnessed the last years of his life, his last hopes and his last achievements. In May 1903, an inventory of the artist's property was made, and later, after the sale of his house at Atuona, all his belongings were auctioned off in Papeete, the capital of Tahiti. Many of his drawings, prints and woodcarvings were branded obscene or simply as having no artistic value and were disposed of without much ado. It was only due to the presence of a few travellers and colonists who knew something about art, and to the ill-concealed greediness of his recent enemies who, for all their hate, did not shrink from making money on his works, that part of Gauguin's artistic legacy escaped destruction. For example, the gendarme of Atuona who had personally supervised the sale and destroyed with his own hands some of the artist's works which supposedly offended his chaste morals, was not above purloining a few pictures and later, upon his return to Europe, opened a kind of Gauguin museum. As the

1. Quoted after: B. Danielsson, *Gauguin in the South Seas.* New York, 1966, p. 293.

result of all this, not one of Gauguin's works remains in Tahiti — the place whose very name is directly associated with the painter and his art. That was why the magnificent Musée Gauguin opened in 1965 at Papeari (where, by the way, the artist never lived) had to be stocked with photographs instead of paintings. The opening ceremony, however, was accompanied by eloquent speeches which paid homage not so much to Gauguin as to France which had brought civilization to the island (the civilization from which Gauguin had escaped to Tahiti). The ceremony was crowned by singing and dancing performed by the natives dressed in clothes "of the Gauguin period" for the amusement of the high-ranking civilians and army officials of the Territory and numerous guests of honour. Incidentally, such pompous celebrations always annoyed Gauguin who saw them as a completely misplaced activity by those authorities whose real duty was to encourage the arts in France. "...Is your mission to discover artists and sustain them in their task, or is it, when the general public ignores their merit, to legalize posthumous success by fancy deals and much fuss while you shelter under a halo of high-sounding words that read like an advertising slogan?"[2]

The news of Gauguin's death, which reached France with a four-month delay, evoked an unprecedented interest in his life and work. The artist's words about posthumous fame came true. He shared the fate of many artists who received recognition when they could no longer enjoy it. Daniel de Monfreid predicted this in a letter written to Gauguin several months before his death: "In returning you will risk damaging that process of incubation which is taking place in the public's appreciation of you. You are now that unprecedented legendary artist, who from the furthest South Seas sends his disturbing, inimitable works, the definitive works of a great man who has as it were disappeared from the world. Your enemies — and like all who upset the mediocrity you have many enemies — are silent: they dare not attack you, do not even think of it. You are so far away. You should not return. You should not deprive them of the bone they hold in their teeth. You are already unassailable like all the great dead; you already belong to the history of art."[3]

True, Gauguin's disappearance from the civilized world and the mystery which enveloped his life and death in the faraway South Seas intrigued the critics and the public alike and for a time reconciled them to works which had earlier puzzled some and shocked others.

In the same year, 1903, Ambroise Vollard exhibited at his Paris gallery about a hundred paintings and drawings by Gauguin. Some had been sent to him by the artist from Oceania, others had been purchased from various art dealers and collectors. In 1906, in Paris, a Gauguin retrospective was held at the newly opened Salon d'Automne. 227 works (not counting those listed in the catalogue without numbers) were put on display — painting, graphic art, pottery, woodcarving. Octave Maus, the leading Belgian art critic, wrote on this occasion: "Paul Gauguin is a great colourist, a great

Self-Portrait.
1903.

2. Quoted after: *Paul Gauguin. Oviri. Ecrits d'un sauvage.* Choisis et présentés par D. Guérin, Gallimard, 1974, pp. 55, 56.

3. Monfreid, p. 233.

draughtsman, a great decorator, a versatile and self-confident painter. He appeared before the public at an exhibition which, as Charles Morice said in a preface to the catalogue, should dissipate the doubts which the very name of the artist arouses in the public."[4]

In 1906 and 1907, Gauguin's works were also shown in Berlin and Vienna, and in 1908, a number of his canvases were included into a joint exhibition of French and Russian artists sponsored by the magazine *Zolotoye Runo* (the Golden Fleece) in Moscow. Gauguin was little known in Russia before his death. His art was familiar only to those connoisseurs, painters or collectors who had visited Paris and could view his pictures in private galleries and collections. Thus, in 1895, a chance visit was paid to Vollard's gallery by the young Russian artist and critic Igor Grabar whose sympathies lay with novel tendencies in contemporary painting and who later became a well-known historian of art. The Gauguins, Van Goghs and Cézannes kept in the gallery were a revelation to Grabar, and he tried to pass on his enthusiasm to both his closest friends and his compatriots, the young Russians then studying under Cormon in Paris. In the early 1900s, Grabar came to France again and paid a visit to Gustave Fayet, owner of a fine collection of Gauguin's pictures. Under Grabar's influence another Russian artist, Alexander Benois, who did not approve of the new trends in painting and whose first reaction to Gauguin had been wholly negative, gradually changed his opinion of the French man. "I have finally come to appreciate Gauguin," he wrote to Grabar from Paris, "and although I do not yet admit him to my Olympus, I take my hat off to him and love him."[5]

However, while acknowledging the artistic merits of Gauguin's pictures, Benois's views on Gauguin's art remained close to the official viewpoint which existed in France at that time. "Gauguin is very good," he wrote in a letter to a friend, "but it is dangerous to place him in the Louvre, for he is a cripple."[6] Nevertheless, in 1904, the magazine *Mir Iskusstva* (the World of Art) headed by Alexander Benois reproduced seven Gauguin paintings together with an enthusiastic review by Igor Grabar; three of these paintings came into Sergei Shchukin's possession soon afterwards. The same aim, of acquainting the Russian public with contemporary French painting, was being pursued by other art magazines in Moscow and St. Petersburg: the magazine *Iskusstvo* (Art) in two of its 1905 issues published a translation of an article on Gauguin by the well-known German art historian Julius Meier-Graefe and reproduced several of his pictures; the magazine *Vesy* (Scales) published excerpts from some of Gauguin's letters, while the *Golden Fleece* and *Apollon* carried translations of articles on Gauguin by Charles Morice's and Maurice Denis and of extracts from Gauguin's book *Noa Noa*. What really brought Gauguin's art home to the Russian public, though, was not those articles or reproductions but his pictures themselves. The Russian public became acquainted with them largely through the collections of Sergei Shchukin and Ivan Morozov. Nowadays the significance

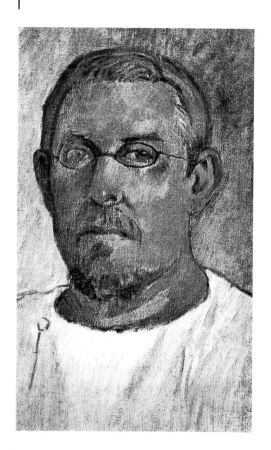

4. O. Maus, *Mercure de France*, 1907, LXV, p. 65.

5. I. Grabar, *Letters. 1891-1917*, Moscow, 1974, p. 389 (in russian).

6. *Ibid*, p. 389.

of these collections for Russian culture is universally acknowledged, whereas at first the enthusiasm of both collectors for the new French painting was received by many art lovers with ill-concealed scepticism. "Yesterday's merchants banished their old master icons to the attics, fell in love with fine arts and hung new icons by Monet, Cézanne and Gauguin in the state rooms of their mansions, renouncing all their former interests,"[7] wrote the painter Kuzma Petrov-Vodkin who, incidentally, knew and admired the artists he named.

The rooms which housed contemporary French paintings and which were open to the art-loving public, often witnessed heated discussions, in which Sergei Shchukin ardently participated. As Petrov-Vodkin recalled, "Sergei Ivanovich himself showed his collections to visitors. He was all agitation and eagerness; trying to overcome his stuttering, he gave the necessary explanations. He said that the concept of beauty was extinct, that its days were over, that it was the type, the expressive possibilities of the depicted object that were now coming to the fore, and that with Gauguin the age of beauty had reached an end..."[8]

According to Boris Ternovetz — a sculptor, who later became Director of the Museum of Modern Western Art in Moscow and who was very familiar with both Shchukin and Morozov and their collections — as early as pre-1900, "two Gauguins hang on the walls of the darkish rooms downstairs in Shchukin's mansion."[9] It is hard to say now which pictures he was referring to, but there appears to be a choice of three works, the date of whose acquisition is not known: *Self-Portrait*, the still life *Fruit* (both 1888) and *Her Name Is Vaïraumati* (1892) (Shchukin purchased all his other Gauguins after 1900). The fact that Shchukin acquired these canvases, even if the purchases were made relatively late, testifies to the unerring judgement and aesthetic qualities that enabled him to choose the most unconventional and avant-garde pieces from the host of Gauguin pictures offered by Vollard and other art dealers. Thus, although the pictorial treatment of *Fruit* still betrays links with Impressionism, its composition and the mask-like face of a woman (?) suggest a certain symbolism heralding the birth of the synthetic style. An even more daring acquisition was *Her Name Is Vaïraumati*. Gauguin himself was somewhat embarrassed by this painting, probably because it was his first excursion into Polynesian mythology, and because, having no pictorial or visual basis for it, he had to rely only on his own imagination. In a letter to Paul Sérusier, describing a sketch for this painting, the artist wrote: "I don't dare talk about what I'm doing here, my canvases terrify me. So, the public will never accept them. It's ugly from every point of view and I will not really know what it is until all of you have seen it in Paris... What I'm doing now is quite ugly, quite mad. My God, why did you make me this way? I'm cursed."[10] May be it was this titillating taste of novelty that had induced Shchukin to purchase the picture, but, bewildered by his own choice, he banished it to a dark room, out of sight from his visitors. Around 1903, another four canvases by Gauguin

7. K. Petrov-Vodkine, *Khlynovsk Euclidean. Space. Samarkandia*, Leningrad, 1982, p. 366 (in russian).

8. *Ibid*, p. 366.

9. B. Ternovetz, *Letters. Diaries. Articles*, Moscow, 1977, p. 106 (in russian).

10. P. Sérusier, *A. B. C. de la peinture. Correspondance*, Paris, 1950, pp. 59, 60.

appeared in Shchukin's collection: *Maternity, Woman Carrying Flowers, Man Picking Fruit from a Tree*, and *Gathering Fruit*. After the Salon d'Automne of 1906, Shchukin bought three other Gauguins: *Be Be (The Nativity), The Idol* and *Tahitians in a Room*; in 1908, he acquired *What! Are You Jealous?* and in 1910, *Scene from Tahitian Life* and *The Queen (The King's Wife)*, one of Gauguin's masterpieces. After Gauguin's death this last work came into the hands of Gustave Fayet, an artist and collector who, incidentally, was rather reluctant to buy it because he, in his own words, had already acquired a sufficient number of "figures nègres". Apparently Fayet did not value this painting very highly and since the price Shchukin offered was almost thirty times more than he had paid for it, he was not really sorry to see it go to Moscow. By 1916 Shchukin possessed sixteen Gauguins which were allotted a separate room in his private gallery.

Ivan Morozov owed his interest in French art partly to Shchukin and partly to his elder brother Mikhail Morozov whose collection by 1900 contained two Gauguins — *The Canoe (A Tahitian Family)* and *Landscape with Two Goats* — and several pictures by other French artists. The *Landscape*, due to a half-obliterated inscription which has only recently been deciphered, was not attributed, and Gauguin's picture by that name was believed lost. Ivan Morozov acquired his first three Gauguins in 1907. These were *Conversation, Landscape with Peacocks*, and *Sweet Dreams* which was listed in the catalogue of his collection as *Rural Life in Tahiti* and later known as *Sacred Spring*. The still life *The Flowers of France* must have been purchased in the same year. In 1908, another five pictures were added: *Cafe at Arles, The Big Tree (At the Foot of a Mountain), Pastorales Tahitiennes, Woman Holding a Fruit*, and *The Great Buddha*. The last two Gauguins to come into Morozov's collection were *Three Tahitian Women against a Yellow Background* and *Still Life with Parrots*. The works by Gauguin displayed in the two private galleries in Moscow were received by the public with anything but indifference. They were admired by some and openly resented by others. Gauguin featured prominently in the articles on contemporary French painting which began to appear in the art magazines of Moscow and St. Petersburg from 1906 onwards. Not all the opinions expressed in those days can be accepted now, but some still retain indisputable validity. Some critics, like Shchukin himself, believed that with Gauguin nineteenth-century art came to an end. Thus, Petrov-Vodkin, having attended several exhibitions in Paris in 1907, wrote: "The songs, so beautifully begun by Gauguin and Cézanne, are being finished by voices that are tired and no longer powerful..."[11] "Is it true that they [Gauguin and Cézanne] start a new route in the development of painting?" Pavel Muratov asked. "Both of them emerged at one time from Impressionism, both eventually came to reject it and, finally, both became inaccessible in their individuality. They passed through, and the door closed behind them."[12]

In contrast with contemporary art critics who tended to analyse

11. Petrov-Vodkine, *op. cit.*, p. 599.

12. P. Muratov, *"On Great Art"*, *Zolotoye Runo*, 1907, No. 12, p. 80 (in russian).

Gauguin's art largely in terms of Symbolism and who sometimes even sought clues to the puzzling details of his compositions in the medieval symbolic repertoire, the majority of Russian critics laid emphasis on the healthy and highly promising nature of the artist's creative pursuits. They saw Gauguin as a creator of a new progressive art, a painter whose symbolism reflected the true essence of things. It is interesting that Maximilian Voloshin, a poet, art critic and painter, who at the beginning of the century was accused of decadent inclinations, of extreme individualism and even of occultism and mysticism, was among the first to discern in Gauguin's art a passionate love for the visual and sensuous beauty of the world. Voloshin knew and understood Gauguin's works better than many of the artist's compatriots. From 1899 onwards, Voloshin had travelled extensively in Western Europe, and from the spring of 1901, he repeatedly spent long periods in Paris. While in Paris, he was a regular guest at the studio of Elizaveta Kruglikova, which was frequented by the young Russian artists who studied painting in France. He also visited the studios of Whistler and Steinlen and the Atelier Colarossi, and regularly sent his *Letters from Paris* to the *Scales* magazine in Russia. Voloshin was close to Wladislaw Slewinsky whose artistic idiom owed much to Gauguin's Pont-Aven programme. In 1902, Slewinsky was Voloshin's guest at Koktebel in the Crimea, where he painted his host's portrait and, in all likelihood, shared his memories of Gauguin. Voloshin knew Gauguin's art from his works in the Moscow and Paris collections. He saw him as an artist who, in his travels to distant lands, imbibed neither the stupefying drugs nor the spicy beverages of the tropics, but the ancient vital juices of the earth, the fundamental aesthetic and humane conceptions which made his art what it is. "Gauguin," he wrote exultantly, "is the conqueror of an empire. If he is not the king of modern painting, he is the king's son. He loved all that was simple, real, concrete and human. He loved substance and its forms, and not abstract ideas. He was seeking not new forms of painting but new facets of life. And when he found them, when he came to love and understand them, the creation of a new painting was for him a matter of course... He is one of those people who are in love with things, and he is ready to sacrifice his immortality for the transient forms of this world."[13] Even though, contrary to Voloshin's idea, Gauguin was always preoccupied with the pursuit of new art, the critic was essentially right, and the proof of it can be found in Gauguin's own writings and letters in which even the bitter complaints about his money problem, bad health and lack of understanding, cannot overshadow the recurrent motif of his love of life — if not at the present moment then in the years to come. "...I'm not one of those who speak badly of life. One suffers, but one also experiences pleasure and, however little it may have been, that is what one remembers."[14] Gauguin wrote those words three months before his death, when the artist, half-blind, restricted in his movements and unable to paint, was already weighing up his life and creative career.

The first edition of *Noa-Noa* in russian.

13. M. Voloshin, "Aspirations of French Painting (Cézanne, Van Gogh, Gauguin)", *Zolotoye Runo*, 1908, No. 7-9, p. X (in russian).
14. Gauguin, *Avant et Après*.

ПОЛЬ ГОГЭНЪ
«НОА - НОА»
ПУТЕШЕСТВІЕ НА ТАИТИ

ПЕРЕВОДЪ О. И Ш. РЕДАКЦІЯ
И ВСТУПИТЕЛЬНАЯ СТАТЬЯ
══ Я. ТУГЕНДХОЛЬДА ══
══ ИЗДАНІЕ Д. Я. МАКОВСКАГО ══

The first edition of *Noa-Noa* in russian.
Title-page.

15. S. Makovsky, "The Problems
of the Body in Painting", *Apollon*, 1910,
October-November, p. 25 (in russian).

16. Paul Gauguin, *Noa Noa.*
Voyage to Tahiti.
Introduced and edited by Ya. Tugendhold,
Moscow, 1914, p. 2 (in russian).

One of the issues discussed by Russian art critics early this century was the depiction of the nude body in art in general and in Gauguin's works in particular. This discussion might have been caused by the appearance of *The King's Wife* at the Shchukin gallery in 1910, since it was in that year that the *Apollon* published two articles on the 'nude' problem — one by Sergei Makovsky and the other by Yakov Tugendhold. Both articles, written in the romantically elevated style of the day, were largely concerned with Gauguin's place in the history of French painting. For the art critic and painter Makovsky, who in 1910 became editor-in-chief of the *Apollon*, Gauguin's Tahitian nudes were something more than just manifestations of a cult of the female body. He admired Gauguin's gift for generalization and synthesis which enabled him to elaborate a new approach to plastic and monumental forms. As Makovsky noted, "Gauguin was the first to reject the tradition of the famous French 'good taste' in order to learn from Tahitian savages a magic simplicity in depicting man and nature... Gauguin's exotic landscapes with their wonderful colourfulness and their simplified forms invariably possess a purely pictorial *recherche du vrai*."[15] The principal contribution to the study of the new French painting in Russia, particularly of Impressionism and Post-Impressionism represented by Cézanne, Van Gogh and Gauguin, was made by Yakov Tugendhold. An art historian and critic, who had been educated at Anton Azbé's school in Munich, Tugendhold spent several years from 1905 on in Paris whence he supplied Russian art magazines with his reviews of Paris Salons and other exhibitions of French and Russian artists, as well as articles on individual painters and the major problems of contemporary art. He also initiated and compiled the first Russian edition of Van Gogh's letters, which he supplemented with an introductory essay. Thanks to Tugendhold, Gauguin's *Noa Noa* was published in Russia in 1914. It was supplemented with the critic's article on Gauguin's life and work. Tugendhold's admiration for Gauguin was not accidental: the painter's creative principles and the critic's artistic credo had much in common. Tugendhold firmly believed in the social mission of art, the fulfilment of which demanded that the artist should break the confines of individualism — an impossible task, in Tugendhold's opinion, in the conditions of philistine bourgeois morality. It was his escape from Europe — from decrepit western civilization to collective forms of artistic consciousness, to the great simplicity of ancient Greece and Egypt — which, the critic thought, had saved Gauguin. He regarded the Frenchman not merely as a poet of primitivism, but as an artist whose work, with its monumental and epic character, had absorbed all the achievements of artistic culture. "Whatever one's attitude to the neo-archaism in contemporary culture, one should not forget that Gauguin was one of its first prophets and victims. And if Gauguin is now little spoken of in Paris, it is not because his art is antiquated, but because he has become a classic of the trend whose imitators and vulgarizers chose to forget their origins,"[16] Tugend-

hold wrote on the tenth anniversary of the artist's death in the hope of undoing the injustice which had hung over Gauguin throughout his life.

Eighty years have passed since. Gauguin's art has gained world-wide fame, and the time when his pictures were not admitted to museums has been forgotten. Today art dealers, collectors and galleries pride themselves on every Gauguin painting in their possession. The price of any one of his pictures far exceeds the total sum the artist received for all his paintings in his lifetime. A great amount of previously unknown data has been accumulated over the years; the artist's letters, critical legacy and books have been published and studied; museums in many countries possess fine collections of his paintings, graphic works, woodcarvings and ceramics. Numerous articles and monographs, biographies and novels, films and TV programmes have been devoted to Gauguin's life and work. But the argument between his passionate admirers and their no less passionate opponents is still going on. When it is the question of accepting or rejecting his artistic credo or of determining his place in art, the different, even mutually exclusive, views expressed by different generations of researchers with different aesthetic tastes are quite justified. Very often though, it is not just a question of different aesthetic views, but of a certain prejudice regarding the artist's personality and work. This also applies to his letters and other writings which would seem to offer a key to the many problems of Gauguin's art, but the lasting prejudice, which is often the product of philistine morality, is only too ready to reject this key under various pretexts.

One of these pretexts is the colloquial and sometimes unpolished style of his writings which is attributed to the "poor vocabulary of a former sailor". For others, the homely simplicity of Gauguin's style is the evidence of a literary gift employed for unseemly purposes: "...An excellent writer, Gauguin had created his image with such amazing skill and craft that the historian had only to pick up the grand sentiments which he flaunted and which somewhat remind of the ulcers forged by the poor from the Court of the Miracles at night to soften the hearts of the donors by day,"[17] wrote the well-known French critic Jean Bouret in the article which appeared in 1960 under a title typical of the period, *Pour un Gauguin enfin démystifié* (On a Gauguin finally demystified). Not even the most venomous critics of Gauguin's lifetime had ever ventured such unambiguously rude and disrespectful criticism as was voiced by this art reviewer of a major Parisian newspaper.

Such pronouncements could be ignored, if it were not for a similar spirit dominating some of the more sophisticated writings by professional art critics. A case in point is the collection of articles by the leading experts on Gauguin published in the series *Génies et Réalités* (Paris, 1960). The title itself seems to suggest that Gauguin is classed among the greatest figures in contemporary art. Indeed, all the authors agree that he was the creator, or at least a forerunner of the new art. But at the same time some of

17. J. Bouret, "Pour un Gauguin enfin démystifié", *Les Lettres Françaises*, 21-27 January 1960, p. 12.

14

Maternity (detail).
The Hermitage, St. Petersburg.

them question the independence of Gauguin's conception and creative method. Thus, the article by the American critic Richard Field, whose research, incidentally, has greatly contributed to the understanding of Gauguin's work, is somewhat sensationally entitled *Gauguin: Plagiarist or Creator?* Field himself does not give a direct answer to this question, letting the reader decide for himself, but his examples of Gauguin's borrowings and imitations, direct or indirect, leave little doubt as to the view he would like his reader to come away with. Likewise Claude Roger-Marx, although crediting Gauguin with a contribution to twentieth-century art and presenting him as a precursor of Matisse, Picasso, Maillol, Modigliani and Bourdelle, in his article *What Does Contemporary Painting Owe to Him?* declares Gauguin to have been an imitator who was only "occasionally" visited by a genius which raised him to the level of truly original artists. In the words of Roger-Marx, Gauguin's art is characterized by cunning as much as by naivety, and "it is hard to say what predominated in him — the natural or the artificial." [18]

The obvious consequence of such disparaging writings is that the reader and then the accordingly prepared viewer perceives Gauguin almost as a prisoner at the bar who, although acquitted by the jury, still leaves some doubt as to his complete innocence. Every critic is certainly entitled to a personal opinion, but there is no reason why, if unfavourable, it should be forcibly stretched so as to include a plagiarist and an artist who lives on somebody else's ideas among the ranks of geniuses.

The present book does not aim to review all the literature on Gauguin. The quotations above have been included so as to draw the reader's attention to the contradictory character of opinions of Gauguin and his art which, while often being based on a superficial approach or even on a hypocritically moralizing attitude to certain problems presented by his work, had a certain impact on scholarly literature.

Scholarly literature on Gauguin, however, for all its objectivity, also reveals a diversity of viewpoints. Some experts see Gauguin as a destroyer of realism who denounced traditions and paved the way for "free art", be it Fauvism, Expressionism, Surrealism or Abstractionism. Others, on the contrary, think that Gauguin continued the European artistic tradition. Some contemporaries reacted to his departure from Europe with mistrust and suspicion, for they believed that a true artist could and must work only on his native soil and not derive inspiration from an alien culture. This opinion was shared, for example, by Pissarro, Cézanne and Renoir. They considered Gauguin's borrowings from the stylistics of Polynesian culture to be a kind of plunder. According to many students of Gauguin, the aesthetics he evolved in Pont-Aven were nothing but a sequence of eccentric delusions and paradoxes which resulted in his disregard for traditions; and it was only his leaving Europe and the ensuing denial of the Pont-Aven delusions that brought him back to the classical norm. Yet another view maintains that the Pont-Aven aesthetics served as the basis for

Van Gogh Painting Sunflowers. (W. 296).

18. C. Roger-Marx, "Ce que lui doit la peinture contemporaine", in: *Gauguin. Génies et Réalités*, Paris, 1960, p. 171.

16

Gauguin's major artistic conception which was further developed and enriched in Tahiti.

Such controversial opinions of Gauguin's art are by no means accidental. His life and work present many contradictions, though often only outward ones. His life was naturally integrated with his creative activity, while the latter in its turn embodied his ideals and views on life. But this organic unity of life and work was maintained through a never-ending dramatic struggle. It was the struggle for the right to become an artist, the struggle for existence, the struggle against public opinion, against his family and friends who failed to understand him, and finally, it was his inner struggle for the preservation of his identity, his own creative and human self. Gauguin could hardly have become an artist who "reinvented painting" (Maurice Malingue) and who "initiated the art of modern times" (René Huyghe),[19] had he not possessed a

clear conception, a strong will and a power to resist everything that stood in his way, including his own family and his personal happiness.

Gauguin began his career as a grown man. Nothing in his childhood or youth betrayed any hint of his future as an artist. He was born in Paris on June 7, 1848, in the midst of the revolutionary events when barricade fighting was going on in the streets of the city. This fact was to have repercussions for Gauguin's later life, as his father Clovis Gauguin worked as a reporter on *Le National* — a newspaper that played a notable part in the revolution of 1848 — and was on close terms with its editor, Armand Marrast. It is difficult to say whether Clovis Gauguin played an active role in the events, but it is a fact that following the failure of Marrast (who was a member of General Cavaignac's government) in the election to the National Assembly, the Gauguins left France. In the autumn of 1849, the family sailed for Peru, where they could count on the support of Mme Gauguin's distant but influential relatives. But Clovis Gauguin's plans were doomed to failure. On October 30, 1849, he died at sea and his wife, with two children, had to continue the journey on her own. The situation in which the young woman found herself in a strange country was fraught with difficulties. She was obliged to impose herself and her children on people who were actually complete strangers and who at one time had rejected her mother's claims to family ties with them. The bold and adventurous character of Flora Tristan, her mother, had not been to the liking of Don Pio de Tristan y Moscoso, the head of a noble Spanish family which had settled in Peru. Don Pio did

19. *Ibid.*, pp. 108-137, 236-283.

not want to know about the family of his late brother whose marriage he regarded as illegitimate. Moreover, Flora's book *Peregrinations of a Pariah* in which she shared her impressions of a visit to Peru, had been publicly burnt in Arequipa. But all this was long before Mme Gauguin's arrival; Flora Tristan was dead, and the gentle disposition of her daughter, quite helpless in her predicament, touched old Don Pio's heart, and he welcomed her into his family.

Childhood in Peru was forever engraved on Paul Gauguin's memory. To the end of his days he remembered old Don Pio, who once acted for the Viceroy of Peru, and his son-in-law Echenique, who at the time of Paul's stay was President of Peru, and the large noisy family with its patriarchal way of life. The recollections of simple, natural relations among people with different-coloured skins, who lacked racial or social prejudice, the relations which might have been largely idealized in the child's memory, merged with the recollections of luxuriant tropical nature with its rich colours under the dazzling sun. It is very likely that these early impressions determined the subsequent development of Gauguin's artistic tastes and ideals. Return to France put an end to Paul's happy and carefree life. In Orleans, in the house owned by his uncle Isidore Gauguin who was under police surveillance for involvement in the revolution of 1848, everything was different: the way of life, the family atmosphere and even the language, since Paul had previously spoken Spanish and now had to learn French. At school in Orleans and later at a Lycée in Paris the dream of tropical countries and the sea never left Gauguin. At fifteen he found employment as a cabin-boy on a merchant ship and sailed to the South American coast, almost retracing the route of his first voyage overseas. But this romantic start was followed by an abrupt and unwelcome change: the Franco-Prussian war broke out, the merchant ship on which Gauguin served was requisitioned, and instead of the tropics he found himself in the north, near the Norwegian and Danish coasts. In April 1871, after the disbandment of the French forces, Gauguin returned to Paris with a third-class seaman's diploma.

Back in Paris, he had to start almost from scratch. His mother was dead, the house at St. Cloud plundered and gutted by fire. In search of work Gauguin turned to his sister's guardian Gustave Arosa who helped him to become a stockbroker at the Bertin bank. He quickly made a success as a businessman, settled down to raise a family, bought a house and began to lead the orderly life of typical bourgeois. The only thing that set him apart from others of his circle was his unorthodox interest in art. It might have been stimulated by the atmosphere in Arosa's house, as the owner loved painting and photography and kept a splendid collection of pictures. A friend of Arosa's, Nadar, was a cartoonist and photographer, and it was in his studio that the first exhibition of the Impressionists took place. Gauguin's passion for art might have also been inherited from his relatives, as there were two artists on his mother's side: a teacher of drawing and a lithographer.

Black chalk drawing Gauguin by Pissarro.
Pastel drawing Pissarro by Gauguin.
Around 1879-1883.
Musée du Louvre, Paris (plate from RMN).

18

Besides, he had grown up in a house decorated with Spanish and Peruvian pottery, portraits and other paintings which were bequeathed to him by his mother but apparently perished in the fire. The earliest known landscape by Gauguin is dated 1871. It was done in oils and was probably a product of the painting lessons which Gauguin attended together with Arosa's daughter Marguerite. Arosa's example as well as his own inclination encouraged Gauguin to form a collection of pictures. Although small in size, it fairly accurately reflected his artistic taste: Manet and Monet, Pissarro and Cézanne, Renoir and Sisley — painters who had very few admirers at that time. Gauguin's only friend at Bertin's, Emile Schuffenecker, was a qualified teacher of drawing but was

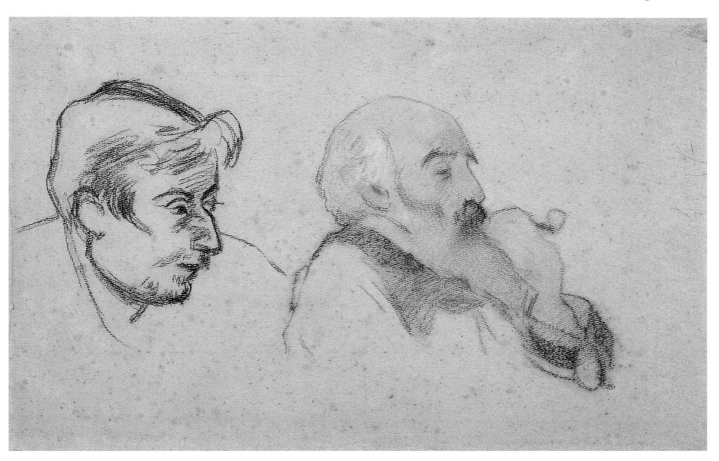

obliged to go into banking to earn his living. A common interest in art brought them closer together: they went to the outskirts of Paris to paint on Sundays and sometimes visited the Atelier Colarossi to draw from the model. They also attended museums and exhibitions, including the first Impressionist exhibition. A decisive part in Gauguin's initiation into art, and especially into Impressionist painting, was played by Pissarro, who willingly advised him on both the theory and technique of painting, and actually instructed him when they worked side by side painting the same motif. At Pissarro's studio Gauguin also met Cézanne who strongly appealed to him both as a person and as an artist, and whose work greatly influenced his own. But Pissarro and Cézanne were not Gauguin's only teachers. He used every oppor-

tunity to fill in the gaps in his artistic education, not only in painting, but in other kinds of art as well. No doubt, it was with this aim in mind that Gauguin rented a house and workshop first from the ceramist and jeweller Jean-Paul Aubé, and then from the sculptor Jules Ernest Bouillot. While working at the latter's studio, Gauguin produced, first in plaster and then in marble, bust portraits of his wife and son.

In 1876, Gauguin exhibited a landscape at the Salon and received a favourable press. From 1879 onwards, he contributed to the Impressionist shows and actively engaged in organizational work, inviting new artists to exhibit with the group. Art was gradually ousting all other interests in Gauguin's life, and when, in 1883, he was obliged to resign his job at Bertin's due to a financial crisis, it was not without joy — albeit not without apprehension either — that he decided to give up his banking career for good. Since that time he made no attempts to resume it, although he realized all too soon that the life of an artist determined on having his say in art was full of hardships. His resources were dwindling fast, and in January 1884 he moved with his family to Rouen, where he hoped to find clients, but he met with no success and decided to go to Copenhagen, his wife's native city. His Danish inlaws felt duty bound to make him see reason and accept a place in a company selling horse-cloths and canvas. Gauguin's attitude provoked open hostility, and as a result, in the summer of 1885, leaving his wife Mette Gad and four of their children behind, Gauguin returned to Paris with his six-year-old son. From now on his only purpose in life was to become an artist, and not just any artist, but an outstanding one.

The earliest period in Gauguin's artistic career, which began with his Sunday lessons in professional skills, was closely linked with Impressionism. This link was inspired first by Gustave Arosa's tastes in art and then by Pissarro's lessons, his views and his steadfast principles. Having turned to art as a grown man, Gauguin, with his independent frame of mind, could not fail to appreciate everything that was bold and new. Thanks to his teachers, whether direct or indirect, Gauguin from the very outset was brought up in a spirit of hostility towards traditional, academy-preserved aesthetics, and he saw the work of the Impressionists as an open war against academic canons. Very soon he began to associate it with rebellion against bourgeois society as well. That was why Gauguin continued to call himself an Impressionist even after he had fully abandoned the Impressionist principles of painting. This also explains the parallel the artist drew between himself, the Impressionists and Jean Valjean, the hero of Victor Hugo's novel, in his *Self-Portrait: "Les Misérables"* (Rijksmuseum Vincent van Gogh, Amsterdam; W. 239). For Gauguin, the "Impressionist is pure, not yet sullied by the putrid kiss of the Ecole des Beaux-Arts".[20] This attitude prompted him to call the 1889 exhibition at the Cafe Volpini 'Peinture du Groupe Impressionniste et Synthétiste', thus emphasizing the challenge to conventional salon painting.

Snow. Rue Carcel.
In Paris. 1882.

20. Malingue, p. 141.

20

However, Gauguin's links with Impressionism were not confined to this aspect alone. Impressionism that had given a fresh impulse to European art, that had discovered the changeability of nature and turned to capturing the effects of ever-changing light, demanded from the artist constant, keen attention to the living world. And the fact that Gauguin had found his way into art through Impressionism was of paramount importance for his further development, even though he later broke away from his teachers more decisively and uncompromisingly than any other of the Post-Impressionists. The main lesson he learnt from Impressionism was the rejection of the time-tested but antiquated traditions and the trust in the artist's own visual experience; Gauguin remained faithful to this lesson all his life. That is why it always took him so long to imbibe the atmosphere of each new place — Rouen or Brittany, Copenhagen or Arles, Martinique or the Pacific Islands. His synthesis or symbolism was always based on the analytical method borrowed from Impressionism.

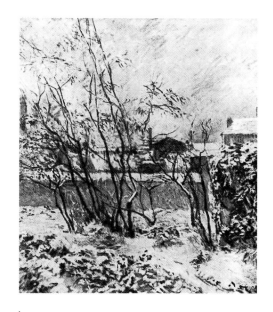

At the same time, certain aspects of Impressionist aesthetics were alien to Gauguin from the start, even though he did not become aware of it until much later. He tried to see the world as the Impressionists saw it, especially Pissarro, whom he regarded as his teacher to the end of his life. He worked in the open air, applied his paints in small, brightly coloured dabs, used the motifs and compositional devices of the Impressionists, discussed the issues which were important to them; he admired, understood and, in his happier days, collected their paintings. Gauguin achieved a complete mastery of the Impressionist technique, to which many of his canvases bear witness, and which makes it possible to single out the Impressionist period in his career. Among those canvases are the summer and the winter views of Rue Carcel where he lived; the landscapes painted near Pontoise, with their blossoming apple-trees or haystacks; the views of Rouen and Dieppe; and the portraits of his wife and children. But Gauguin assimilated Impressionism at a time when it was an already established system and when the Impressionists themselves were coming to realize the necessity of breaking out of its confines. That necessity was at first intuitively and later consciously appreciated by Gauguin as well. To follow the principles of his teachers he had to force his own artistic vision. The moment he moved away from Pissarro, his influence began to fade, overpowered by other tendencies. The shimmering light which dissolved the outlines of figures and objects, and the flickering touch, combined with the brightness of colour, gave way to dense brushwork somewhat artificially distributed reflections and a reserved, rather dark palette, which at time brings an element of drama to the composition. It was not surprising that the dull, subdued colours of the landscapes Gauguin exhibited at the 1882 Impressionist show were immediately noticed by Joris Karl Huysmans. The static forms in those landscapes were emphasized by the unbroken stroke, by the even, matt pictorial surface. Even water, which always attracted the Impressionists with its con-

stant changeability and movement, was heavy and almost immobile in Gauguin's works. In an attempt to reconcile his vision with Pissarro's lessons and in answer to Pissarro's reproach he rather illogically explained that his dense brushwork was a necessary step in mastering the "rainbow and sunlit palette".[21] Equally controversial are his *Notes synthétiques*[22], which were probably written while still in Rouen, in 1884. In them Gauguin argues with critics of Impressionism, defending the Impressionist principle of the primacy of colour over drawing and insists on the necessity of the 'broken colour' technique. At the same time he declares that nature can be cognized only through the inherent perspective sensations of the artist, that is, subjectively rather than visually, in other words, through the artist's inner vision. These new ideas also coincided with Gauguin's sudden interest in graphology, the study of which enabled him to assess human character. According to Pissarro himself, Gauguin analysed some Pissarro family letters quite impartially and convincingly.

Gauguin's deviation from Impressionism first manifested itself during his stay in Rouen. It is particularly evident in his plastic works, a case in point being the carving of a small wooden jewellery box. The decor of the external sides ornamented with theatrical masks and ballet dancers in tutus (a design borrowed from Degas) is in striking contrast with the corpse-like figure in the bottom of the box, which is reminiscent of a Peruvian mummy. This clash of motifs — worldly amusements and death — leaves no doubt as to the allegoric meaning the artist wanted to convey: the theme of *vanitas*, the transience of human life.[23] This interest in the artist's inner feelings, in conveying an abstract idea instead of his visual impressions, was far removed from the Impressionist conception. It is also worthy of note that the treatment of folial designs, of a bizarre male profile and of a female figure (which is thought to symbolize maternity) betrays certain iconographic and stylistic features found in Gauguin's future symbolic works, particularly of his carved wooden panels.

Gauguin's stay in Copenhagen, far from his recent fellow artists, stimulated him to form an independent opinion of his art which, by his own admission, was rather "one of thought than of acquired technique".[24] The winter in Copenhagen was not conducive to working in the open, and Gauguin concentrated on theoretical problems. Art magazines kept him in touch with artistic life in Paris, and he was well informed about all exhibitions which took place there, including the Delacroix retrospective. He was acquainted with the press it received and with the written works of Delacroix himself and his interpreter Charles Baudelaire. Excited by the coincidence between some of Delacroix's ideas and his own, Gauguin sent a letter to his old friend Emile Schuffenecker (January 14, 1885), in which he once again raised the theme touched upon in the *Notes synthétiques*: "Sometimes I wonder if I'm crazy, and yet the more I think things over at night, in my bed, the more I believe I'm right. For a long time the philosophers have been reasoning about phenomena which seem supernatural

21. Rewald, 1962, p. 60.
22. Quoted after: Rewald 1962, pp. 57-64.
23. Ch. Gray, *Sculpture and Ceramics of Paul Gauguin*, Baltimore, 1963, pp. 4, 5, 120, 121, cat. 8.
24. Rewald 1962, p. 45.

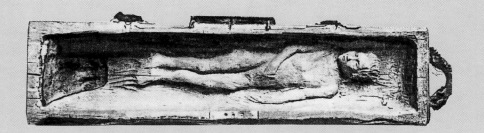

Carved wooden box (bottom). 1884.

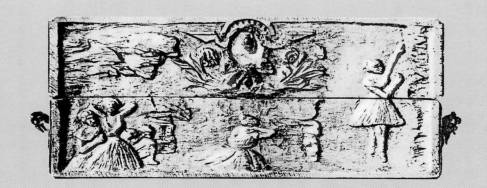

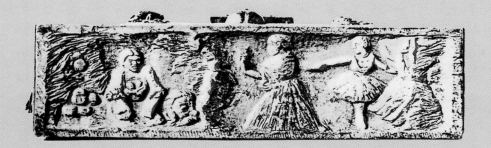

Carved wooden box (external side). 1884.

to us and which we nonetheless sense. That word is the key to everything... In my opinion, the great artist is the formulator of the greatest intelligence. The sentiments which occur to him are the most delicate and, consequently, the most invisible products, or translations, of the mind... All our five senses reach the brain directly imprinted with an infinity of things that no education can destroy. I conclude from this that there are lines that are noble, deceptive, etc There are tones that are noble, others that are common, harmonies that are calm and comforting, others that excite you with their boldness... The more I advance, the more I give credence to this sense of translations of thought by something totally different from literature... In Raphael's paintings there are harmonies of line of which one is not aware, as it is the most intimate part of the soul that finds itself completely concealed." Then came a word of advice: "...Work freely and madly; you will make progress and sooner or later people will learn to recognize your worth — if you have any. Above all, don't sweat over a painting; a great sentiment can be rendered immediately. Dream on it and look for the simplest form in which you can express it."[25] Gauguin developed those views in another letter to Schuffenecker (on May 24, 1885), which was entirely devoted to Delacroix, then the idol of the French artistic avant-garde. Gauguin's infatuation with Delacroix was symptomatic in many respects. In contrast to some of his contemporaries, who, like Paul Signac — the founder of Neo-Impressionism — mostly admired Delacroix as a colourist, Gauguin saw his strength in his expressive and vigorous drawing which endowed his paintings with vitality and dramatic tension. Gauguin was enchanted by the flight of imagination apparent in Delacroix's pictures, by the freedom and suppleness of form and by his ability to sacrifice prosaic verisimilitude for the sake of revealing the essence of visual reality. Gauguin saw Delacroix as a painter whose personality and temperament were reflected in his artistic manner. "That man had the temperament of the wild beasts. That's why he painted them so well," he wrote to Schuffenecker. "Delacroix's drawing always reminds me of the strong, supple movements of a tiger. When you look at that superb animal you never know where the muscles are attached, and the contortions of a paw are an image of the impossible, yet they are real."[26] In Delacroix's *The Barque of Dante*, Gauguin sensed the breathing of a powerful monster, while the supple folds of draperies made him think of snakes ("les draperies s'enroulent comme un serpent"). He was ready to give a picture of his own for a photograph of that canvas, as he considered it to be a quintessence of pure painting. "Nothing but painting, no *trompe l'œil*," Gauguin added in the same letter. He admired Delacroix not only as a fine draughtsman, but also as a great innovator whose drawing served to perfectly emphasize the idea. It is difficult to disagree with those students of Gauguin, who, having discovered a number of close parallels between his statements in the letter of January 14, 1885 and certain formulations made by Delacroix, refuse to regard them as accidental. On the

25. Malingue, pp. 44-47.
26. Malingue, pp. 62, 63.

24

other hand, it would be naive to conclude that Gauguin owes his aesthetic views fully and directly to Delacroix and not to his own understanding of art. Delacroix's theory was no news to him, for it had been expounded by the painter himself, as well as by Baudelaire and other critics and men of letters. Delacroix's formulations concerning the symbolism of line and colour were even included in Charles Blanc's well-known treatise *Grammaire des arts du dessin* (Grammar of the Art of Drawing), intended for art students, a work Gauguin must have been familiar with. But up to a certain time he remained indifferent to these issues. The aesthetic views of Delacroix really attracted his attention only when they became consonant to his own artistic vision and, in a way, served to confirm the validity of his own ideas. Hence the borrowings of phrases which had stuck in his memory. Moreover, Gauguin's work, in which those ideas eventually found realization, was so different in manner and method from that of Delacroix, that these borrowings can be only viewed as a kind of starting point in the development of a new trend in his art. It would be interesting in this respect to remember what Delacroix himself wrote about Raphael: "Nowhere did he reveal his originality so forcefully as in the ideas he borrowed. He takes everything he finds and gives a new lease of life to it. He, in fact, takes all that legitimately belongs to him, cultivating the shoots which seemed to be waiting for his touch to bear fruit." [27] These words are equally applicable to Gauguin and might serve as an answer to those who accuse him of borrowings and lack of originality.

However, no matter whether Gauguin owed any of his new artistic views to Delacroix or not, it should be noted that in his letters written in early 1885 he formulated, albeit not very consistently, the fundamental principles of an aesthetic system which was to be developed and implemented in his later work and which he himself termed 'synthetism'.

The year spent in Paris after his return from Copenhagen was one of the hardest in the artist's life. The comfortable settled life of earlier years was over; instead, moving from one temporary residence to another, indigence, poor health and loneliness became his lot. To support his son and pay the rent he had to earn money by pasting posters. However, he was able to contribute 19 paintings to the Impressionist exhibition in May 1886. Despite the fact that the critics and the public were preoccupied with Georges Seurat's picture *A Sunday Afternoon on the Island of La Grande Jatte,* which marked the emergence of Neo-Impressionism, the changes in Gauguin's manner did not escape the attention of a young but experienced critic, Felix Fénéon. That reviewer noticed the stability of forms, the rich and saturated colouring and the reserved harmony of Gauguin's new works.

But a favourable review could hardly help Gauguin out of his poverty, and, having installed his son in a private boarding-school, he left for Brittany. The life at Pont-Aven gave the artist relative freedom and an opportunity to think over certain issues which had long preoccupied him.

27. E. Delacroix, "Raphael", *Revue de Paris*, 1830, XI, p. 145.

One of the organizers and participants of the 8th and last Impressionist exhibition, Gauguin could not fail to realize the significance of controversies within the Impressionist circle, controversies involving not only the young members, but also the well-known figures who had begun the trend. This split was keenly sensed by the artists themselves. Neither Monet, nor Renoir, nor Sisley took part in the exhibition. Pissarro, who had always been for Gauguin an authority on Impressionist theory and practice, participated as a follower of Seurat. Felix Fénéon, who became the principal exponent of the new aesthetic credo of Seurat and Signac, declared in his articles that the naturalistic, intuitive Impressionism had faded away and that a strict rational system had taken its place.

Gauguin spent about six months in Pont-Aven, a small, god-forsaken place lying at the foot of two large hills. His first impressions of Brittany, a country poeticized in French literature as a relic of the old Celtic civilization, were powerful, but not exactly inspiring. Everything in that land — its archaic way of life, its heathen-flavoured Christian monuments and its dour, hard-working peasants — mirrored Gauguin's own unhappy mood. Gradually adapting himself to the new atmosphere, he painted, along with Impressionist pictures, a number of canvases in a new stylistic vein. Strictly speaking, this manner was not entirely new, for it had first manifested itself in works done in Dieppe where he had spent a few weeks in the summer of 1885 after leaving Denmark. Evidence of this can be found in three canvases: *The Harbour at Dieppe* (City Art Gallery, Manchester; W. 169), *The Beach at Dieppe* (Ny Carlsberg Glyptotek, Copenhagen; W. 166) and *Women Bathing* (National Museum of Western Art, Tokyo; W. 167). The order of their painting is unknown, but stylistically they may be assigned to three different periods. While the *Harbour* is a purely Impressionist work, the *Beach* combines Impressionist features with a novel treatment of space. The third picture bears no trace of Impressionism: its space is reduced to a minimum and the figures are placed parallel to the surface of the canvas in a frieze-like fashion emphasized by the repeated pattern of bent arms and by the unbroken line of the drawing.

Gauguin's stay in Brittany saw a further development of his new style. The flickering light and air of his earlier pictures gave way to flat forms which at times acquire solidity evocative of Cézanne, as in the *Still Life with Profile of Charles Laval* (Josefowitz collection, W. 207) or, as in the compositions with female figures, are arranged on the surface in a kind of decorative pattern formed by the clear contours of caps and collars — the important elements in traditional Breton dress.

Gauguin was gradually acquiring confidence in his new artistic method. As early as the summer of 1886, he gathered around him in Brittany a small group of artists who admired his aesthetics. Unfortunately this could not be said of his fellow-artists in Paris which he visited to make ceramics, or of his former friends. Pissarro called him a sectarian and openly disapproved of his work,

*Still Life with Profile of Charles Laval.
1886.*

particularly the ceramics, which Gauguin counted on selling. Being obliged to divide his time between Pont-Aven — crowded with touring artists in summer but dull and desolate in autumn and winter — and Paris, Gauguin began to consider leaving the capital for good: "Most of all, I would like to escape from Paris, as it is a desert for a poor man."[28] Paris, where he had only recently prospered, but prospered as a businessman, was becoming for him a symbol of venality, callousness and, moreover, of the fall of European culture. Civilization and individual freedom, particularly the freedom of a creative personality, were for him incompatible notions. Unlike other painters, including the Impressionists, he never made the city the subject of his pictures. But his idea of leaving Paris had nothing to do with a rural idyll: he dreamt of distant tropical lands inhabited by free people, by savages unspoilt by the European civilization. These tropical fancies, born in the very first year of his financial troubles, were to stir his imagination from that time on with pictures of luxuriant and abundant nature, amongst which he saw himself living as a savage.

His first contact with the reality, when in 1887, together with the young painter Charles Laval, he went to Panama, proved the ephemeral character of these dreams. The building of the Panama Canal attracted hordes of adventurers and moneyhunters to the country. The corruption and tyranny of the authorities made life in Panama unbearable for Gauguin. He had to change his brush for a spade to earn money for his passage — this time to Martinique which lured him with the same dream of a happy life, an opportunity to devote himself to painting, and of a family reunion. But in less than six months a fatal lack of money and tropical fever forced him to return to Paris.

However, Gauguin's stay on Martinique turned out to be extremely important, for it finally freed him from Impressionism. Nature itself showed that it could be viewed from more than just the Impressionist angle: it offered a wealth and variety that called for a different pictorial system. The tropical sun revealed new possibilities in the rendering of light, space, volume and colour. Under its dazzling rays objects neither cast semitransparent, diffused shadows nor lose the clarity of their shapes. On the contrary, forms become clear-cut and stand out boldly as solid masses of colour. Hence Gauguin's new tendency to concentrate large pools of contrasting colour, to stress contours and smooth, expressive lines. This is seen in his *Mangoes*, or *Gathering Fruit* (Rijksmuseum Vincent van Gogh, Amsterdam; W. 224), in *Tropical Landscape* (Bayerische Staatsgemäldesammlungen, Munich; W. 226), as well as wooden reliefs and pastels done later. On Martinique the artist seemed to re-enter a world which had been familiar to him since his childhood, but overshadowed by a different way of life and different aesthetic education. It was a world of slow, leisurely rhythms, of natural grace of movement possessed even by those black women who were no longer young and slender. "I have never before made paintings so clear, so lucid,"[29]

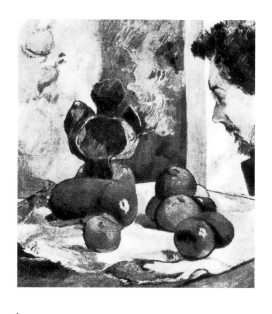

28. Malingue, p. 100.
29. Malingue, p. 117.

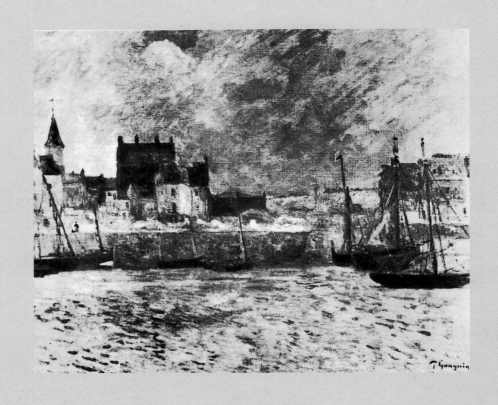

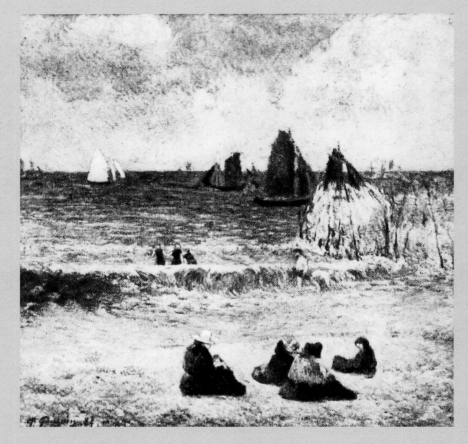

◀ *The Harbour at Dieppe.*
1885.

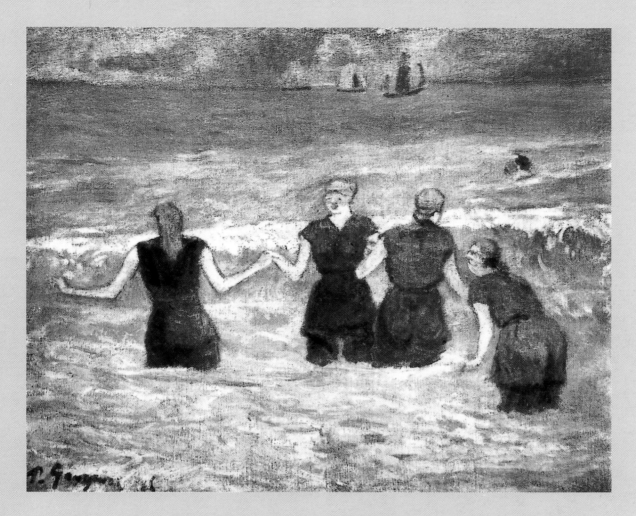

Women Bathing at Dieppe.
1885.

◀ *The Beach at Dieppe.*
1885.

he wrote to Schuffenecker. After Martinique, he remained forever faithful to the arabesque — that 'thread of Ariadne', as it was dubbed by René Huyghe, which proved so important in his future work particularly in the development of cloisonnism or synthetism. The pictures painted on Martinique were enthusiastically received by Vincent van Gogh, who wrote: "His Negresses have a touch of great poetry; everything he does nowadays is soft, pathetic and striking in character."[30] Under Van Gogh's influence, his brother Theo arranged a display of Gauguin's ceramics and several new pictures at the Galerie Boussod et Valadon. Gauguin had first tried his hand at ceramics in 1886 and took it up again upon his return from the Antilles. Felix Fénéon, who reviewed this exhibition, was the first to note the essential changes in the artist's work which turned him into "the authentic Gauguin" (in contrast with the earlier period when his creative individuality had not yet been fully formed). Here is an excerpt from that review: "From a voyage to the Antilles he brought back a Martinique landscape... amidst the heavy verdure is the flaming splash of a roof, typical of what is real Gauguin. Barbaric and peevish in character, scarcely filled with air, with diagonal strokes vigorously applied from right to left, these fiery pictures could have epitomized the whole work of Paul Gauguin had this obstinate artist not first of all been a potter. Stoneware, spurned by all, funereal and hard, he loves it: haggard faces, with broad brows, with smallest eyes half closed, with flattened nose — two vases; a third — head of a royal ancient, some Atahuallpa whom one robs of his possessions, his mouth torn into an abyss..."[31]

This new, real Gauguin failed to conceal his quest for a different, a non-European imagery — both in his art and in his life. To preserve moral strength for his work, he did not allow himself to get involved in any kind of emotional experience outside his creative pursuits and replied to his wife's complaints with the following words: "There are two natures in me: the Indian and the sensitive. The sensitive has disappeared, which permits the Indian to walk straight ahead firmly."[32] He called himself an Inca and a Peruvian savage, and it had nothing to do with make-believe or playing a primitive. Martinique had revived his memories of Peruvian art, of collections of Peruvian pottery in the house of his childhood and at Arosa's in Paris. His passion for ceramics gave a fresh and powerful impulse to his work. The significance of Gauguin's ceramic sculptures for an understanding of his evolution as an artist was revealed by Merete Bodelsen.[33]

Having acquired the necessary professional skills under the ceramist Ernest Chaplet, Gauguin set to work in his own way. He rejected the potter's wheel and used the primitive method of

Peruvian Mummy.
Musée de l'Homme, Paris.
Gauguin made a drawing of this. The pose can be seen in several of his paintings.

30. V. Van Gogh, *Lettres à Emile Bernard*, Paris, 1911, p. 83.

31. F. Fénéon, *Œuvres*, Paris, 1946, p. 116.

32. Malingue, p. 126.

33. M. Bodelsen, *Gauguin's Ceramics*, London, 1964.

34. Malingue, p. 141.

35. Gauguin, *45 lettres*, p. 245.

36. Malingue, p. 322.

Head of a Breton Girl. Vase.
1887-1888 (ceramics).

Self-Portrait Vase.
Stoneware.

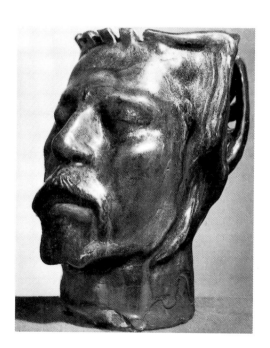

hand-moulding; the traditional shapes of Greek vases did not satisfy his creative fancy, and he invented his own forms, evocative of both small-scale Mexican clay sculpture and Japanese netsuke. He did not entrust the firing of his wares to anyone but himself. Many of Gauguin's clay figurines and compositions possess artistic qualities of a professional sculptor's work. And indeed, Gauguin regarded ceramics not as a craft, but as an art in its own right, a sacred creative process whose secrets he was trying to disclose through experiments with shapes and colours. Even the fire in the kiln possessed a magic nature for him, fascinating him with the way it affected the forms and colouring of his sculptures.

The study of ceramics had an immediate impact on Gauguin's painterly manner. Not only did he introduce the whimsical forms of his clay sculpture into his pictures — as exemplified by *Still Life with a Japanese Print and Self-Portrait Vase* (G. Ittleson collection, New York; W. 375) and *Self-Portrait with the Yellow Christ* — but, what is much more important, he often applied the potter's techniques to achieve the effect of clay texture, particularly that which he attained when firing his *Self-Portrait Mug* (or *Vase*). The imagery of his ceramic sculptures served as a clue to the symbolism of his pictorial vocabulary. This follows from a letter to Schuffenecker, in which Gauguin wrote about his *Self-Portrait* (with a profile of Bernard): "*Les Misérables*": "The colour is remote from nature: imagine something like pottery twisted by the furnace! All the reds and violets streaked like flames, like a furnace burning fiercely, the seat of the painter's mental struggles."[34] In a letter to Van Gogh he again tried to explain the meaning of this essentially programmatic painting through the prism of a potter enchanted by fire: "The face is flooded with blood, and the blazing tones of the forge envelop the eyes, indicating the fiery lava which inflames the painter's soul."[35]

According to Bodelsen, the influence of ceramics was also manifested itself in the simplification of the drawing, in which the fragmented hatching was replaced by rigid unbroken outlines enclosing objects and figures. Very soon this new tendency developed into the so-called cloisonnist method.

Yet, no matter how strong the impact of ceramic art was, the decisive role in Gauguin's creative evolution belonged to his own inborn inclinations which were awakened by his discovery of Martinique. Only after his stay at Martinique did he find new forms and colours in the old craft and translated them into the language of painting. It was Martinique, too, that helped him to see Brittany in a new light.

A few months in Paris sufficed to reawaken Gauguin's irresistible urge to leave that city, and early in 1888 he again moved to Pont-Aven. "You are a Parisian," he wrote to Schuffenecker, "but I like the countryside. I love Brittany, for I find there the savage, the primitive. When my wooden shoes reverberate on this granite soil, I hear the muffled, heavy and powerful note I'm seeking in painting."[36] The dark, rainy winter days and his illness, however, were

not conducive to work, but to a "silent contemplation of nature". His attempt to convey in painting what appealed to him in the scenery of Brittany and in the character of its people was not immediately successful. Many works of this period still bear traces of Impressionist technique, for example, minute broken strokes and reflections of colour. They coexist in a peculiar unity with the characteristic shading which first appeared during the Martinique period. These features sometimes overshadow Gauguin's new approach to the depiction of reality and his aspiration to reveal the spirit of nature and its forms. A telling example is the still life *Fruit* (Pushkin Museum, Moscow), in which two distinct tendencies can be observed. On the one hand, it is a true-to-life representation of the fruit, on the other — an obvious departure from visual verisimilitude manifesting itself in the use of arbitrary perspective, in an unexpected angle of vision, in the absence of the background and, finally, in the picture's symbolic implication. A strange gloomy face recurs in the outline of the vase, thus stressing the archaic, primitive, character of Breton forms.

Gauguin's break with this dualism and his turning to more essential and simpler elements devoid of any narrative overtones were largely influenced by Japanese art which he admired throughout his life. The Japanese print, with its flat forms, high horizon, asymmetrical composition and a well-defined outline dividing space into chromatically uniform planes, was a source of Gauguin's theoretical essays and practical experiments. The aesthetics of the Japanese print was neither something new to him, nor something he blindly imitated. It enriched his understanding of the conceptual integrity of a picture, which embraced in equal measure its composition, linear drawing, harmony and emotionally charged colour values. Japanese art with its cult of the telling detail suggested new laconic means which enabled Gauguin to make his fantasies convincing, and which he variously used in different periods of his career.

One of the first paintings, which Gauguin himself links with his new aesthetics, is *Wrestling Boys* (private collection, Paris; W. 273). Here he refrains both from the linear and light-and-air treatment of space and from the modelling of forms. Instead, his use of bold outline flattens the figures on the canvas's surface, transforms the volumes into silhouettes, and thus fuses the entangled bodies of the boys into a kind of decorative pattern. The links with Japanese art are evident in the high horizon and the impression of the immobility of the figures. Due to this lack of dynamism, an ordinary genre scene seems to bear the mark of eternity. "The picture is one completely Japanese, by a savage from Peru...,"[37] Gauguin wrote to Van Gogh. The artist was not concerned with visual verisimilitude achieved through a precise rendition of every minute detail, for he firmly believed that true art could not exist without fantasy. And he repeatedly expressed this view in conversations and letters. In 1888, he wrote to Schuffenecker: "A word of advice: don't paint too much direct

The Vision after the Sermon, or Jacob Wrestling with the Angel. 1888. 73 x 92 cm.

37. Gauguin, 45 lettres, p. 215.

32

from nature. Art is an abstraction, derive this abstraction from nature while dreaming before it, and think more of the creation which will result..."[38] As a matter of fact, these ideas began to preoccupy Gauguin three years earlier, but by the time of sending the letter he was confident of his rightness.

Until quite recently there was no consensus among art historians as to who should be considered the founder of the Pont-Aven aesthetics — Gauguin or Emile Bernard. Nowadays the majority of scholars agree that the indisputable leader in that school was Gauguin, although Bernard certainly made his contribution — if not in painting proper, then in the theory of the trend. At the same time, most art historians still believe that the key work of the new trend, *The Vision after the Sermon*, or *Jacob Wrestling with the Angel* (National Gallery of Scotland, Edinburgh; W. 245), was conceived by Gauguin under the influence of the *Breton*

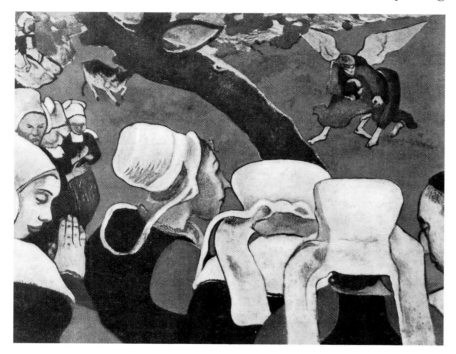

Women in the Meadow by Bernard (D. Denis collection, Saint-Germain-en-Laye). It is true that Gauguin's *Vision* appeared after *Breton Women*, but this does not necessarily imply (as was convincingly shown by Mark Roskill[39]) that he was influenced by Bernard's picture, for the general tendency of Gauguin's creative evolution and some of his previous works indicated a new artistic outlook and a realization of this in his painting. In the *Vision,* real figures are juxtaposed with imagined figures, and this combination is achieved by extremely simple, purely plastic means without any narrative element. "I believe," Gauguin wrote to Van Gogh, "that in my figures I have attained a great simplicity, which is both rustic and superstitious. The whole thing is very severe. As far as I'm concerned, in this picture the landscape and the struggle exist only in the imagination of the people whom the sermon has moved to prayer. That's why there is a contrast between the people, depicted naturally, and the struggle in the unnatural and disproportional landscape."[40] The entire structure of the painting, its colouring and its proportions emerge from the inner logic of the composition based on the harmonious fusion of the real and the imaginary. Nothing of this kind can be observed in the *Breton Women* by Bernard, which, while certainly innovative, is a purely decorative picture lacking any inner psychological meaning. It is not unlikely that even in the figural arrangement, in the rhythmic pattern of variously directed lines and in the enclosed contours evocative of cloisonnism, Bernard might have been influenced by Seurat's painting *A Sunday Afternoon on the Island of La Grande Jatte,* which had created a sensation. Moreover, it was only much later,

38. Malingue, p. 134.

39. M. Roskill, *Van Gogh, Gauguin and the Impressionist Circle.* London, 1970, p.103.

40. Gauguin, 45 lettres, pp. 229, 231.

33

when Gauguin was already acclaimed the originator of Symbolism in painting, Bernard began to insist on his own priority, whereas at that time he respected Gauguin as a more experienced artist and openly admired his *Vision after the Sermon.* He even accompanied Gauguin to the Curé of the Nizon church, being quite certain that the latter would accept the picture as a gift. Gauguin's prestige was, in fact, so enormous that Bernard, despite Van Gogh's insistent requests, for a long time did not dare to paint his portrait. Gauguin was really the moving spirit of a group of young artists who communicated to one another his thoughts on art, often expressed in an aphoristic or jocular manner. In September 1888, he gave Paul Serusier something of an object lesson in the use of 'synthetic' pure colour: "How do you see that tree? It's green, you say? Well, take a green, the best green on your palette, and that shadow — it seems rather blue? Don't be afraid to paint it as blue as you can." The small landscape Serusier painted under Gauguin's direction on the lid of a cigar box, and called symbolically *The Talisman,* was a revelation for the future Nabis who were then studying at the Académie Julien. Recalling the enthusiastic comments on *The Talisman* and Serusier's story of Gauguin's lesson, Moris Denis wrote: "Thus for the first time we have been presented, in a paradoxal, unforgettable form, with the fertile concept of the surface covered with colours assembled in a certain order. Thus we have learnt that every work of art is a transposition, a caricature, the passionate equivalent of a concrete sensation." [41]

The episode with *The Talisman* received an unexpected interpretation in the article by Denis Sutton, organizer of a large exhibition devoted to the Pont-Aven School (1966). This is what he wrote: "As a good Balzacian he may have seen himself in the guise of another Vautrin with Lucien de Rubempré! Gauguin, who was a shrewd man, must have realized that he was making a clever move by bringing Sérusier into his orbit... he would have grasped that, as 'massier' at the Académie Julien, Sérusier held a key position in up-and-coming artistic circles in Paris. This was a further step in a campaign to capture the seats of power." [42] This was the rather unexpected side to Gauguin's character deduced by the English critic under a false premise from a phrase in Moris Denis's article whose meaning he either misunderstood or deliberately distorted.

Whatever transformations Gauguin's teaching suffered at the hands of his immediate or indirect followers and interpreters, his own aesthetic interests, tastes and convictions remained logically interbalanced and consistent. And it was by no means anybody else's theory or idea that determined the lines along which his art was developing. On the contrary, his inner struggle against various influences urged him to oppose them with his own well-grounded artistic credo. Thus, having long sensed the conflict between the Impressionist outlook and his own, he gradually arrived at a strikingly precise formula: "For them there is no such thing as a landscape that has been dreamed, created from nothing.

The Yellow Christ.
1889.

41. P. L. Maud,
"L'influence de Paul Gauguin", L'Occident,
1903, October, No. 23, p.161.
42. D. Sutton,
Gauguin and the Pont-Aven Group.
The Tate Gallery, London, 1966, p.9.

They focused their efforts around the eye, not on the mysterious centre of thought." [43]

He was not satisfied with painting from life and recording visual experiences; yet life and nature were something he could not do without, for they inspired his dreams and fantasies, nourishing his imagination. He passed phenomena of life through the prism of his artistic vision and they re-emerged in a concentrated, generalized form. Hence the replacement of concrete individual images with the synthetic ones, bearing the eternal truth and recreating the mysterious past, the childhood of mankind — that is, all that later, particularly after his escape from Europe, was to become his major theme. This view on the essence of painting presupposed the artist's right to transform life with the help of emphatic linear treatment and expressive, strongly suggestive colouring so as to capture its intrinsic harmony and rhythm. Long before Brittany Gauguin was convinced that art did not exist without exaggeration. "Yet you have fewer means than nature," he wrote, "and you condemn yourself to renounce all those which it puts at your disposal. Will you ever have as much light as nature, as much heat as the sun?" [44]

The Breton period was interrupted by a two-month visit to Arles, where he was invited by Van Gogh who looked forward to founding a kind of 'Workshop of the South' (L'Atelier du Midi) modelled on a medieval guild, in which like-minded artists could work together along new lines. The idea was doomed to failure, for Gauguin was the only painter who joined Van Gogh, and mainly because he hoped Vincent's brother Theo might help him escape from his poverty.

However dramatic their life together turned out to be, this period of intimate artistic communion had a profound significance for the work of both Gauguin and Van Gogh. Working side by side, each eager to prove he was right, they tried to re-examine a number of important questions. Perhaps it was in Arles that Gauguin finally saw what Japanese engraving could offer to his theory of synthesis. In any case, his attitude towards the treatment of light and shade, one of the basic means of reproducing reality in traditional European painting, was set out in the letters he wrote from Arles: "You discuss with Laval," he wrote to Bernard, "the question of shadows and ask me whether I care a rap about them. As regards the explanation of light, yes. Look closely at the Japanese; they draw so admirably, and you will see that there is life outdoors and in the sun without shadows. They use colour only as a combination of tones, as different harmonies which create the impression of heat... Therefore I will move as far away as possible from whatever gives the illusion of a thing, and since shadow is the *trompe l'œil* of the sun, I'm inclined to do away with it. But when shadow enters your composition as a necessary form, that is another matter. Then instead of a figure, you give its shadow only — this is an original point of departure calculated to be unusual." [45] The originality of this point of departure was fully exploited by Gauguin in Tahiti, where the

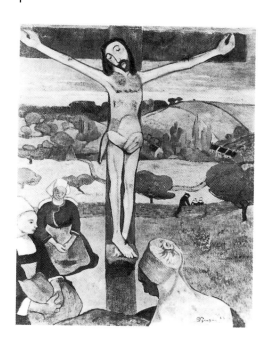

43. Quoted after: Rotonchamp, p.243.
44. Rewald 1962, p.63.
45. Malingue, p.150.

dazzling tropical sun virtually deprives objects of their shadows. During the two months when Van Gogh and Gauguin were in daily contact, the impact of their work was felt — both directly and indirectly — in the mutual borrowing of certain stylistic features and, even more so, in mutual differences. Faithful to his principle of painting not so much from nature as from memory, Gauguin peopled his *Vineyards at Arles* (Ordrupgaardsamlingen, Copenhagen; W. 304) with Breton women, one of whom almost exactly repeating the girl in the Moscow *Fruit*, but for the first time used the impasto technique, applying the paint by the palette knife. Many of his works of the Arles period show an unprecedented freedom in the organization of space, in the rhythmical arrangement of figures and elements of the landscape and in the harmony of colour accents. The cases in point are the *Laundresses of Arles* (William Paley collection, New York; W. 302), *Farms at Arles* (Nationalmuseum, Stockholm; W. 309), *Landscape at Arles with Bushes* (private collection, W. 310) and *Blue Trees* (Ordrupgaardsamlingen, Copenhagen; W. 311). In spite of the obvious cloisonnist aspect of many pictures, the form-enclosing contours are supple and flowing, and the colour inside each form is not monochrome but is enlivened by a variety of thickly or thinly applied shades.

At times Gauguin and Van Gogh turned to the same subject, at which point the difference in their interpretation of visual experiences became even more apparent. Such are Gauguin's *Old Women of Arles* (Art Institute of Chicago; W. 300) and Van Gogh's *Ladies of Arles* (*Reminiscence of the Garden at Etten*, Hermitage, St. Petersburg). Gauguin knew what he meant when he wrote that the women of Arles, "with their shawls, falling in folds, are like the primitives, like Greek friezes". He treats the figures and the landscape in a very economic manner, simplifying and generalizing forms and transforming volumes into flat silhouettes defined by near geometric contours and local colour. Van Gogh's picture, on the other hand, has nothing of the decorativeness of Gauguin's composition, with its mournful procession of women passing through a hospital garden and its undisturbed equilibrium of forms. Despite the similarity in the compositional scheme and Van Gogh's genuine desire to paint a truly synthetic picture in accordance with his friend's theory, his every brushstroke radiates life, which is completely out of tune with Gauguin's outlook.

The differences in their interpretation of one and the same subject are particularly evident in the representation of a night cafe at Arles, in which both masters remained faithful to their methods and perception of nature. It was that little cafe by the station, where, as Van Gogh once prophetically remarked, one could perish, go mad or commit a crime, and where one of the most dramatic episodes in his own life took place. Van Gogh painted the cafe some months before Gauguin's arrival. The picture inspired Gauguin to make his own version. Both works are pervaded with the same oppressive atmosphere of loneliness, but while Van Gogh's canvas is perceived as a cry of despair, in Gauguin's pic-

Blue Trees.
1888.

ture, with its influxes of parallel planes, trapped in the cramped space of a smoke-filled interior, there is a certain drama, but it is of the commonplace kind, of a universal human character. The balanced, harmonized areas of colour, the solid stability of all the components and the calm pose of the Arlesienne only serve to stress the unalterability of the age-old course of life. The slightly ironic gaze of the woman also introduces an everyday feel into the composition. Evidently it was this psychological aspect which prompted the organizers of the Brussels exhibition in 1889 to exhibit the painting under the title *Vous y passerez, la belle* ("You too will go through this, my beauty").[46]

Gauguin's sojourn at Arles was cut off rather abruptly and unexpectedly. Van Gogh's extreme excitability and recurrent depressions turned the life of the two artists into a series of violent arguments and subsequent reconciliations. "Vincent and I cannot live together without trouble because of the incompatibily of our characters... He is a man of remarkable intelligence. I esteem him highly and leave with regret,"[47] Gauguin wrote to Van Gogh's brother after another quarrel. But a week passed and he wrote again, begging Theo to forget his previous letter as a bad dream. However, Van Gogh's attempt at suicide put an end to Gauguin's stay at his house. As soon as Theo had arrived at Arles and arranged for his brother to go into an asylum at his own request, Gauguin left for Paris.

Finding himself back in the capital without funds, while waiting for the results of the Brussels exhibition (held in February-March 1889) Gauguin organized an exhibition of like-minded artists which took place in the Café Volpini in March and April that year. From Van Gogh's letter to his brother of 9 January 1889 we know that Gauguin had brought with him the self-portrait (Fogg Art Museum, Cambridge, USA) which Vincent had given him and a self-portrait of his own, on which he had been working in the last days before leaving Arles[48] — presumably the one which is now in Moscow. If we accept Françoise Cachin's suggestion that in the right-hand part of the background of the self-portrait one can make out fragments of the painting *In the Waves* (Art Museum, Cleveland; W. 336), which was in the Café Volpini exhibition, then the Moscow work should be dated to between late 1888 and January-February 1889. It is possible that Gauguin made some changes or additions to the Arles self-portrait when already in Paris. This dating is also supported by something many researchers have noted — the shape of the moustache with ends pointing upwards, while after Arles the artist depicted them pointing down. There is also a curious similarity between the Moscow work and the self-portrait of Van gogh which Gauguin brought from Arles — in the treatment of the shape of the head, in an abandonment of the symbolic details seen in *Les Misérables* and in the psychological intensity and integrity of the image, which was also to a large extent bolstered by a restrained colour-scheme that avoids bright flashes. This is much more powerful and convincing portrayal of the *"peintre maudit"* than the Pont-Aven self-

46. Gauguin, 45 lettres, p. 263.
47. Gauguin, 45 lettres, p. 85.
48. J.B. de la Faille,
The Works of Vincent Van Gogh: his Paintings and Drawings,
New York, 1970, p. 570.

◄ *Maternity* (detail).
The Hermitage, St.Petersburg.

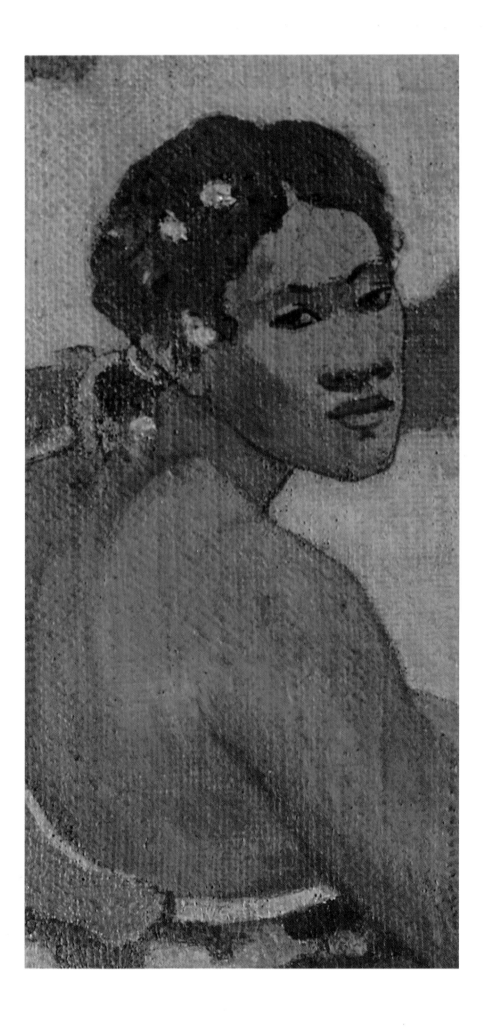

Café at Arles (detail). ►
The Pushkin Museum of Fine Arts,
Moscow.

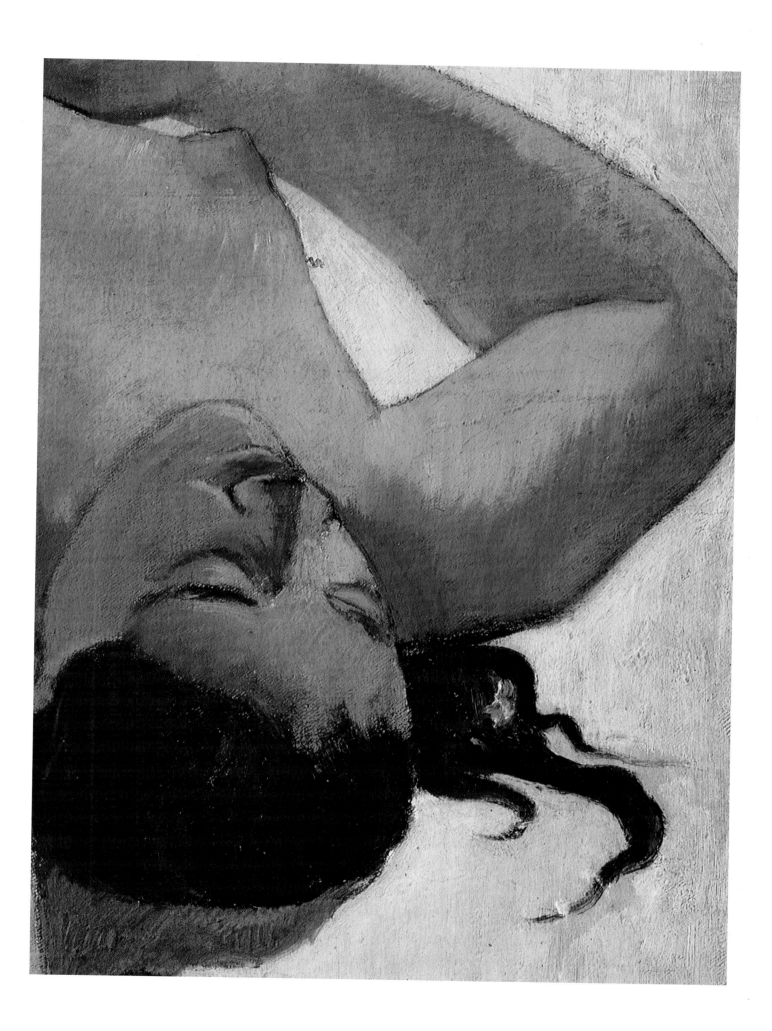

In Tahiti Gauguin was reconsidering his attitude to Greek art, opposing it to archaic art which, in his view, possessed greater value, as it emerged from the people's creative imagination. "The animal substance that remains in all of us," Gauguin wrote from Oceania, "is not at all deserving of scorn as is usually supposed. It was those devilish Greeks who thought up Antaeus, gathering his strength from touching the earth. The earth — that is our animal substance." [60] This natural, animal grace of the Tahitian Eve, who as the artist said, can go about naked even after the Fall and not seem shameless, is certainly among the highest achievements in Gauguin's Polynesian painting.

Human figures in Gauguin's pictures often ousted the other elements of the composition, reducing them to a kind of accompaniment to the leading theme. Most compositions are centred on one or two figures sitting, standing or lying down, with no narrative link between them. A case in point is — *What! Are You Jealous?* (Pushkin Museum, Moscow). Gauguin considered it (in August 1892) his most successful nude study. Sending it to the Copenhagen exhibition, he ranked it next in importance to his *Spirit of the Dead Watching* (Albright-Knox Art Gallery, Buffalo, New York; A. Conger Goodyear collection, 1965; W. 457), which was particularly dear to his heart as a memento of Tehura, his Tahitian *vahine*. Gauguin's words about the animal substance in human nature give a far better key to the message of the painting than the title describing its subject-matter, which in the text of *Noa Noa* edited by Charles Morice developed into a rather banal narrative episode. In his Tahitian figure compositions Gauguin evolved a new method of spatial arrangement. He sets his figures one behind another, showing them in movements and poses which often tend in different directions; one faces the viewer, others have their backs towards us; one is sitting, another lying, and so on. This method is used in *What! Are You Jealous?*, *Two Tahitian Women on the Beach* (Honolulu Academy of Arts, Hawaii; W. 456) and *Two Women from Tahiti* (Gemäldegalerie Neue Meister, Dresden; W. 466). It was not a totally new device as such, and Gauguin had employed it before, but in his earlier pictures the figures had never occupied the foreground and had never possessed such a monumental character. Moreover, they had never been treated as the focal point of the composition. In Tahitian pictures the powerful bodies, set close to each other, are designated by a precise outline which brings out their slightly modelled forms against the flat surface. The figures are arranged in compact sculptured groups which produce the effect of integrity and classical equilibrium. Linear drawing gradually acquired increasing importance in Gauguin's work. His smooth, fluid outlines designated figures and imparted an arabesque-like pattern to the forms of the natural world — flowers, leaves, shadows and so on. It is worthy of note that even at this time Gauguin remained faithful to the deeprooted Impressionist treatment of space, insisting on the auxiliary function of drawing and declaring that the drawing was his own secret not to be revealed to spectators.

Previous pages:
What! Are You Jealous? (details).
The Pushkin Museum of Fine Arts, Moscow.

Two Tahitian Women on the Beach.
1892.

60. Monfreid, p. 190.

52

The first thing that struck Gauguin in Tahiti was the statue-like immobility of the natives, who could sit or stand in one and the same position for hours on end. This ability of his models greatly appealed to the artist, for lack of movement in his pictures had long become a more or less consistent principle since the Pont-Aven period. While still in France, Gauguin discovered a theoretical basis for his intuitive view in a discourse by the Turkish poet Vehbi-Mani-Zunbul-Zadi: "Let everything you do breathe the soul's calm and peace. Also, avoid the pose in motion. Each of your figures must be in the static state... An unsustainable pose would elicit a scornful smile after the first minute. Apply yourselves to each object's outline; the sharpness of the contour is a prerogative of the hand that no hesitancy of will weakens."[61] Gauguin was not the only reader of Zunbul-Zadi's treatise among French artists; it attracted many of the young painters, for example, Georges Seurat whose own views echoed those of the Turkish poet. Gauguin must have brought the treatise (or excerpts from it) with him to Tahiti, as it is quoted in his last essay *Avant et Après*. The static attitudes of figures in Gauguin's Breton and Tahitian paintings were of a different nature and performed different functions. Whereas in the former, those rigid postures and frozen faces were a metaphor of a torpid mind, as, for example, in *La Belle Angèle* (Musée d'Orsay, Paris; W. 315), *Young Breton Woman* (Dr. and Mrs Max Ascoli collection, New York; W. 316) and *The Green Christ*, or *The Breton Calvary* (Musée Royaux des Beaux-Arts, Brussels; W. 328), in Tahitian canvases the static equilibrium of forms symbolized the tranquil serenity of a harmonious world immune to the ruinous effects of time. The new orientation of Gauguin's creative searchings is evident in his *Pastorales Tahitiennes* (Hermitage, St. Petersburg), *Amusements* (Musée d'Orsay, Paris; W. 428) and *Autrefois* (private collection, New York; W. 467). These works are not mere studies of Tahitian nature, but pictorial representations of the essence extracted from it and transformed by the artist's imagination. In the *Pastorales*, everything stands still, suggesting the enchanted world of reverie: a woman has stopped short in her walk and is either listening to a melody or daydreaming; an orange-red dog is lying prostrate on the ground; the motionless branches of a tree echoing the silhouette of a woman standing nearby. The two women are separated by the tree and are facing in opposite directions, which produces the optical effect of an expanded pictorial surface. The scene itself seems to extend beyond visual perception into the sphere of the spiritual. Even the word 'pastorales' in the title acquires a new meaning here. Gauguin conveyed this scene through the emotional symbolism of colours, realizing the theories he had earlier expounded in his *Notes synthétiques*: "A green next to a red does not produce a reddish brown, but two vibrating tones. If you put a chrome yellow next to this red, you have three tones enriching each other and augmenting the intensity of the first tone — the green."[62] Here, too, Veronese green unifies all the colours into a single chord. This pigment was traditionally used in fresco-paint-

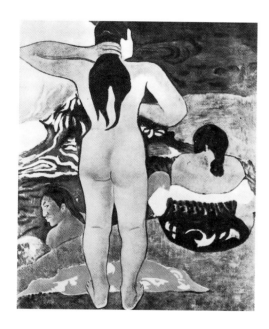

61. Gauguin, *Avant et Après*, p. 36.
62. Rewald 1962, p. 62.

53

ing, and its introduction into the colour scheme adds to the picture's decorative aspect. The rhythmic juxtaposition of colour areas and forms, one flowing into the other, the muted colour tones, with Veronese green and cinnabar dominant among them, all indicate that the painting has been treated as a decorative panel. Paintings inspired by Polynesian legends occupy a special place in Gauguin's works. The lore and rituals of the Maori, already forgotten by Gauguin's contemporaries but recorded by Jacques-Antoine Moerenhout in an ethnographical study which fell into the artist's hands, nourished his imagination and enabled him to "rekindle a fire out of the ashes of the old furnace"[63], as he metaphorically put it in *Noa Noa*. The ancient Polynesian religion inspired Gauguin with both admiration and horror at the thought of how the European public would react to his works based on local mythology. He introduced into his paintings and sculpture the myth of the Moon Goddess Hina and the earth genie Te Fatou, who argued about the Eternity of Matter. Fatou stood for mortality, Hina for permanence... One of the local legends about the love of the god Oro for a Tahitian beauty served as the subject for several compositions, among them *Her Name Is Vaïraumati* (Pushkin Museum, Moscow) and *The Germ of the Areois* (Mr and Mrs William Paley collection, New York; W. 451).

All the images in these works are the fruit of the artist's imagination, since no visual sources illustrating the local legends survived in Tahiti if they had ever existed at all. Nevertheless, the characters he created and endowed with the features of living people grow originally from the fairy-like reality of Polynesian nature and convey the flavour of the ancient poetry of the primitive peoples of the Pacific. Fruitful though this stay in Tahiti was, illness and constant lack of money eventually forced Gauguin to return to France, where he was as ever haunted by the image of his 'promised land'. In Paris he wrote *Noa Noa*, prepared drawings and prints for the text, and continued to paint on Tahitian motifs. His Paris canvases seem to be woven from memories of his recent past, as, for example, *Sacred Spring* (Hermitage, St. Petersburg) and *The Day of the God* (Art Institute of Chicago; W. 513).

In France Gauguin was hounded by misfortune. His efforts to reestablish relations with his family came to nothing, while a trip to Brittany ended in tragedy: he broke his ankle and sustained a wound which never healed. But worst of all was the fact that the public and the critics did not accept his art. "...The confusion of sun-filled paintings... pursued me into my sleep... You have created a new earth and a new sky, but I don't like being in the midst of your creation. It is too sunny for me, a lover of chiaroscuro... Gauguin, the savage, who hates the restraints of civilization, who has something of the Titan who, jealous of the Creator, makes his own little creation in his spare time... preferring to see the sky red, rather than blue with the crowd,"[64] — such was the opinion of a sophisticated spectator, August Strindberg, who certainly new his way about in contemporary art and who had been quite a frequent guest at Gauguin's studio in Paris.

63. P. Gauguin, *Noa Noa*, p. 20.
64. Quoted after: Rotonchamp, p 151.

Gauguin at the 1893 show of his works.
Caricature by G. Manzana-Pissarro.

Gauguin in Paris in 1893.
Caricature by G. Manzana-Pissarro.

While Strindberg's view of Gauguin's paintings, though not complimentary, at least revealed comprehension, official critics, the press and the public made no attempts to understand what they saw or to conceal their sneering attitude. Henri Roujon, Director of the Ministry of Fine Arts, declared that Gauguin's works were too revolutionary for his taste, and that as long as he lived he would not allow "a single centimetre" of his canvases to be purchased.

A review published in *Bourgeois de Paris* read: "To amuse your children, send them to the Gauguin exhibition; they will have fun looking at the coloured images representing quadrumanous females lying on the cloth of a billiard table."[65] Even Pissarro, Gauguin's first teacher and an old friend, did not accept his new art, being of directly opposite views himself. "Certainly, Gauguin does not lack talent," he wrote to his son after visiting the exhibition, "but it is so difficult for him to feel reassured. He always poaches on a foreign land, and at present he pillages the savages of Oceania."[66] He regarded Gauguin's artistic innovations as a kind of stunt to attract the attention of the public, and could not understand Degas who liked Gauguin's paintings.

The artist's only choice was to feign indifference to public opinion and to assume a role of a neglected genius and an eccentric. He found himself a conspicious mistress — a half-Indian, half-Malayan girl known as Annah the Javanese — and arrayed himself in an exotic outfit, which was ridiculed even by his sincere admirer, Pissarro's son Georges Manzana, who left a series of rather wicked caricatures on his idol.

In the end, Gauguin who, often even against his will, provoked both his friends and his enemies, and whose art upset all conventions and old dogmas, resolved to leave France for good. And soon, in the autumn of 1895, he again arrived in Tahiti.

This time he settled on the west coast, at Punaauia, a small village near Papeete — the only place with a hospital and professional doctors, whose help Gauguin now needed almost daily. He built himself a bamboo cottage, and soon his new Tahitian *vahine* came to live with him. Very quickly he was again in desparate need of money. The futility and humiliation of his constant struggle for existence and the lost faith in his recognition as an artist made him think of committing a suicide, and this thought was becoming more and more persistent: "I'm so demoralized, discouraged, that I don't think it possible anything worse could happen." To Monfreid he wrote: "I'm nothing but a failure."[67] It was in this pessimistic mood that he painted his tragic *Portrait of the Artist (At Golgotha)* (São Paulo Museu de Arte, W. 534).

But the vital force of his creative impulse was still very strong, and his desperate pessimism soon gave way to a new urge to work. His unfading admiration for the visual, sensual beauty of nature distracted him from his pains and troubles, and in the spring of 1896, when he was passing through a period of profound depression, he painted a series of brilliant works which opened his second Tahitian period. The highlight of this group of paint-

Mask of Teha'amana.
1892.
Painted wood, 25 x 20 cm.
Musée d'Orsay (plate from RMN).

65. *Ibid.*, p 139.
66. C. Pissarro, *Lettres à son fils Lucien,* Paris, 1950, p. 217.
67. Monfreid, p. 87.

ings is *The Queen* (Pushkin Museum, Moscow). In a letter to Monfreid Gauguin wrote that in colour he had never before made anything of such a majestic deep sonority. The two old men near the big tree, who, according to the artist, are discussing the tree of knowledge, are not by chance ousted into the background by the triumphant nakedness of the Tahitian queen. It is she who is the winner in their argument, for she is an organic part of the opulent and luxuriant tropical nature. It is no accident that most scholars compare the picture to Titian's *Venuses*, to the *Sleeping Nymph* by Lucas Cranach the Younger or to Manet's *Olympia*, each of which must have influenced Gauguin's conception of his royal *vahine*. Incidentally, shortly before his departure for Tahiti, Gauguin made a copy of *Olympia* a picture which he greatly admired. But the reclining woman's pose is only the point of departure for the realization of his own conception. And although certain elements of the composition may be suggestive of the symbolism of the lost Paradise, the gorgeous woman lying beneath a mango-tree can hardly be associated with either the innocent Eve in the Garden of Eden, or a woman repenting her sin. It is more likely that Gauguin's queen is a complex image embodying the features of Eve, Venus and a nymph. Ever since his trip to Martinique, Gauguin was continually turning to this image, each time seeking a new plastic and pictorial treatment. *The Queen* in the Moscow museum, however, was the most perfect manifestation of his quest for primordial harmony. The artist repeated this composition with slight alterations and in different techniques several times — in a pen drawing, in watercolours and in woodcuts. Explaining his interpretation of this theme which recurs in numerous works executed in Tahiti, Gauguin wrote that he wanted to evoke through his picture of simple, naked nature the feeling of a pristine, barbaric luxury — "It is not silk or velvet, or cambric or gold that make up this luxury, but the flesh itself, enriched by the artist's hand."[68]

While painting from life, in the surroundings which were most inspiring for his creative work, the artist was absorbing the world around him and extracting from it the images which were inherent in it. Once transferred onto his canvases, these images acquired a new vitality and began to speak a new language — the language of his pictures. This interaction of the natural and the depicted had nothing mystical about it; it was a natural fusion of dream and reality: "Here, by my cabin, in complete silence, I dream of violent harmonies, intoxicated by the fragrant odour of nature...

68. Monfreid, p. 101.

57

I breath in the joy of the past. Animal-like figures are immobile as statues; there is something ancient, something majestic and religious in the rhythm of their gestures. The dreaming eyes reflect an unravelled enigma... My eyes close to see a sort of dream in a space receding into infinity..."[69] Gauguin's canvases of that period are peopled with static figures of Tahitian women absorbed in dreamy contemplation; they are depicted in isolation, in pairs or groups, in front of their huts or inside them. Such are *The Dream* (Courtauld Institute Galleries, London; W. 557), *Tahitians in a Room* (Pushkin Museum, Moscow), *The Canoe* (Hermitage, St. Petersburg) and its version *The Poor Fisherman* (São Paulo Museu de Arte, W. 545), *Why Are You Angry?* (Art Institute of Chicago; W. 550) and *Nevermore* (Courtauld Institute Galleries, London; W. 558). The dull, dense and powerful palette which Gauguin had been exploring during his Breton period, was enriched in Tahiti with a hot and spicy aroma of the tropics. The colours lose their specifically local identity and grow softer and warmer. To record his visual and emotional experience of the unbridled tropical landscape and its dazzling, generous sun, Gauguin needed no more than three or four colours: yellow, red, blue and Veronese green, always slightly muted, as if dissolved in a heat-haze. What he was after was their harmony and not opposition, their unison and not dissonance. Hence the characteristic uniformity of colour treatment, the interdependence of colour and the pattern of drawing and that rare emotional effect which surprised Stéphane Mallarmé in his earlier pictures as an evidence of Gauguin's unique gift of endowing such brilliant colours with so much mystery and expressive power.

Living in the South Pacific, Gauguin perceived oriental art not as a European admiring exotic curiosities, or as those artists who brought back from their travels wrestling scenes and various piquant subjects, or like Pierre Loti, a famous writer who looked down at Tahiti or Japan with an air of condescending superiority. For Gauguin, the art of the Orient was an integral part of his own aesthetic conception. His keen observation enabled him to discern essential similarities in various primitive cultures — Greece and Polynesia, Ancient Egypt and Japan, India and Cambodia, Italian primitives and medieval French artisans. While regarding classical Greek art as a great error, Gauguin was nevertheless much closer to it in his own creative work than many of the artists who claimed to be the successors of classical traditions. Gauguin believed Greek art of the archaic period to be continued in Oceanian mythology. "Reading *Telemachus* one may involuntarily catch the idea that Greece lies near Tahiti and the Maori isles in general,"[70] he wrote to Charles Morice. From the plastic repertoire of Greek sculpture he borrowed those forms which were close to the statuary immobility of his Tahitian models. Similar features were discovered by him in Cambodian art and in the relief of the Javanese temple of Borobudur with their characteristic treatment of postures and movements, their rhythm and their folial designs. Gauguin's interest in Borobudur went back to the World Fair of

Look mysterious.
1890.
Painted wood, 73 x 95 cm.
Musée d'Orsay (plate from RMN).

69. Malingue, p. 288.
70. Quoted after: Morice, p. 213.

58

1889 in Paris where he was a regular visitor to the Javanese village. It was there that he acquired the first photographs of Borobudur friezes and painted his first *Exotic Eve* under their obvious influence. It is possible that the way he saw Tahitians was also affected by the sculptural decor of Borobudur. The reliefs and friezes of the Parthenon, of the theatre of Dionysus and of the Buddhist temple on Java had equal aesthetic value for Gauguin. He boldly and consciously combined in his works the forms and images that had crystallized over the centuries in the arts of different eras and peoples, enriching with them the Euro-

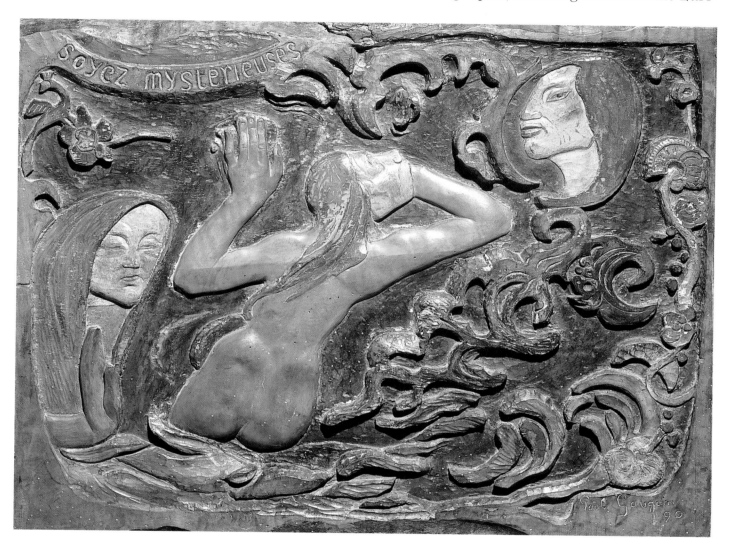

pean artistic tradition, particularly that of French art. The album he took with him to Tahiti included prints by Hokusai and lithographs by Daumier and Forain, photographs of paintings by Giotto and Raphael, Michelangelo and Rembrandt. It was by no means a random selection on his part, for "precisely because they look different I wish to demonstrate the links between them,"[71] he wrote in *Avant et Après*. His own work provided convincing evidence of those links. Gauguin's borrowings from the art of various peoples or individual masters, of which he was often accused, reflected not his weakness, but his powerful artistic imagination

71. Gauguin, *Avant et Après*, p. 61.

59

and his gift for creative transformation. It is thanks to these qualities that he is regarded not merely as a painter of exotics, but as an artist who gave a new vital impulse to twentieth-century painting.

These borrowings were realized by Gauguin in various ways. Thus, during his first years in Tahiti, the influence of ancient Egyptian art had given rise to frank imitation, in the shape of conventionalized silhouettes and rhythmic stylizations — beautiful, effective, yet always outward. Later, the influence of Egyptian murals was no longer so direct, and their stylistic patterns became far less apparent in the changed structure of pictorial surface and composition. In *The Canoe*, for example, the frontal view of the shoulders and the profile view of the head and legs, evocative of Egyptian wall-paintings, are combined with a certain modelling of the man's body, which softens and subdues the ornamental silhouette presentation. The rhythm is also changed: the rigid angularity is no longer there, as is the frieze-like parallelism in the arrangement of spatial planes, characteristic of such earlier pictures as *The Market* (Kunstmuseum, Basle; W. 476). The space is organized in the way evocative of Japanese woodcuts: the clear contour outlining the body of the woman lying beside the boat serves to hold the middle foreground together, in the manner which is both extremely bold and natural, by providing the mirror-images of the man's and woman's gestures and poses. *The Canoe* and many other pictures that followed were painted on rough canvas, almost sackcloth full of knots and wrinkles, and not only because the artist could not afford to buy canvas of quality, but because the uneven rugged texture of the cloth affected the character of the painted surface, creating the illusion of an old fresco damaged by time. A born decorator and fresco-painter at heart, Gauguin used this method in his large panels *Where Do We Come From? What Are We? Where Are We Going?* (Museum of Fine Arts, Boston; W. 561), *Preparations for a Feast* (Tate Gallery, London; W. 569) and *Scene from Tahitian Life* (Hermitage, St. Petersburg). Parts of the surfaces in these canvases seem to have been rubbed out, as though a whitewashed wall is showing through she paint. Gauguin avoided smooth, even surfaces in both painting and sculpture, lest he should fall into the "atrocious sugariness of the Ecole des Beaux-Arts", and he recommended to a friend, a sculptor, to mix more sand into his clay, so as to create "useful difficulties",[72] since a rough material contained something weightier and more profound than a smooth, soft one. Hence his acute resentment of Thorwaldsen, who, as a representative of the so-called Roman school of sculpture, imitated the smooth silky treatment of antique statues. "Greek mythology turned into Scandinavian, and then, after another washing, into Protestant. The Venuses look down and chastely drape themselves with wet clothes. The nymphs are dancing the gigue...,"[73] he wrote, recalling his impressions of contemporary Danish art. The life in Polynesia, where the natural world itself was full of mystic symbolism, and where the very existence of man — from

72. Monfreid, p 113.
73. Gauguin, *Avant et Après*, p. 146.

60

birth to death — had a simpler, purer and more natural meaning, led to a further development of symbolist tendencies in Gauguin's art. Along with the old, pre-Tahitian theme of the sacrificial, messianic mission of Christ and the Artist, a new motif appeared in Gauguin's works — that of Christianity as transformed in the minds of Polynesians. In the early Tahitian pictures this motif was treated in a rather straightforward manner, in accordance with the established Christian canons. In *Hail, Mary* (Metropolitan Museum of Art, New York; W. 428), for example, Gauguin merely showed the appearance of Mary with Child to believers. Later, he transferred this theme into a different plane, juxtaposing the past and the present, the real and the imaginary, as was the case with his much earlier work, *The Vision after the Sermon* (W. 243). Vivid examples of this interpretation are his *Birth of Christ, Son of God* (Bayerische Staatsgemäldesammlungen, Munich; W. 541) and *Be Be* (Hermitage, St. Petersburg). The latter was painted soon after the death of his daughter who lived only a few days; hence the morbid figure of the angel, a purely allegorical figure, for it is not seen by the Tahitian mother. The message of her child's death so far exists only in her imagination, just as the Nativity scene. "The general harmony of the picture is a sad violet, a sad blue and chrome which serves as a transition to the green and enriches the musical chord... and sounds for the eye as a death-knell," as Gauguin put it referring to one of his favourite works depicting his *vahine* Tehura. In short, it is the harmony of colours and not the subject-matter that accounts for the intensity of the picture's emotional impact.

The sound of the knell rings out in many of the works of 1897, one of the unhappiest years in Gauguin's life. He received news of the death of his sixteen-year-old daughter, suffered unbearable physical pain and was subject to spells of blindness. Driven by all this to the point of committing suicide, he created his largest picture, *Where Do We Come From? What Are We? Where Are We Going?* (Museum of fine Arts, Boston, USA; W. 561), painted as his final statement. Two of the Hermitage works are related to this composition: *Landscape with Two Goats*, executed in a dark, sombre tonality, and *Man Picking Fruit from a Tree*, painted in a thin misty layer of ghostly yellow. The figure of the man in a smudged contour, softly sketched in an equally thin layer of dark blue, seems to dissolve in the mysterious shimmering yellow light. The similarity of this figure to the well-known drawing attributed to Rembrandt or his circle is difficult to deny, but it is of purely iconographic order and has nothing to do with the emotional quality of the painting.

The dark colour range of *Where Do We Come From?*, enlivened only by the rhythmical splashes of the brightly coloured human bodies, was in full accord with the artist's tragic mood. It is an established fact that Gauguin's composition was influenced by Puvis de Chavannes. But that influence was on a superficial, formal level. Gauguin was undoubtedly inspired by the decorative rhythm of Puvis's wall panels with their alternation of horizontal

61

and vertical forms. However, whereas in Puvis's work there is a rarefied atmosphere — at times even blank spaces, in Gauguin's there is a dense, unbroken mass of paint charged with energy. The symbolic message of the painting, if one neglects Gauguin's own somewhat artificial allegoric interpretation of every individual detail, is fairly simple. It is revealed in the motto (borrowed from a verse by Paul Verlaine), preceding Gauguin's letter to one of the interpreters of this painting:

Un grand sommeil noir
Tombe sur ma vie
Dormez, tout espoir
Dormez, toute envie.

In this picture Gauguin summed up his thoughts on the destinies of mankind in the eternal flow of life, on the essence of the Universe and the mysteries of birth, life and death, and on that elusive something which does not lend itself to a rational explanation and cannot be expressed through concrete tangible images. He compared his panel to a musical poem which did not need a libretto, because "colour vibrates like music and as such is capable of evoking what is the most general and, consequently, the most elusive in nature: its inner force."[74] As regards the difference between Symbolism in painting and Symbolism in literature, Gauguin wrote: "Painting should seek suggestion more than description, as indeed music does."[75]

The same theme occurs in the Hermitage painting *Rave Te Hiti Aamu*, which is usually referred to in literature as *The Idol,* as the meaning of the Tahitian title is hard to decipher. *This strange figure, this cruel enigma,* was how Gauguin inscribed his woodcut with an identical image sent to Stéphane Mallarmé in 1895. The iconography of *The Idol* goes back to a large stone statue in the

Lintel of "la Maison du Jouir".
1902.
Wood.
Musée d'Orsay (plate from RMN).

Marquesas Islands, which Gauguin knew from a photograph. The same figure with an animal pressed to its body appeared in his 1892 painting *Where Are You Going?* (Staatsgalerie, Stuttgart; W. 478). The clay figurine, almost identical in shape to the Hermitage idol, was executed by Gauguin in France after his first visit to Tahiti — the artist called it *Oviri* (The Savage). All these works treat one and the same theme: an idol murdering a wolf, its own child. Since Gauguin liked to call himself "a scrawny wolf", one

74. Malingue, pp. 287,288.
75. Monfreid, p 182.

Lintel of "la Maison du Jouir".
1902.
Wood, length 2.4 m.
Musée d'Orsay (plate from RMN).

can imagine that *Oviri* personifies the wild natural force which gave him life, nourished his art and then, having squeezed all vital juices out of him, killed him. This is a condensed version of *Where Do We Come From?* with its description of the successive events in human life: the barely discernible tiny human figure by the bent right arm of the idol symbolizes the foetus of the man-wolf, whose future birth will be followed by his inevitable death. Birth, life and death form that "cruel enigma" which nature sets before man. This picture, whose title may be interpreted as 'the bite of an insatiable monster', was probably painted soon after Gauguin's abortive suicidal attempt.

The artist's return to life was marked by such works as *Preparations for a Feast (Faa Iheihe)* (Tate Gallery, London; W. 561), *Gathering Fruit* (Pushkin Museum, Moscow), *Two Tahitian Women* (Metropolitan Museum of Art, New York; W. 583), *Maternity*, *Woman Carrying Flowers* and *Three Tahitian Women against a Yellow Background*. Some of them are thematically or iconographically related to *Preparations for a Feast*, in which Gauguin returns to the motif of the Promised Land, using the specific set of pictorial devices. The landscape, with its gold background, is reduced to a symbolic paradise; Gauguin turns away from the conventional optical division into planes and, as a result, the characters which inhabit the imaginary world of the picture seem to exist outside any space or time. The rejection of perspective increases the role of the arabesque which serves as the pivot of the composition. The purely ornamental elements take shape of human bodies, while the figures themselves and the landscape became an interplay of decorative, stylized forms.

A decorative pattern also appears in the Hermitage version of *Maternity*, but its function here is markedly different. The clear smooth contour incorporates the figures of women into the landscape and determines the colour scheme of the whole scene. The red cloth on the body of one of the women seems to uncoil, turning into the strip of coral sand which extends almost beyond the frame of the picture; the blue cloak on the shoulder merges into the blue of the sea. The interweaving of the gestures and poses of the figures with the elements of the landscape creates a single rhythmical unity and the impression of spaciousness and depth. The motif of a woman suckling her baby turns into a symbol of motherhood, of the great mystery of nature.

During this period Gauguin elaborated yet another theme, which had long preoccupied him — the theme of the common origin of different religions, particularly Buddhism and Christianity, to which he devoted a number of socio-theological writings and paintings, among them *The Last Supper* (Mme Katia Granoff collection, Paris; W. 580) and *The Great Buddha* (Pushkin Museum, Moscow). The motionless figures of Tahitian women seated at the feet of the huge Buddha, with the vision of the Last Supper in the background, create a fantastic fusion of the real and the unreal, a fusion incorporating different religions and cults — Christianity, Buddhism and paganism, as the statue of Buddha used for the title of the picture is almost identical to the symbolic sculpture of an ancient Polynesian chieftain surviving in New Zealand.

Although the composition is visually divided into two planes, the real and the imaginary are not so much separated from each other, but rather linked together by the figures of two women, proceeding in opposite directions: one from, the other towards the spectator. The fantastic moonlit landscape seen through the arch in the right top corner of the canvas endows the whole scene with a mystic character.

A burst of creative energy inspired Gauguin to undertake the last journey of his life, yet further into the heart of Polynesia, to the tiny island of Hivaoa in the Marquesas group. "Here poetry appears of its own accord, and when you paint you only have to abandon yourself to reverie to give expression to it. I only ask for two years of health, and not too many money worries, which now have an excessive hold on my nervous temperament, in order to reach a certain maturity in my art. I feel that I'm right about art — but will I have the strength to express it convincingly enough,"[76] he wrote from his newly built 'Maison du Jouir' at Atuona.

Fascinated by the wild, primitive beauty of nature, the artist pours out onto his works a joy that is almost painful in its intensity. The fruit he paints become corporeal and juicy, the plumage of the island birds shines with gentle tints of colour, the sunflowers take on an air of mystery due not to any literary associations or to the comparison with the 'All-Seeing-Eye' — although all this is present in his compositions as a tribute to his former friends — but simply to the rich gamut of colours. Occasionally Gauguin enlivens his colour harmonies with flickering Impressionist brushstrokes or light, bluish shadows gliding along the surface. The artist seems to return to the beginning of his career, repeating, with a dogged persistence, a composition with flowers which must have stuck in his memory since his younger days. It is hard to believe, that such joyous paintings, as *Still Life with Parrots. The Ford* (both in the Pushkin Museum, Moscow), the two versions of *Riders on the Beach* (Folkwang Museum, Essen; W. 619. Stavros Niarchos collection, New York; W. 620), and *Girl with a Fan* (Folkwang Museum, Essen; W. 609), were done by a fatally ill man almost on the threshold of his death.

Panels of "la Maison du Jouir".
1902.
Wood, height 2 m and 1.6 m.
Musée d'Orsay (plate from RMN).

76. Monfreid, p 185.

64

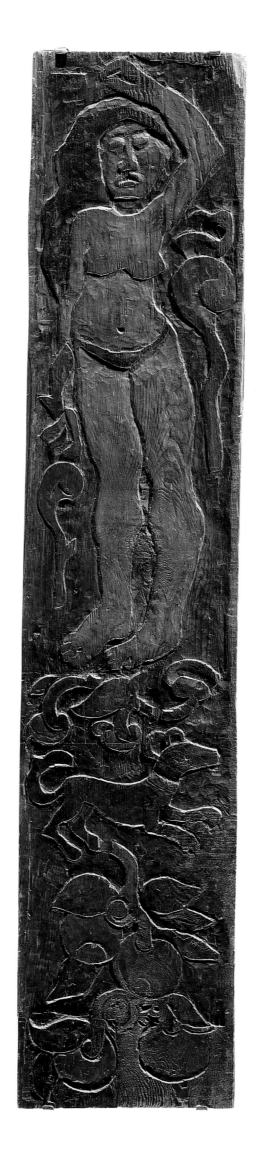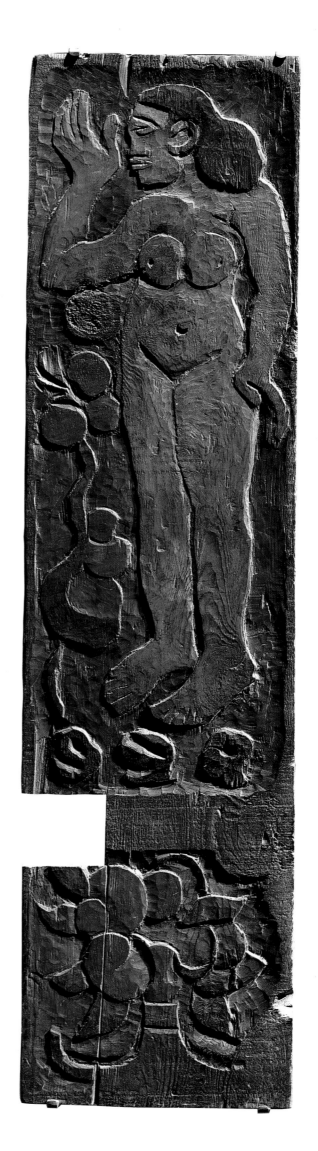

From that time on he had every right to insist that Symbolism in literature was alien to him — just as any other literary reminiscences or associations. He admitted having once yielded to the temptation, being unable to resist the flattering response, but it was all in the past and no longer meant anything to him.

Fate gave Gauguin two years of life in Atuona, and despite his illness and his exasperating conflict with the colonial authorities, he still had enough strength to prove that "in his art he was right". His immersion in the depths of a different culture outside the European tradition gave his work a specific character which partly hid the true significance of his artistic aspirations in exotic, savage forms. Turning to the art of primitive and ancient peoples, to their folklore and crafts, Gauguin not only rescued from oblivion the poetic world of Oceanian culture and made its luxurious forms and colours accessible to us, but also enriched the artistic tradition of the West. Paying tribute to Gauguin, Maurice Denis, in an article written in 1903, pointed out his tremendous influence on the younger generation of artists: "At an instance Gauguin succeeded in persuading several young people that art is first of all a means of expression... that every object of art should be decorative... that grandeur is nothing without simplification, clarity and the homogeneity of matter... He has been able to discover a tradition in the rough archaism of the Breton calvaries and the Maori idols or in the indiscreet colouring of the *images d'Epinal...* He passionately loved simplicity, clarity and he inspired us to dare anything; for him, synthesis and style were almost synonymous." [77]

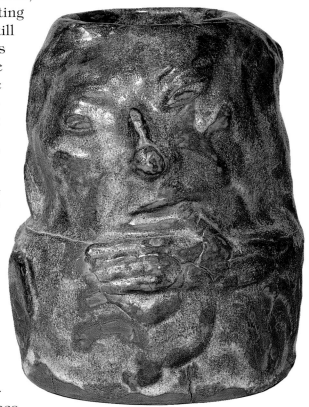

Self-Portrait Mug.
1889.
Tobacco jar, glazed earthenware.
Musée d'Orsay (palte from RMN).

Gauguin, like great masters of the past, had inexhaustible energy and versatile creative interests. Having once begun an artist's life, he devoted himself entirely to art. He was a painter and a draughtsman, a sculptor and a woodcarver, a critic and a writer. In any new sphere of artistic activity, he made a point of studying its techniques in the minutest detail. He reached great heights in pottery, using methods and forms going back to the ancient stages of this craft. Gauguin's letters, critical essays and memoirs, despite the established prejudice concerning his alleged callousness and ingratitude, testify to the contrary: his admiration and respect for his first teacher Pissarro, for Van Gogh and Degas, Cézanne and Renoir. And if some of his declarations were not devoid of cynicism, it was not merely a tribute to the fashion of the time, but also bravado and the mask of an outcast and a pariah.

77. P. L. Maud, *op. cit.*, p 164.

Idol with shell (profile).
1892.
Wooden statuette, mother-of-pearl,
teeth in bone. 27 x 14 cm.
Musée d'Orsay (plate from RMN).

Gauguin belongs among those masters whose work marks a turning point in the history of art. In his quest of recreating, and by no means imitating, the real world, he discovered its intrinsic fantastic elements and set new goals before art.

After Gauguin, interest in black art or the art of the Aztecs, Ancient Egypt or Japan became a matter of course. But Gauguin never imitated the external art forms of this or that people, or of this or that work by his contemporaries. He borrowed and absorbed only that which was in tune with his own artistic and philosophic vision and which he embodied in his work in a new original manner. His borrowings made local art part of world culture. The aspiration to record emotional and mental states not through the subject-matter, but with the help of plastic forms and colouring, led Gauguin beyond the boundaries of the classical artistic tradition which was considered the only correct and acceptable one in Europe. The simplification of form, the use of pure colour, the approach to colour as a pictorial equivalent of light, the arrangement of space by the juxtaposition of contrasting areas of colour, the right to construct a work according to his own independent artistic laws, the right to intervene actively in the visible world and by reshaping it to reveal some as yet unknown aspects of reality — in short, everything that lay at the source of modern art, if it did not find its systematic realization in Gauguin's works, was at least formulated by him on the level of artistic theory. His clear understanding of the creative tasks which the next generations were to resolve enables us to regard Gauguin as one of the immediate predecessors of twentieth-century art.

Gauguin's aesthetics had an impact not only on the Nabis such as Denis, Sérusier, Maillol, Vuillard and Bonnard. At the start of the century, after Gauguin's posthumous exhibition, his influence was also felt by Picasso and Matisse — the two masters whose work is inseparable from the art of our age. But most important is the fact that Gauguin's work, directly or indirectly, gave an impetus to a reappraisal of the foundations of modern art.

"Nothing happens by accident. It was no accident that, at a given moment, a young generation appeared on the scene, startling the world with its intelligence and richly diverse art seeming every day to solve problems which had not even been thought of before. It happened because the Bastille which had for so long inspired dread had been destroyed; it happened because it is good to breathe in air that is free,"[78] wrote the artist who took great pains to be able to breathe in "free air". His last entry in his memoirs reads: "You see, I believe that we all are workers... Before all of us is the anvil and the hammer, and our duty is to forge."[79] Ever since he first took it up, Gauguin's "hammer", remained in his hand until his dying day.

Asya KANTOR-GUKOVSKAYA

78. P. Gauguin, *Racontars de Rapin,* ed. by Falaise, 1951, pp. 78,79.

79. Gauguin, *Avant et Après*, p. 196.

THE COLLECTIONS
of the Russian Museums

Café at Arles (detail).
The Pushkin Museum of Fine Arts,
Moscow.

1. CAFÉ AT ARLES

1888.
Oil on canvas. 72 x 92 cm.
Signed and dated twice, on the table, bottom right,
and on the billiard table, bottom left: *P. Gauguin 88*.
Pushkin Museum of Fine Arts, Moscow. Inv. No. 3367. W. 305.

The picture was painted in November 1888 at Arles where Gauguin arrived on Van Gogh's persistent invitation. It depicts the interior of the Café de la Gare owned by J. Ginoux. The same motif was used by Van Gogh in his famous painting *The Night Café* (at one time in I. Morozov's collection, Moscow; now in the Yale University Art Gallery, New Haven). The woman in the foreground is Mme Ginoux, the owner's wife, who also posed for two versions of Van Gogh's *L'Arlésienne*. Both artists painted Mme Ginoux at one and the same time. At an hour's sitting Van Gogh did an oil portrait, while Gauguin made a drawing of her (Rewald 1938, No. 15). Later, already in the hospital at St. Rémy, Van Gogh made several oil copies of drawing by Gauguin. In a letter to Emile Bernard, Van Gogh wrote: "At the present moment Gauguin is working on a canvas with the same night

Café at Arles (detail).
The Pushkin Museum of Fine Arts, Moscow.

71

café I've painted, but with figures we've seen in brothels. It promises to be a beautiful thing" (Verzamelde brieven van Vincent van Gogh, vol. IV, Amsterdam, 1954, NB. 19a). In a letter to Bernard, Gauguin himself thus described the painting: "I've also painted a cafe which Vincent loves very much, more than I do. It is in fact not in my spirit, and the vulgar local colour does not suit me. I like it in the other artists' works but I'm afraid of it myself. This is a matter of education, and man cannot change himself" (A. Meyerson, "Van Gogh and the School of Pont-Aven", *Konsthistorisk Tidskrift*, 1946, XV, p. 144). Enclosed in this letter were some sketches of the future painting. The bearded man at the table at left and wearing a casquette is easily identified as the postman Roulin, while the extreme left figure, cut by the frame, is probably the Zouave Milliet. Both characters are also the subjects of the well-known portraits by Van Gogh. Both the choice of characters and the use of local colours which somewhat annoyed Gauguin, betray the influence of Van Gogh who was working side by side with him during this time. At the same time, the *Café at Arles*, with its wellbalanced composition, is a vivid example of Gauguin's synthetic style based on the interaction of colour and line; the contrasting, evenly painted zones of colour outlined by curving arabesques are primarily the result of the joint efforts of Gauguin and Emile Bernard at Pont-Aven. Having concentrated on conveying the genre aspect of the composition, Gauguin failed to endow it with the acute emotional tension achieved by Van Gogh in his *Night Café*. In Gauguin's notebooks there are sketches of Arlesian women resembling Mme Ginoux (Huyghe, p. 19). A similar character also appears in the foreground of his picture *In the Garden of the Asylum at Arles* (W. 300) and his zincograph *The Spinsters* (Guérin, No. 11).

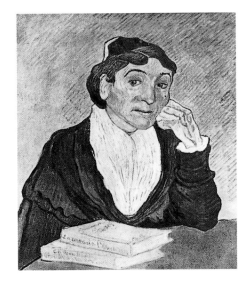

Café at Arles. ►
The Pushkin Museum of Fine Arts,
Moscow.

Van Gogh. *L'Arlésienne.*

Provenance: A. Vollard Gallery, Paris; 1908, I. Morozov collection, Moscow (bought from A. Vollard); 1919, Second Museum of Modern Western Painting, Moscow; 1923, Museum of Modern Western Art, Moscow; since 1948, The Pushkin Museum of Fine Arts, Moscow.

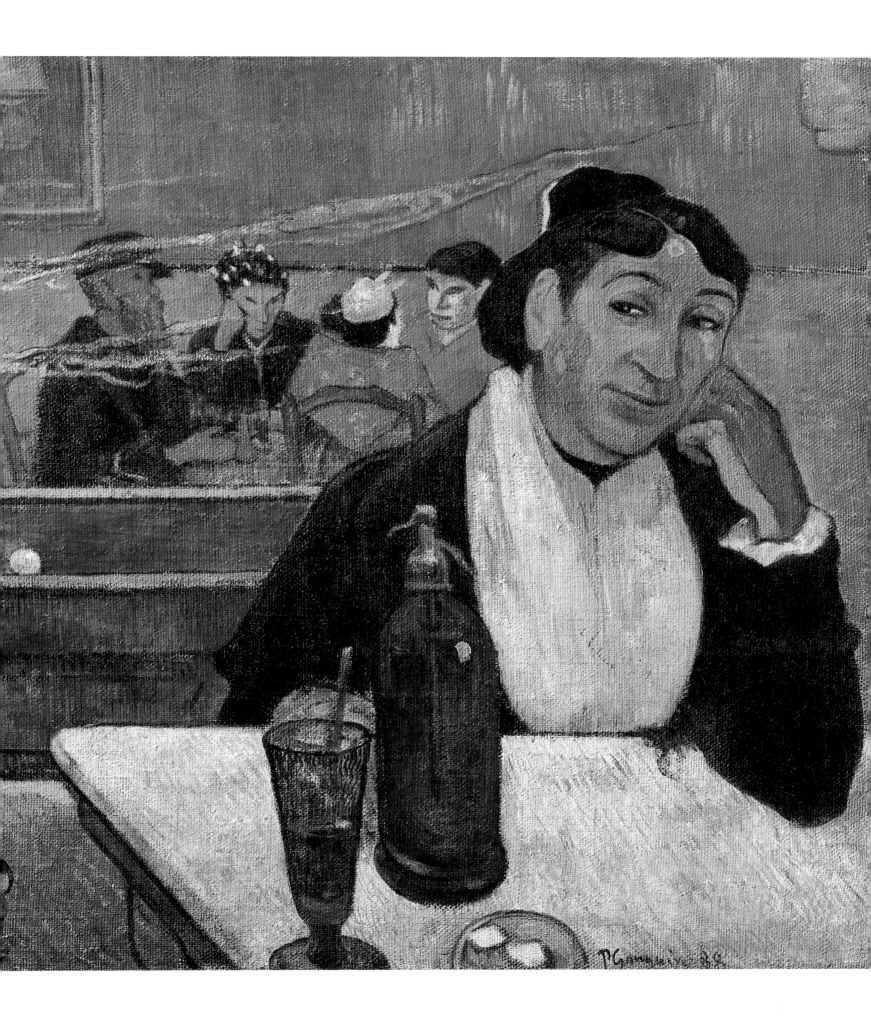

2. FRUIT

1888.
Oil on canvas. 43 x 58 cm.
Inscribed, signed and dated, bottom right: *A mon ami Laval P. Go/88.*
The Pushkin Museum of Fine Arts, Moscow. Inv. No. 3271. W. 288.

This small still life is one of the earliest Gauguins in the Pushkin Museum and, in fact, in Russian collections as a whole. In the room of Shchukin's Moscow mansion allocated to Gauguin's works, *Fruit* was the only picture which stood out against the famous Gauguin 'Tahitian iconostasis'. The canvas is signed and dated 1888. The date, placed beneath the signature and the inscription and written by an uncertain hand with a thinner brush, was probably added later. Nothing is known for certain of the whereabouts of the picture after its creation and of the date of its acquisition by Shchukin. It can only be presumed that it was housed at the E. Druet Gallery, for an old negative taken from the painting still remains there. The still life was not mentioned in any of the inventories or catalogues compiled in Gauguin's lifetime, or shortly after his death. But the date and the dedication, in Gauguin's own hand, to his friend Charles Laval, who accompanied him to Martinique and who joined him at Pont-Aven, refer the picture to a concrete period in the artist's life and career. The well-balanced distribution of colour patches on the canvas's surface points to the artist's familiarity with Japanese prints, while the solid forms of the fruit on a flat wicker dish and the diagonal line of the edge of the table which seems to extend beyond the frame of the picture, betray the influence of Cezanne. Despite the absolutely realistic representation of the fruit, there is some peculiar tension in their appearance and arrangement on the table. They seem to be driven by some mysterious force, working against the law of gravitation, to the edge of the table which, in its turn, appears to be on the verge of toppling over on the spectator. The dishes and plates with fruit are drawn close together, as if by magnetic force, which makes them almost collide with one another. This strange motion of the dishes has two different directions: from the upper right corner of the picture and from the left bottom one upwards. The white plate with fruit and the painted bowl are gliding along the surface of the table backwards — to its upper edge approaching the enigmatic face of the girl placed in the upper left corner of the picture between the table and the frame.

One almost cannot help feeling that the girl is literally attracting the plate by her glance. And while her right eye is half closed, the left one, indeed, possesses some hypnotic power. The presence of this face with a strange inward look of the slanting eyes, endows this still life with a sense of mystery and anxiety, a sense enhanced by an unexpected cut of the composition by the frame. The message implicit in the still life which at first sight seems to be a mere tribute to the luxuriant ripeness of fruit, or, as Gauguin later put it in Tahiti, 'la végétation luxuriante', calls for an interpretation. The search for a close analogy of this work leads to *Vineyards at Arles* (W. 304) done in November 1888 in Van Gogh's presence. According to Van Gogh's letter to his brother Theo, Gauguin painted it not from life,

but "from his head" (*Verzamelde Brieven van Vincent van Gogh*, vol. IV, Amsterdam, 1953, No. 559). In the same letter Van Gogh wrote that the picture was "very beautiful and very strange". And indeed, everything in it is perceived as a challenge, as, for example, the inclusion of Breton women in an Arlesian landscape "for the sake of inaccuracy", as Gauguin put it in his letter to Bernard where he described his *Café at Arles* (Meyerson, *op. cit.*, pp. 146, 147), and the representation of a redheaded beggar girl, whose posture and face are identical to those of the girl in the Moscow still life. Gauguin sent *Vineyards at Arles* to Les XX exhibition in Brussels under the title *Human Miseries*. "It is the best picture I painted this year," he wrote, "and as soon as it gets dry I will send it to Paris" (Meyerson, *ibid.*). The price he asked for the painting at that show was 1,500 francs.

"The best picture..." But early in the same year he painted *The Vision after the Sermon* (W. 245) and *Still Life with Three Puppies* (W. 293) — the major works of his cloisonnist period. Although only a couple of months or so separated them from *Vineyards*, Gauguin's artistic conception had undergone tremendous change. What, then, is the implication of *Vineyards*? In his letter to Bernard, Gauguin, as usual, merely names various elements of the picture and describes its colouring. The content of the canvas is clarified by a picture of 1894, *Village Drama* (W. 523), painted in Brittany between the artist's first and second trips to Tahiti. Using his favourite device of 'quoting' the key-motifs of his earlier paintings, Gauguin depicts in it the central character of *Vineyards*. His *Village Drama is* full of human sorrow, it is a 'parable' about outraged honour — this is unambiguously indicated by the figure of an overdressed fellow contemptuously looking down at a bareheaded young woman. Her dreams and her unconscious sensuality brought her nothing but grief and bitter disappointment which showed the futility of earthly pleasures. In *Vineyards* the drama is only anticipated: it might await the young beggar absorbed in her dreams and doing nothing while two elderly Breton women are toiling in the field. This idea of hard work as a punishment for one's fall is embodied in their bent figures and in the frozen posture of a married — as her costume implies — Breton woman with grapes in her apron. The Breton women in their traditional dresses were introduced into the composition not merely "for the sake of inaccuracy", as Gauguin said, but for clarifying the conceptual meaning of the picture.

Village Drama was conceived by Gauguin immediately after he had finished *Vineyards*. The bareheaded woman of the latter picture can be recognized in a zincograph executed in Paris after Gauguin's escape from Van Gogh at Arles.

According to the American scholar Wayne Andersen in *Gauguin's Paradise Lost* (New York, 1971, pp. 88, 121), the posture of the beggar girl in *Vineyards* is an expression of a conflict between desire and fear. In Andersen's opinion, Gauguin depicted in this painting "Eve before the Fall, at the moment of temptation". Andersen was the only critic who pointed out in this connection the exact likeness between the face of the beggar and the girl in the Moscow still life. He remarked that the girl in the *Fruit* had a foxy glance: that she

Portrait of Meyer de Haan.
(W. 317).

76

ing Laval, admonishing her against the ruinous loss of chastity. The letter, naturally, was strongly resented by the girl's family. However, Gauguin's presentment about their marriage turned out to be almost prophetic. In 1890, Laval, who by that time had already contracted tuberculosis, left with his young wife for Cairo, where he died four years later. A year afterwards his wife died of the same disease. Thus, the Moscow picture may be regarded as Gauguin's codified message to Laval and Madeleine, which conveyed his own depressive mood and a warning to his friend and his fiancee.

The same girl with loose hair is shown sitting by a young Breton in a zincograph of 1889 (Guérin, No. 5), in a preliminary watercolour for it (Rewald 1958, No. 21) and in a gouache from the collection of D. Vernier (W. Andersen, *op. cit.*, p. 91, pl. 54). During his second

Fruit (detail).
The Pushkin Museum of Fine Arts, Moscow.

Tahitian period Gauguin made a woodcut from memory, based on his early Arles picture with an enlarged figure of a seated beggar girl in the foreground (Guérin, No. 69).

Provenance: E. Druet Gallery, Paris; S. Shchukin collection, Moscow (bought from E. Druet before 1908); 1918, First Museum of Modern Western Painting, Moscow; 1923, Museum of Modern Western Art, Moscow; since 1948, The Pushkin Museum of Fine Arts, Moscow.

3. *TE TIARE FARANI*
THE FLOWERS OF FRANCE

1891.
Oil on canvas. 72 x 92 cm.
Signed and dated, bottom left: *P. Gauguin 91.*
Inscribed on the table, bottom right: *Te Tiare Farani.*
The Pushkin Museum of Fine Arts, Moscow. Inv. No. 3370. W. 426.

The year 1891, the date the picture bears, was crucial for Gauguin. In that year he left France for Tahiti, where he stayed till 1893. This stay in Tahiti determined his future life and career, for in 1895, after a sojourn in France, he returned there for good. The canvas was painted in the first year of his stay in Tahiti, and is full of nostalgia for the abandoned homeland. Hence the strange contrast between the full-blooded still life with the blossoming oleander branches and the melancholic face of the islander wearing a hat, his listless posture and his absent look. The treatment of the still life a tabletop with a pitcher of large flowers — betrays the influence of Cézanne. The compositional structure of the painting and the arrangement of the figures, cut by the frame, go back to Manet and Degas. In its overall visual effect, *Te Tiare Farani is* strongly evocative of Manet's *Luncheon in the Studio.*

Thus, there is a direct connection between the figure of a Tahitian in a hat, with his aloof attitude and his vacant stare, and the young man in a straw hat, leaning on the table in Manet's picture. If we agree that the latter conveys the inner state of a young man at the crossroads, a man preparing to start on a distant journey (which is suggested by a map on the wall), such an interpretation will be fully consonant with Gauguin's own mood at the time when he made up his mind to leave Europe for ever and to settle in Polynesia. Therefore the nostalgic title of *Te Tiare Farani* has an additional implication: it is not merely a reminiscence of his homeland, but also the artist's last tribute to his former idols — Cézanne, Degas and Manet. In one of Gauguin's notebooks there is a sketch for the figure of the young islander in a hat (Dorival 1954, fol. 28v). The picture *Te Tiare Farani* was exhibited at the Durand-Ruel Gallery in 1893. Later Gauguin sent it to the Hôtel Drouot, where the sale of his paintings took place on February 18, 1895 before his final departure for Tahiti. It is one of the artist's earliest

Edouard Manet. *Luncheon in the Studio.*

works to bear a Tahitian inscription — the actual title of the canvas revealing its message. *Te Tiare Farani* is literally translated as the 'Flower of France' (Bouge, p. 164; Danielsson, pp. 233, 77).

Provenance: 1895, A. Vollard collection, Paris (purchased from the sale of Gauguin's paintings at the Hotel Drouot, No. 24, February 18); 1908, I. Morozov collection, Moscow; 1919, Second Museum of Modern Western Painting, Moscow; 1923, Museum of Modern Western Art, Moscow; since 1948, The Pushkin Museum of Fine Arts, Moscow.

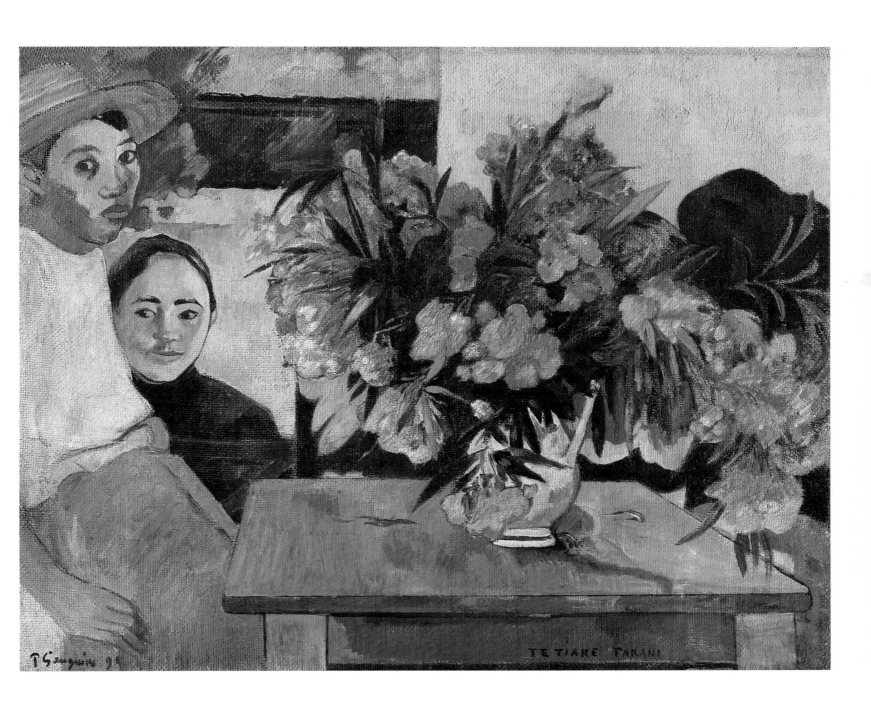

Te tiare Farani.
The Flowers of France.
The Pushkin Museum of Fine Arts,
Moscow.

4. *LES PARAU PARAU CONVERSATION*

1891.
Oil on canvas (relined). 71 x 92.5 cm.
Inscribed, signed and dated, bottom left: *Les Parau Parau P Gauguin 91.*
The Hermitage, St. Petersburg. Inv. No. 8980. W. 435.

During his first stay in Tahiti Gauguin painted two pictures with almost identical titles: *Les Parau Parau* (Hermitage, St. Petersburg) and *Parau Parau* (1892, now in the George Whitney collection, New York; W. 472). One of these he sent to Paris, for an exhibition in Copenhagen. In a letter to his friend Monfreid, on December 8, 1892, he gave the title of that picture: *Parau Parau,* that is, *Conversation* or *Gossip* (Monfreid, p. 62). The title given by Gauguin figured in the catalogue of the sale of his paintings, which he arranged at the Hotel Drouot on February 18, 1895, to raise money for his second voyage to Tahiti. In the manuscript inventory of Morozov's collection, the painting was listed as *Conversation.* At present there is no agreement among students of Gauguin as to which of the two paintings was displayed at the exhibitions of 1893 and 1895. Wildenstein believes it to have been the painting now in New York. However, there are two indirect indications that it was the Hermitage canvas. One of them is the size of the canvas (71 x 92.5 cm) which exactly coincides with those of all other paintings shipped by Gauguin to Paris. Identical sizes of the pictures naturally facilitated their packing.

Head of a Tahitian Woman.
(Rewald 1958, No. 76).

Three Tahitian Women.
(Field Monotype, No. 44).

Besides, the New York picture being smaller in size (56 x 76 cm), Gauguin could have hardly meant it for a large exposition and sale. It should also be remembered that Gauguin was deeply concerned about his paintings and their Tahitian titles being properly understood, but in the New York picture the group of conversing women is so deeply removed into the background that the title *Conversation* becomes almost irrelevant. Sutton agrees that it was the Hermitage version that appeared at the Copenhagen exhibition (D. Sutton, "Notes on Gauguin Apropos, a Recent Exhibition", *The Burlington Magazine,* 1956, March, p. 91).

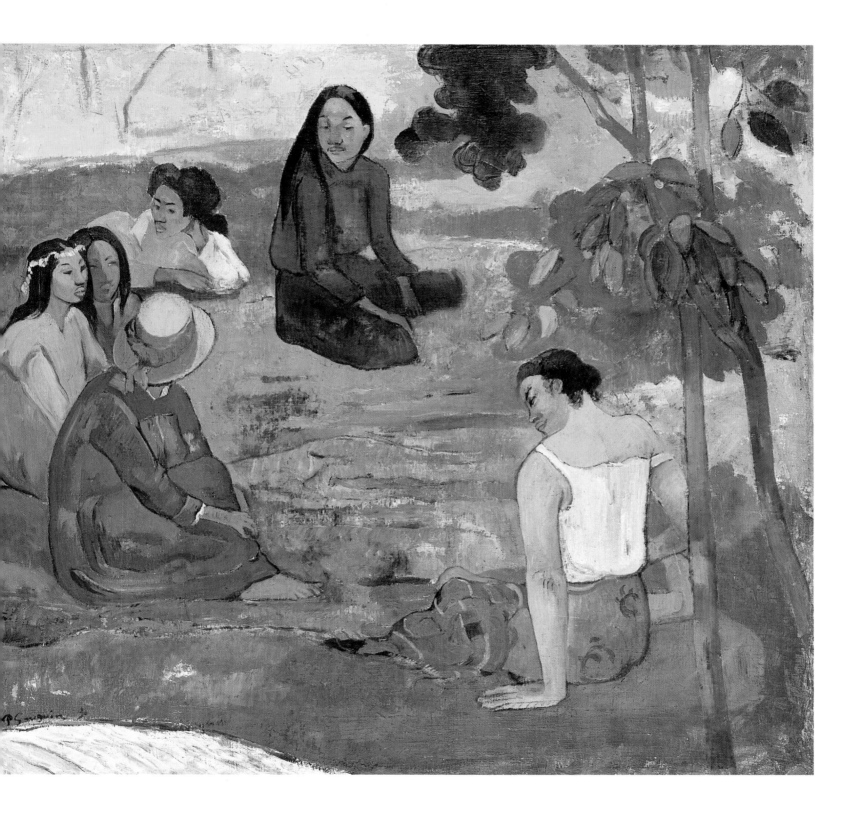

Les Parau Parau.
Conversation.
The Hermitage, St. Petersburg.

Gauguin transferred certain figures from an earlier, Hermitage, composition to a later one: in *Parau Parau*, these are two women seated at left and a third, with her back turned to the spectator. Some figures and heads were repeated in his monotypes and drawings. The woman in black appears in a monotype in reverse (Field, Monotypes, No. 36); her head, in a drawing (Rewald 1958, No. 93); the woman wearing a hat, in a monotype in reverse (Field, Monotypes, No. 44); finally, the figure of the first woman and the head of the second occur in a watercolour on sheet 173 of the Louvre manuscript of *Noa Noa*.

Conversation (detail).
The Hermitage, St.Petersburg.

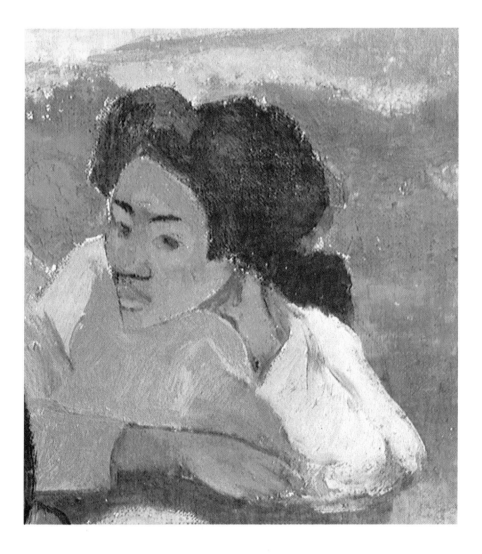

Provenance: A. Vollard Gallery, Paris; 1907, I. Morozov collection, Moscow; 1919, Second Museum of Modern Western Painting, Moscow; 1923, Museum of Modern Western Art, Moscow; since 1948, The Hermitage, St. Petersburg.

Conversation (detail).
The Hermitage, St.Petersburg.

5. *FATATA TE MOUA*
AT THE FOOT OF A MOUNTAIN,
OR THE BIG TREE

1892.
Oil on canvas. 67 x 91 cm.
Inscribed, signed and dated, bottom right: *Fatata te Moua P Gauguin 92.*
The Hermitage, St. Petersburg. Inv. No. 8977. W. 481.

In 1893, at the sale of Gauguin's pictures at the Durand-Ruel Gallery
in Paris this painting was displayed under the title *Fatata te Moua,*
that is, *At the Foot of a Mountain.* The painting was not sold, and
in 1895, under the same title, it was put on sale at the Hotel Drouot.
And again, it was not sold. In the receipt given by Vollard to Morozov,
who purchased the picture in 1908, it was called *The Big Tree* and
under this title became known to the Russian public. It was listed
as *The Big Tree* both in the first description of Morozov's collection
published by the *Apollon* magazine and in the manuscript inventory
of this collection. In 1957, Sterling pointed out that Gauguin gave
this title to two other pictures painted in 1891 (W. 437, 439) and
that, to avoid confusion, the original title of the Hermitage picture
should be restored.

At present this painting has two titles. One, *At the Foot of a Mountain*
was supplied by the artist; under the other, *The Big Tree,* the picture
was known among Russian collectors. The second title is also justi-
fied by the fact that the tree is the focal point of the composition and
the colour scheme. The canvas was painted at Mataiea, a village on
the southern coast of Tahiti, where, according to Danielsson, Gau-
guin lived from the end of 1891 to the middle of 1893. During this
period the motif of a large tree figured prominently in Gauguin's
work: it occurs in a number of his canvases, sometimes as the main
element of a landscape *(Women at the River,* 1892, W. 482), some-
times as a detail of the background *(Matamua,* or *Autrefois,* 1892,
W. 467), and in woodcuts (Guérin, Nos. 36, 39). This tree is a per-
manent attribute of compositions representing the Moon Goddess
Hina, such as *Hina Maruru,* or *Feast of Hina* (1893, W. 500), a
watercolour on sheet 59 of the Louvre manuscript of *Noa Noa,* a
monotype (Field, Monotypes, No. 4) and a woodcut (Guérin,
Nos. 23, 37, 92). Characteristically, the motif of a big tree also
appears in the *Sacred Spring* inspired by Gauguin's Tahitian impres-
sions which he painted upon his return to France.

Provenance: A. Vollard Gallery, Paris; 1908, I. Morozov collection, Moscow (bought
from Vollard for 800 francs); 1919, Second Museum of Modern Western Painting,
Moscow; 1923, Museum of Modern Western Art, Moscow; since 1948, The Hermi-
tage, St. Petersburg.

Fatata te moua.
At the Foot of a Mountain, or the Big Tree.
The Hermitage, St. Petersburg.

6. VAÏRAUMATI TEI OA
HER NAME IS VAÏRAUMATI

1892.
Oil on canvas. 91 x 68 cm.
Signed and dated, bottom left: *Paul Gauguin 92 Tahiti.*
Inscribed on the leaf, bottom centre: *Vaïraumati tei oa.*
The Pushkin Museum of Fine Arts, Moscow. Inv. No. 3266. W. 450.
(as owned by the Hermitage).

The picture was painted during Gauguin's first Tahitian period. It was inspired by ancient Maori legends which Gauguin knew from Jacques-Antoine Moerenhout's book *Voyages aux Iles du Grand Océan* (Paris, 1837) and from the stories told by his Tahitian mistress Tehura. The myth of the god Oro and the beautiful Vaïraumati was related by Gauguin in his *Noa Noa:* "Oro, the son of Taaroa, and, after his father, the greatest of the Gods, once decided to choose a companion from among the mortals. He wished her to be virgin and beautiful, since he had the intention to found with her... a superior and privileged race... Many days were spent in vain efforts, and when he felt like going back to the skies he noticed... a young girl of rare beauty... She was tall of stature and the sunrays sparkled on the gold of her skin while the mysteries of love slumbered in the night of her hair... Vaïraumati was the name of the young girl... Vaïraumati, meanwhile, had prepared for the reception a table laden with fruit, and a couch formed of the thinnest of mats and the richest of cloths... Every morning the god returned to the summit of Paia; every evening he descended to sleep with Vaïraumati... After his death, he was taken to the sky where Vaïraumati also enthroned herself among the goddesses." Such was the origin of the privileged Areoi race. Gauguin's picture is something more than just an illustration to the legend. His Vaïraumati is seated at a couch before a table laden with fruit (the manuscript of *Avant et Après* contains a watercolour showing the same table), and Oro, enchanted by her beauty, is standing beside her. But the purely illustrative character of the foreground scene is counterbalanced by the concrete and completely realistic Tahitian landscape in the background dominated by a stone sculpture — a work of an ancient craftsman representing an episode from the same legend. The scene in the foreground thus appears to be a modern interpretation of this myth. Gauguin's Vaïraumati, with a smoking cigarette in her hand, has a fairly realistic appearance of a Tahitian woman, rather than of a mythological character. In his preface to *Noa Noa,* Charles Morice noted Gauguin's tendency to endow Tahitian *vahines* with divine qualities. To impart a divine appearance to a Tahitian *vahine,* Gauguin depicted her in the attitude of a priestess from an ancient Egyptian frieze in the British Museum; he had a photograph of it in Tahiti. In the same year this frieze also inspired him to paint *Te Matete (The Market,* W. 476), in which several female figures are shown in the pose of Vaïraumati. Another source of the Moscow painting was Puvis de Chavannes's well-known canvas *Hope* (Musée d'Orsay, Paris), where a naked girl is sitting on a bed of flowers in a spring landscape. As a young man, Gauguin greatly admired Puvis de Chavannes, particularly his alle-

Vaïraumati tei oa.
Her Name is Vaïraumati.
The Pushkin Museum of Fine Arts,
Moscow.

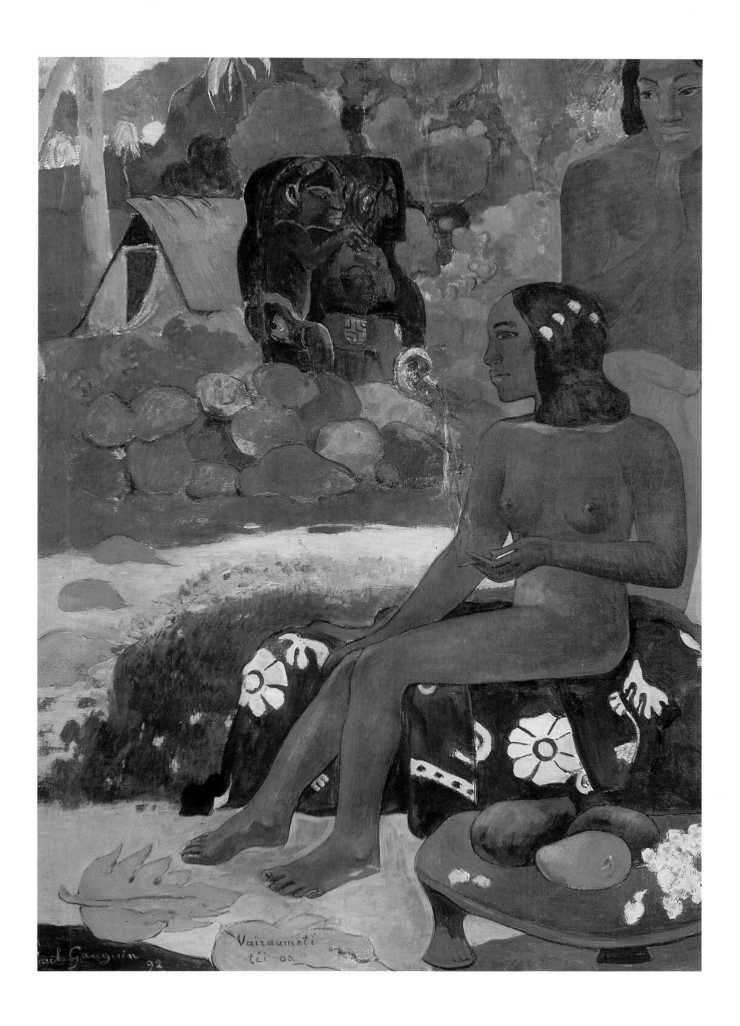

Vairaumati tei oa

Paul Gauguin 92

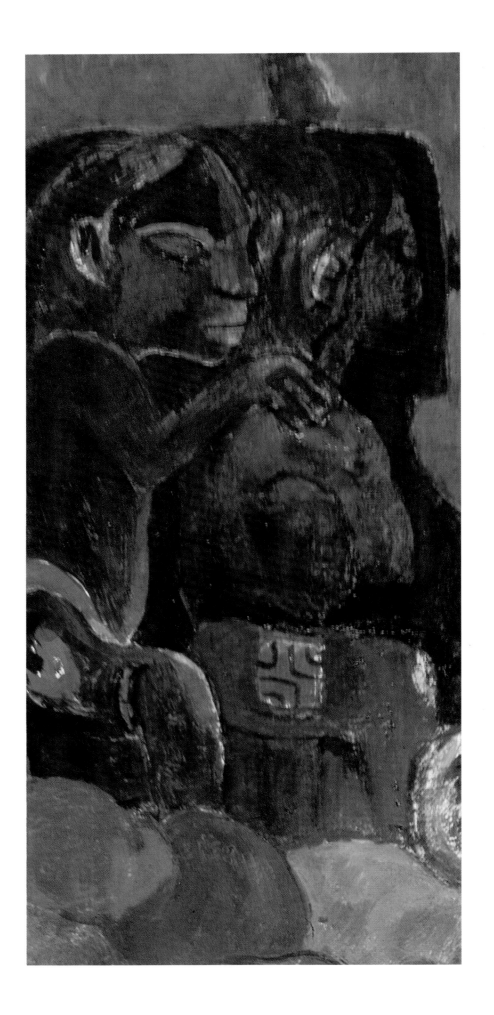

Her Name is Vaïraumati (detail).
The Pushkin Museum of Fine Arts,
Moscow.

gories and his somewhat reserved monumental style. Therefore, Gauguin's borrowing of some images and motifs from the compositions by this artist, about which, incidentally, he wrote in *Avant et Après*, was perfectly natural and justified. He even made a copy of the *Hope* and executed a monotype based on this canvas (Field, Monotypes, No. 32). In a version entitled *Te Aa no Areois (The Germ of the Areois*, W. 451) showing Vaïraumati but without Oro or the stone idol in the background, the woman holds a budding flower in her left hand, the symbol of the clan's origin. According to Rewald, the model for this version was Tehura, Gauguin's first Tahitian wife. She is apparently depicted in the Moscow painting. *The Germ of the Areois*, with its single symbolic message, might have been Gauguin's first interpretation of the myth of Vaïraumati. In his letter to Sérusier on March 25, 1892, the artist tried to express his emotions aroused

P. Puvis de Chavannes. *Ta matete (The Market).*
Hope. (W. 476).

by his new environment and the people he had come to know in Tahiti. "... What I'm doing now is quite ugly, quite mad. My God, why did you make me this way? I'm cursed" (P. Sérusier, *A.B.C. de la peinture. Correspondance*, Paris, 1950, pp. 59, 60, 144). Enclosed with the letter was a sketch for the Moscow canvas. The Tahitian sculpture with Vaïraumati and Horo also occurs in the background of *Nave Nave Moe (Sacred Spring*, Hermitage, St. Petersburg), where it symbolizes the sublime heavenly love which is the source of the love of the mortals. Painted in 1894 during Gauguin's last stay in France, the picture is in fact the summing-up of his Tahitian impressions conveyed by symbolic images from his earlier Tahitian canvases. It is worthy of note that among these iconographic images we find characters and details from the two 1892 works now in the Moscow museum: *Aha oe Feii? (What! Are You Jealous?)* and the present picture. The main elements of these canvases, together with the big tree from the Hermitage painting, which can also be seen in the background of *Sacred Spring*, formed the basis of Gauguin's vision of Noa Noa — the 'promised land'.

Provenance: February 18, 1895, Sale of Gauguin's works at the Hotel Drouot, Paris, No. 15 (remained with Gauguin's family); S. Shchukin collection, Moscow; 1918, First Museum of Modern Western Painting, Moscow; 1923, Museum of Modern Western Art, Moscow; since 1948, The Pushkin Museum of Fine Arts, Moscow.

7. AHA OE FEII?
WHAT! ARE YOU JEALOUS?

1892.
Oil on canvas. 66 x 89 cm.
Signed and dated, bottom centre: *P. Gauguin 92.*
Inscribed, bottom left: *Aha oe feii?*
The Pushkin Museum of Fine Arts, Moscow. Inv. No. 3269. W. 461.

This picture, painted during Gauguin's first Tahitian period, is one of the earliest examples of his synthetic style as applied to the treatment of Tahitian landscape and figures. The women are depicted on a shore, but the sand and the water are rendered schematically, being reduced to a single screen-like surface enlivened by areas of saturated colour. Gauguin witnessed this scene in Tahiti and later described it in *Noa Noa:* "On the shore, two sisters are lying after bathing, in the graceful poses of resting animals; they speak of yesterday's love and tomorrow's conquests. The recollection causes them to quarrel: What! Are you jealous?" (Gauguin, *Noa Noa*, p. 13). The last sentence, in its would-be Tahitian version, Gauguin wrote on the canvas itself. It was Danielsson who first noticed Gauguin's mistake in translation: the actual meaning of the words *Aha oe feii is* 'to have a grudge against somebody'. Because of this correction, Cooper translated the title of the painting as *Why Are You Angry?* (Cooper, p. 576, No. 19), which is definitely wrong, for Gauguin himself wanted to entitle the picture with a phrase from *Noa Noa — What! Are You Jealous?* Under this title it was displayed at the Durand-Ruel Gallery in 1893. The picture itself has nothing of the anecdotal; the postures of the girls are carefully balanced, the central figure's attitude being almost identical to that of the statue of Dionysus, whose photograph Gauguin brought to Tahiti. The artist himself was enormously pleased with this work. In a letter to Monfreid of August 1892, he wrote: "I've just painted a splendid nu — two women at the water's edge which I think is the best of what I've done so far" (Monfreid, p. 99).

In December 1892, Gauguin sent a number of his pictures to an exhibition in Denmark. Among them was *Aha oe Feii?* In a letter to his wife Gauguin asked her not to sell it for less than 800 francs. The figure of the central woman, in a wreath of white flowers, was later repeated in several of Gauguin's compositions: *Nave Nave Moe (Sacred Spring)*, *Eiaha Ohipa (Tahitians in a Room)*; *Women on the Bank of a River* (1898, W. 574), *The Great Buddha*, and *And the Gold of Their Bodies* (1901, W. 596). A model depicted in the same attitude can be seen in Gauguin's notebook *Carnet de Tahiti*, as well as in a watercolour, monotype, drawing and woodcut executed for *Noa Noa*.

Provenance: February 18, 1895, Sale of Gauguin's works at the Hotel Drouot, Paris, No. 19 (bought by Leclanché for 500 francs); 1908, S. Shchukin collection, Moscow; 1918, First Museum of Modern Western Painting, Moscow; 1923, Museum of Modern Western Art, Moscow; since 1948, The Pushkin Museum of Fine Arts, Moscow.

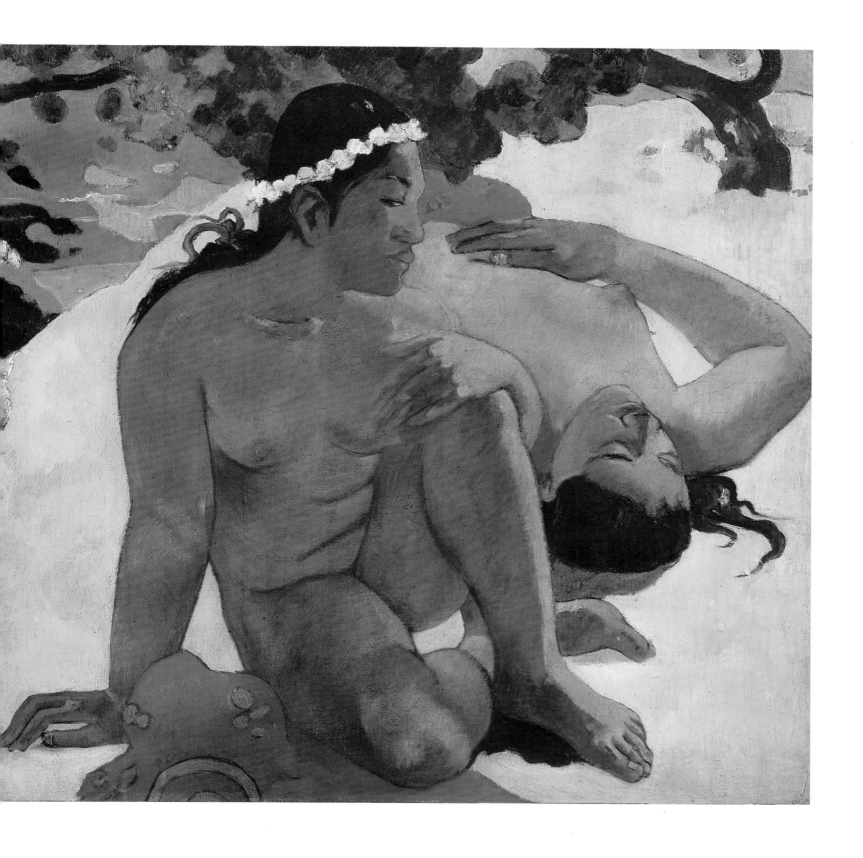

Aha oe feii?
What! Are You Jealous?
The Pushkin Museum of Fine Arts,
Moscow.

8. *MATAMOE*
LANDSCAPE WITH PEACOCKS

1892.
Oil on canvas. 115 x 86 cm.
Inscribed, signed and dated, bottom right: *Matamoe P. Gauguin 92.*
The Pushkin Museum of Fine Arts, Moscow. Inv. No. 3369. W. 484.

Landscape with Peacocks is one of Gauguin's finest works from his first stay in Tahiti which provided him with an inexhaustible source of new motifs. Gauguin admired Tahitian villages with their huts covered with pandanus leaves, the tall and graceful coconut palms on the shores of coral lagoons, the streets abounding in exotic plants and the birds evoking pictures of a lost paradise. Later Gauguin recalled: "It was so simple to paint everything the way I saw it, to apply the red paint beside the dark blue without calculation..." (Gauguin, *Noa Noa*, p. 46).

The central figure in the painting, a young Tahitian with an axe lifted over his head, is a real character whom Gauguin saw soon after his arrival to Tahiti, during an early morning walk along the beach. He described him in *Noa Noa:* "It is morning. On the sea close to the strand I see a pirogue, and in the pirogue a half-naked woman. On the shore is a man, also undressed. Beside the man is a diseased coconut tree resembling a huge parrot... With a harmonious gesture the man raises the heavy axe in his two hands. It leaves above a blue impression against the silvery sky, and below a rosy incision in the dead tree" (Gauguin, *Noa Noa*, p. 41). Apparently it was this powerful visual impression that prompted Gauguin to paint *Man with an Axe* (1891, W. 430) which depicted the scene the way it was described in *Noa Noa.*

This picture preceded the *Landscape with Peacocks,* in which the figure of the man with an axe appears without any changes. It is interesting that despite the real visual impression, the man's attitude is borrowed from a frieze of the Parthenon — the artist had with him in Tahiti a set of photographs of the Parthenon friezes (Dorival 1951, p. 121). The bend of the man's body and the position of his legs are identical to those of one of the figures in the frieze. Gauguin also made a preliminary drawing for the *Tahitian with an Axe,* which is reproduced by Morice in his book about Gauguin (Morice, p. 140). The meaning of the word *matamoe,* inscribed in large characters in the lower right corner of the canvas, aroused controversy among art critics. Some insisted that it was Gauguin's spelling mistake, and the word he really had in mind was *matamua,* meaning 'once upon a time'. This interpretation seems hardly justified. Bouge, in his list of Gauguin's Tahitian inscriptions, translated this word as 'strangers'. The word *matamoe,* however, occurs in one more of Gauguin's inscriptions — *Arii Matamoe* found on a picture representing the execution of a Tahitian prince (W. 453). In the catalogue for an exhibition at the Durand-Ruel Gallery, it was translated by Gauguin himself as 'La fin royale'. It can be assumed, therefore, that by *matamoe* Gauguin meant 'death'. Such interpretation was also suggested by Bengt Danielsson, who explained the strange dissonance between the magnificent joyous landscape and such a 'morbid' title, relying on a passage in *Noa Noa.* Gauguin described how he and a young

Matamoe.
Landscape with Peacocks.
The Pushkin Museum of Fine Arts,
Moscow.

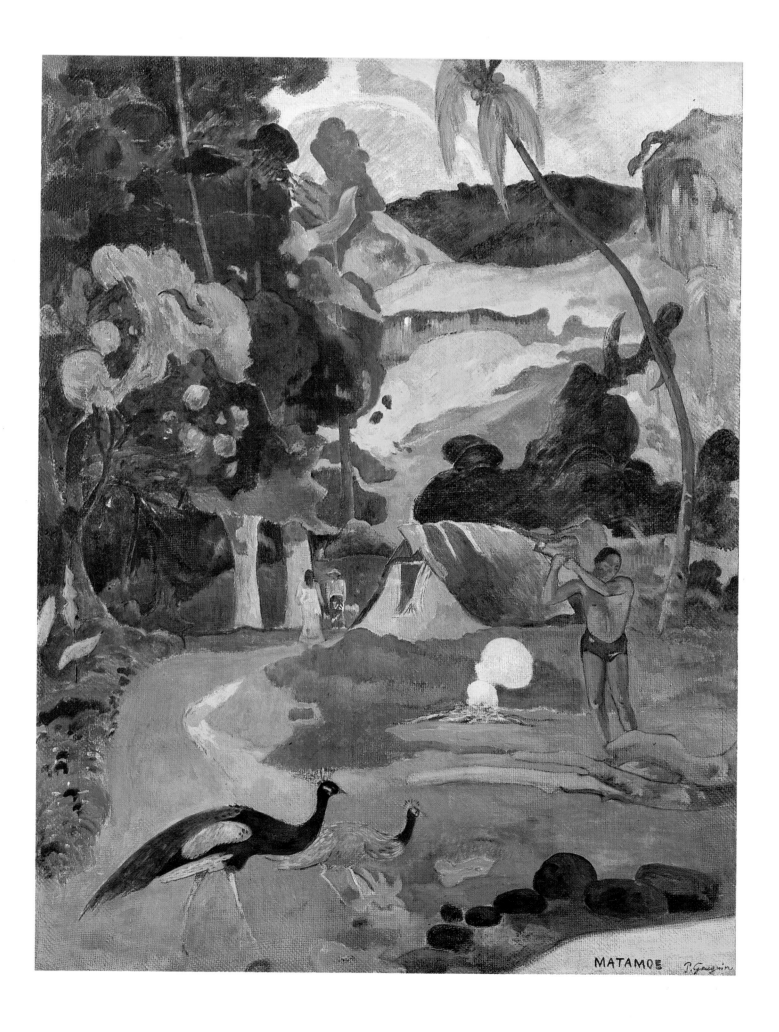

Landscape with Peacocks (detail).
The Pushkin Museum of Fine Arts,
Moscow.

9. *PASTORALES TAHITIENNES*

1893.
Oil on canvas. 86 x 113 cm.
Inscribed, signed and dated, bottom right:
Pastorales Tahitiennes 1893 Paul Gauguin.
The Hermitage, St. Petersburg. Inv. No. 9119. W. 470.

In late December, 1892, Gauguin wrote to Daniel de Monfreid: "I've just completed three pictures... I think they are the best, and as in a few days it will be 1 January, I'm dating one of them, the very best, 1893. As an exception, I've given it the French title: *Pastorales Tahitiennes,* for I could not find a corresponding expression in the Kanaka language. I do not know why, but although everything is covered with pure Veronese green and vermilion, the picture seems to resemble an old Dutch painting or a tapestry. Why should this be so..." (Monfreid, p. 64). As follows from this letter, the painting should be dated to December 1892. Characteristically, in several works of his first Tahitian period, Gauguin, dwelling on the pastoral theme, used similar landscape motifs, e.g. in *Matamua* (Autrefois, W. 467), *Arearea* (Amusements, W. 468), *Rupe Tahiti* (W. 509), *Women Bathing* (W. 572), etc. Sterling (Sterling, p. 130) points out that, although the date 1893 put by Gauguin on this canvas means that the artist was pleased with the work, *Pastorales Tahitiennes,* compared to his other canvases, is somewhat dry and schematic. According to Antonina Izerghina (French 19th Century Masters, No. 72), this picture was a milestone in the artist's career, and in it "Gauguin completely overcame the immediacy of perception characteristic of his earlier Tahitian works. *Pastorales Tahitiennes* is treated as a decorative panel, based on the combination of the exquisite rhythm of linear arabesques and flat areas of local colour."

Rupe Tahiti.
Glass-work.
(W. 509).

Provenance: Bernheim-Jeune Gallery, Paris (judging by the firm's label with No. 15286 on the reverse); A. Vollard Gallery, Paris; 1908, I. Morozov collection, Moscow (bought from Vollard for 10,000 francs); 1919, Second Museum of Modern Western Painting, Moscow; 1923, Museum of Modern Western Art, Moscow; since 1948, The Hermitage, St. Petersburg.

10. *EU HAERE IA OE*
WOMAN HOLDING A FRUIT,
OR WHERE ARE YOU GOING?

1893.
Oil on canvas. 92 x 73 cm (relined).
Signed, dated and inscribed, bottom left: *P. Gauguin 93 Eu haere ia oe.*
The Hermitage, St. Petersburg. Inv. No. 9120. W. 501.

The date given by the artist is questioned by several researchers. Thus, Bernard Dorival (Dorival 1954, p. 28) and Charles Sterling believe that the canvas was conceived and produced in 1892 and merely signed in 1893. Their only argument is that the figures in the middle distance come from Gauguin's works of 1891 and 1892. This argument, however, is not convincing, for Gauguin frequently used the same figures and details of his earlier compositions in a number of paintings.

Comparison of the Hermitage painting with the 1892 *Where Are You Going?* in the Staatsgalerie, Stuttgart (W. 478), confirms the dating of 1893. The Stuttgart canvas is an earlier version of the theme, still treated as an everyday scene. Bouge and Danielsson translated the Tahitian title of this canvas as 'Where are you going?' (a greeting), which perfectly corresponds to the scene depicted. The Hermitage picture is perceived in an utterly different way. It is larger in width and smaller in height than its counterpart in Stuttgart. The principal figure therefore appears closer to the centre and seems more monumental, while the figures in the middle distance merely serve as

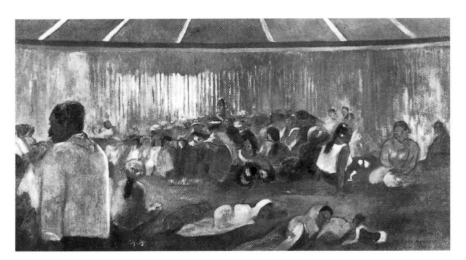

elements helping to clarify the symbolic meaning of the composition. It was probably not accidental that the figure of the girl, seated in front of the hut, was taken by Gauguin from his 1892 canvas *Nafea Fa'aipoipo? (When Will You Marry?,* W. 454) and that to the right of her he depicted a woman with a child in her arms. There is a certain symbolic link between these two female figures and the fruit in the hands of the principal character. This green-coloured fruit acquired a symbolic meaning of fertility and the continuity of life (according to Danielsson, the woman is holding not a fruit but a vessel made of pumpkin). Since *Woman Holding a Fruit is* not a mere genre scene, its Tahitian title, although phonetically it is close to that of the Stutt-

Te Fare Hymenee
(The House of Hymns).
(W. 477).

Eu haere ia oe.
Woman Holding a Fruit,
or Where Are You Going?
The Hermitage, St. Petersburg.

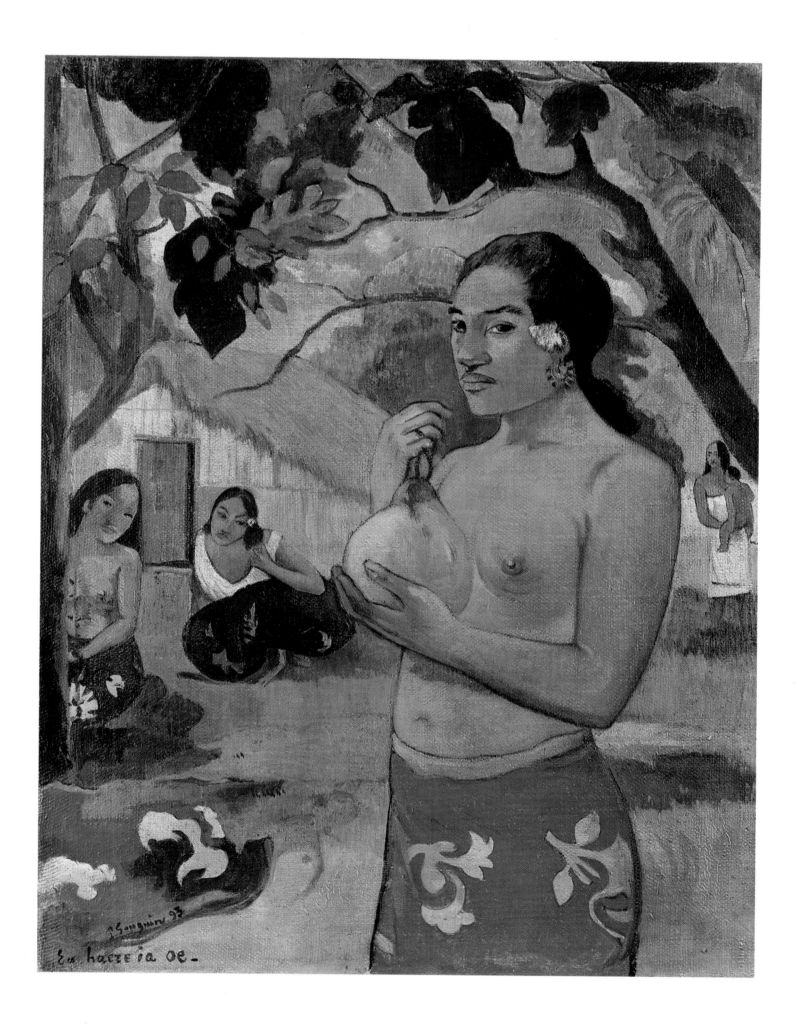

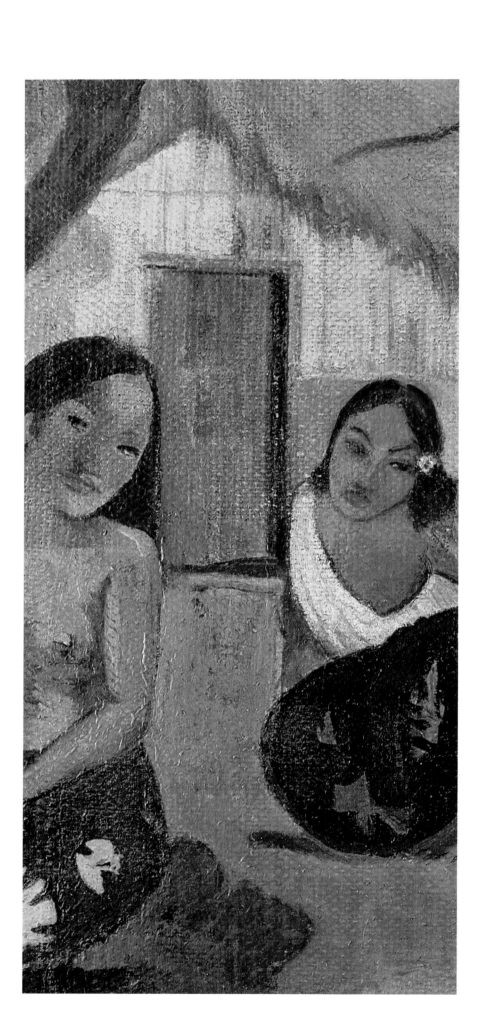

gart canvas, becomes irrelevant, and the painting itself should certainly be regarded as a later and a more mature version. Ann Distel assumes that the central figure in the picture represents Tehura, Gauguin's *vahine* (A. Distel, *De Renoir a Matisse*. Paris, 1978, No. 14). The two seated women at left recur in some of Gauguin's drawings (Rewald 1958, Nos. 46, 47), and the girl sitting in front of the cottage appears in the *Landscape with Black Pigs* (1891, W. 445), in *Nafea Fa'aipoipo* and in *Te Fare Hymenee (The House of Hymns*, 1892, W. 477). The earliest representation of this girl is a squared-up charcoal and pastel drawing (Langer, p. 49, No. 14). The woman with a child standing to the right of the girl has an analogy in a drawing from Gauguin's Tahitian diary (Dorival 1954, fol. 58), and the cabin is repeated in a pasted-in watercolour in the Louvre manuscript of *Noa Noa*.

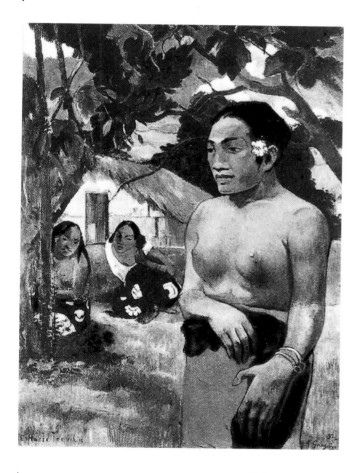

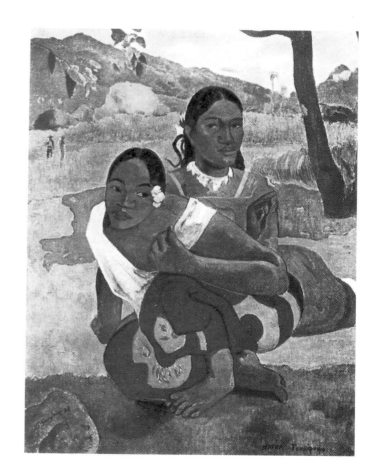

E haere oe i hia?
Where Are You Going?
(W. 478).

Nafea faa ipoipo?
When Will You Marry?
(W. 454).

Provenance: A. Vollard Gallery, Paris; 1908, I. Morozov collection, Moscow (bought from Vollard for 8,000 francs); 1919, Second Museum of Modern Western Painting, Moscow; 1923, Museum of Modern Western Art, Moscow; since 1948, The Hermitage, St. Petersburg.

107

11. *SELF-PORTRAIT*

Early 1890's.
Oil on canvas. 46 x 38 cm.
Signed, bottom left: P. GO.
The Pushkin Museum of Fine Arts, Moscow. Inv. No. 3264. W. 297.

In April 1903 Gauguin sent three of his paintings to Gustave Fayet to be sold in Paris. Among them was a self-portrait. From Fayet, the paintings *Ruperupe (Gathering Fruit)* and *The Ford* were later acquired by Shchukin. At the same time the collector bought a self-portrait, which may mean — although there is no documentary evidence of this — that it was the one sent by Gauguin from Tahiti in 1903. Since Gauguin did not date this *Self-Portrait*, there is no agreement among scholars as to its dating. Rewald and Sterling placed it between 1888 and 1889. Wildenstein accepted this dating and entered the picture in his catalogue under 1888. Sterling based his dating on the curved shape of Gauguin's moustache, which from his *Self-Portrait with the Yellow Christ* (W. 324) of 1889 onwards he depicted

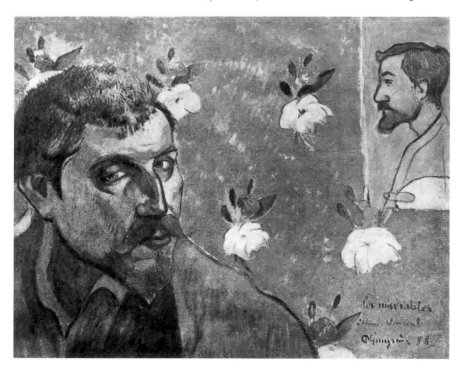

as hanging downwards. Wildenstein assumed that it was the Moscow *Self-Portrait* which was mentioned by Van Gogh in a letter to his brother of January 9, 1889, as the one just finished by Gauguin at Arles. This view is shared by Douglas Cooper. However, the bright yellow stripe in the left margin of the canvas is reminiscent of the yellow background in many of Gauguin's Tahitian paintings. A similar yellow band is also seen in the *Self-Portrait with a Hat* (W. 506) painted in 1893-1891 after Gauguin's return to Paris from Tahiti. The two self-portraits are of the same size and are signed in the same way: *PGO (Self-Portrait with a Hat* is signed on the reverse of the canvas). These similarities suggest that the dating of the Moscow painting, 1888-1890, is not unquestionable. The Polynesian origin was believed true by P. Pertsov and probably also by Shchukin him-

Self-Portrait "Les Misérables".
(W. 239).

Self-Portrait.
The Pushkin Museum of Fine Arts,
Moscow.

108

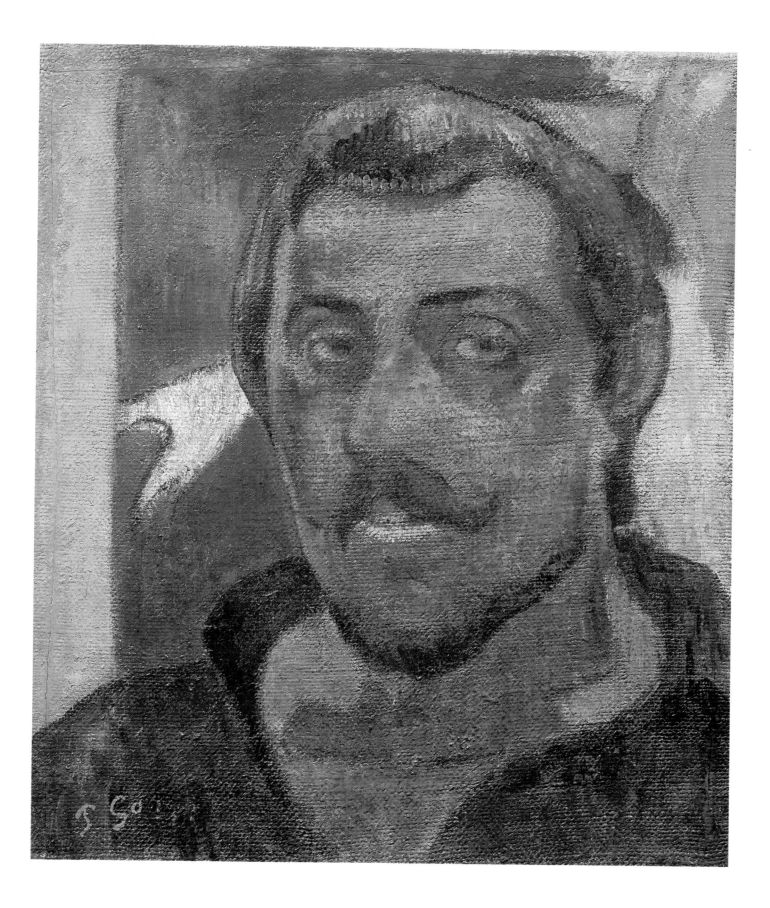

"A bandit's head at first sight, a Jean Valjean (*Les Misérables*),
but it also personifies a disreputable Impressionist painter
burdened a chain for the world."

From a Letter by Gauguin to Emile Schuffenecker, of October 8,1888.

self. Nevertheless, the dating of this work should for the time being remain an open question. Some students of Gauguin refer it to the last period in his career, identifying it with the self-portrait sent to Fayet from Tahiti in 1903 and pointing out the coarse, thick-grained texture of the canvas frequently used by Gauguin in Tahiti (Georgievskaya, Kuznetsova, No. 192; *Villa Favorita. Capolavori impressionisti e postimpressionisti dai musei sovietici. Collezione Thyssen-Bornemisza. Villa Lugano,* 1983, p. 58). However, these arguments are not very reliable, for Gauguin used rough canvas at various phases of his career, including the Arles period in 1888. Françoise Cachin discovered that in this work Gauguin depicted himself against the background of the painting *In the Waves* (W. 336) which features the figure of an Undine with her red hair let down. *In the Waves* was the principle symbolic work which Gauguin produced before Tahiti. We have here, then, Gauguin's favourite device of depicting himself in front of his own works. It is interesting that in the *Self-Portrait with a Hat* mentioned above he recorded himself against the background of *Manao tupapau,* a painting which he considered one of his key works. The presence of the early symbolic work in the Moscow *Self-Portrait* may be evidence that it too was created in 1889 or that, on his return to Paris, Gauguin felt a need to depict himself together with the most significant works of the past five years, works which were linked by a common symbolic context. In any case, the pair of works — the Moscow *Self-Portrait* and *Self-Portrait with a Hat* — form a kind of diptych affirming their creator's artistic creed.

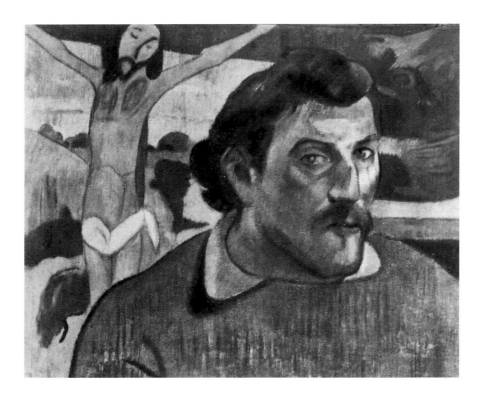

Self-Portrait with the Yellow Christ.
(W. 324).

Provenance: after 1906, S. Shchukin collection (bought from G. Fayet ?); 1918, First Museum of Modern Western Painting, Moscow; 1923, Museum of Modern Western Art, Moscow; since 1948, The Pushkin Museum of Fine Arts, Moscow.

Self-Portrait with a Hat.
(W. 506).

Self-Portrait at Golgotha.
(W. 534).

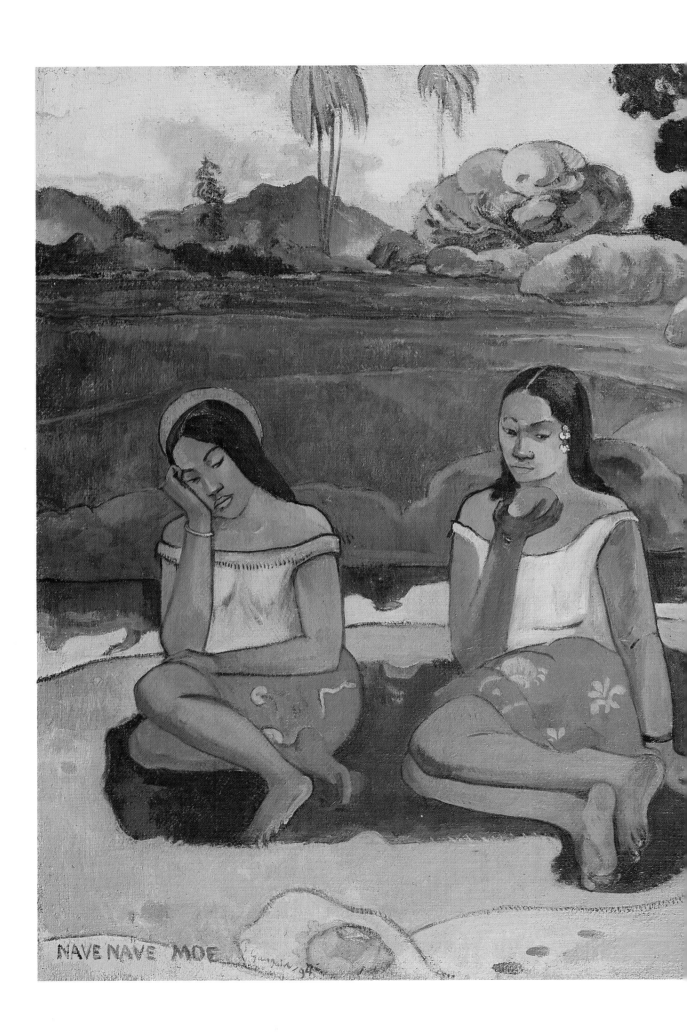

Nave nave moe.
Sacred Springs, or Sweet Dreams.
The Hermitage, St. Petersburg.

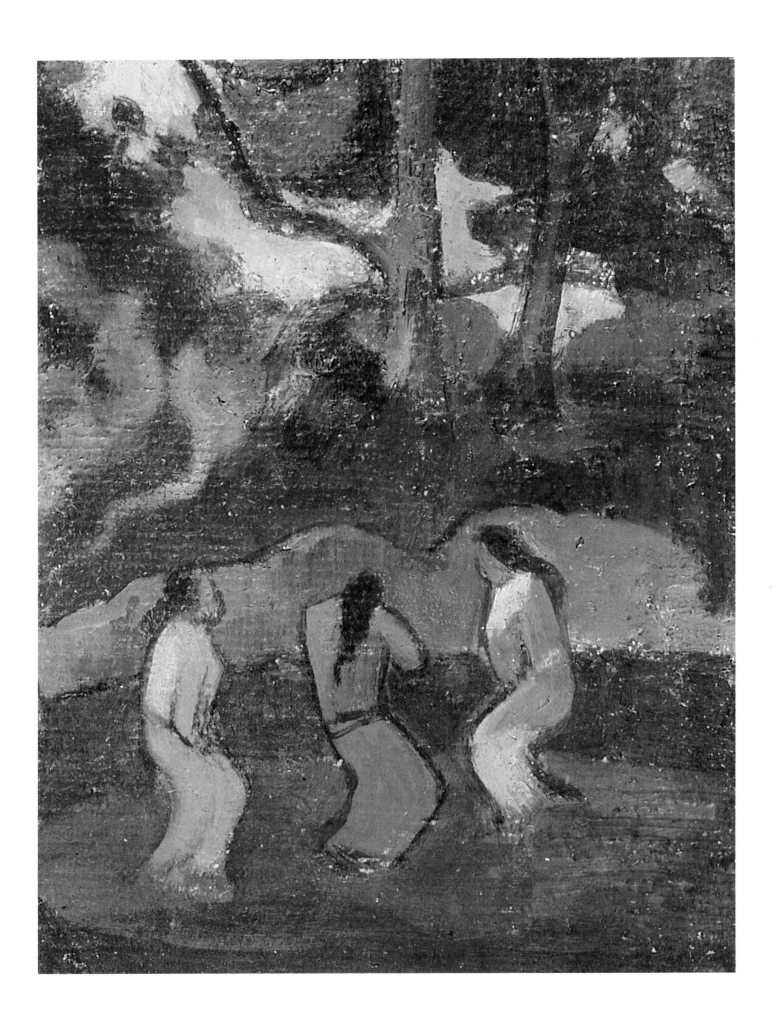

12. *NAVE NAVE MOE*
SACRED SPRING, OR SWEET DREAMS

1894.
Oil on canvas. 73 x 98 cm.
Inscribed, signed and dated, bottom left: *Nave Nave moe P. Gauguin 94*.
The Hermitage, St. Petersburg. Inv. No. 6510. W. 512.

The Tahitian title of the painting, written by the artist on its front side, was translated into French and English by Bouge and Danielsson as *Douces Reveries* and *Delightful Drowsiness*, respectively. In the catalogue of the 1895 sale of Gauguin's paintings at the Hôtel Drouot, however, the picture was listed *as Nave Nave Moe, or Eau délicieuse*.

Since at that time Gauguin was in Paris, he must have translated the Tahitian title himself. No doubt, his version of the title was closer to the symbolic implication of the painting than the accurate, but rather narrow interpretation of Bouge and Danielsson. The painting was first reproduced in Russia in the *Apollon* magazine (1912), under the title *Rural Life in Tahiti*. In the 1928 catalogue of the Museum of Modern Western Art, Moscow, it was listed as *Sacred Spring*, and under this title it is known in the Hermitage collection.

Nave Nave Moe belongs to Gauguin's major works painted in France after his first stay in Oceania. Presenting a summary image of Tahiti, it was most likely painted in Paris, in the early 1894, soon after his stained-glass panels *Nave Nave* (W. 510) and *Tahitian Women in a Landscape* (W. 511), since already in April 1894 Gauguin moved to Pont-Aven and embarked on his earlier Breton motifs.

What Gauguin wanted to convey by this work was probably his vision of Tahiti as a 'promised land', where everything obeyed the laws of the natural course of time. The task he set himself — to represent the three cardinal states of nature and human life — called for a symbolic rendition of the concept. Thus, the lily, which goes back to his *Pastorales Tahitiennes* (1892), probably symbolizes the virginal purity of the 'enchanted island'. The female images symbolize the different stages of human life. The young girl is sunk in a deep sleep, her feelings not yet awakened. The halo around her head is a sign of chastity. The elder girl holds a fruit which she is going to taste. On the other side of the spring two older women are engaged in a conversation — their postures are so static that they seemed rooted to the earth. One of them is turned to the right, the other to the left, their gazes thus embracing the entire expanse of the 'promised land'. In the dim depths of the canvas, a group of Tahitian women are dancing in ecstasy around gigantic pagan idols. The colour scale changes from the foreground, with its large areas of radiant pink and red, to the background, where the sky is coloured by the pale-yellow hues of the setting sun whose last rays are burning on the round top of a tree. This tree in the background frequently appears as the main component of Gauguin's Oceanian landscapes, being perhaps one of the symbols he chose for Tahiti's vigorous, uncultivated nature: *Women at the River* (1892, W. 482), *At the Foot of a Mountain, Tahitian Scene* (1894, Field, Monotypes, No. 4) and *Tahitian Landscape* (1894, Field, Monotypes, No. 34). Gauguin repeatedly depicted this

Sacred Springs, or Sweet Dreams (detail).
The Hermitage, St. Petersburg.

115

tree in compositions with the Moon Goddess Hina, e.g. in *Parahi te Marae (There Is a Temple, 1892, W. 483), Matamua (Autrefois, 1892, W. 467)*, and *Hina Maruru (Feast of Hina, 1893, W. 500)*. In *Matamua (Autrefois)*, the goddess is shown against a tree, surrounded by dancing Tahitians. The mirror image of this scene occurs in the upper right corner of the woodcut *Manao Tupapau (Spirit of the Dead Watching, 1893-1894*, Guérin, No. 36). It was this detail of the woodcut that Gauguin used as an illustration for his manuscript version of *Noa Noa* (Louvre, p. 61; Guérin, No. 37). The persistent representation of the tree next to the Goddess Hina suggests that in *Sacred Spring* this tree, lit by the last rays of the sun, symbolizes the approaching moonrise. Moonlight was traditionally associated by the Tahitians with the fear of the spirits of the dead, and this is implied by the ritual dancing around the idols. The painting *Women on the Bank of a River* (W. 574) is almost identical to the right-hand part of the Hermitage picture. Its date, being not very distinct, reads either as 1892 or 1898. If the correct date is 1892, it means that it is a sketch for *Sacred Spring*. If, as the case may be, the date is read as 1898, it indicates that this painting is a later repetition of the right-hand part of the Hermitage canvas, which is hardly feasible, considering that by 1898 *Sacred Spring* was already sold. The two Tahitian women in the foreground come from the 1891 painting *Te Fare Maori (Tahitian Hut, W. 436)*, the one in the right being originally represented in *Te Ra'au Rahi (The Large Tree, W. 437)*. The couple in the middle distance also occurs in *Women on the Bank of a River*. The figure on the left can be seen in *What! Are You Jealous?, The Great Buddha* and in *And the Gold of Their Bodies* (1901, W. 596). According to Field, Gauguin borrowed this figure from the photograph of the statue of Dionysus.

Mahana no atua (detail).
(*The Day of the God*).
(Guérin, No. 42).

Provenance: 1895, A. Schuffenecker collection, Paris (according to the catalogue of the sale of Gauguin's works, bought on February 18, at the Hotel Drouot); November 10, 1897, Dosbourg sale, Paris (lot 16, sold for 160 francs); Prince Wagram collection, Paris; A. Vollard Gallery, Paris; 1907, I. Morozov collection, Moscow (bought from Vollard for 8,000 francs); 1919, Second Museum of Modern Western Painting, Moscow; 1923, Museum of Modern Western Art, Moscow; since 1931, The Hermitage, St. Petersburg.

Sacred Springs, or Sweet Dreams (detail). The Hermitage, St. Petersburg.

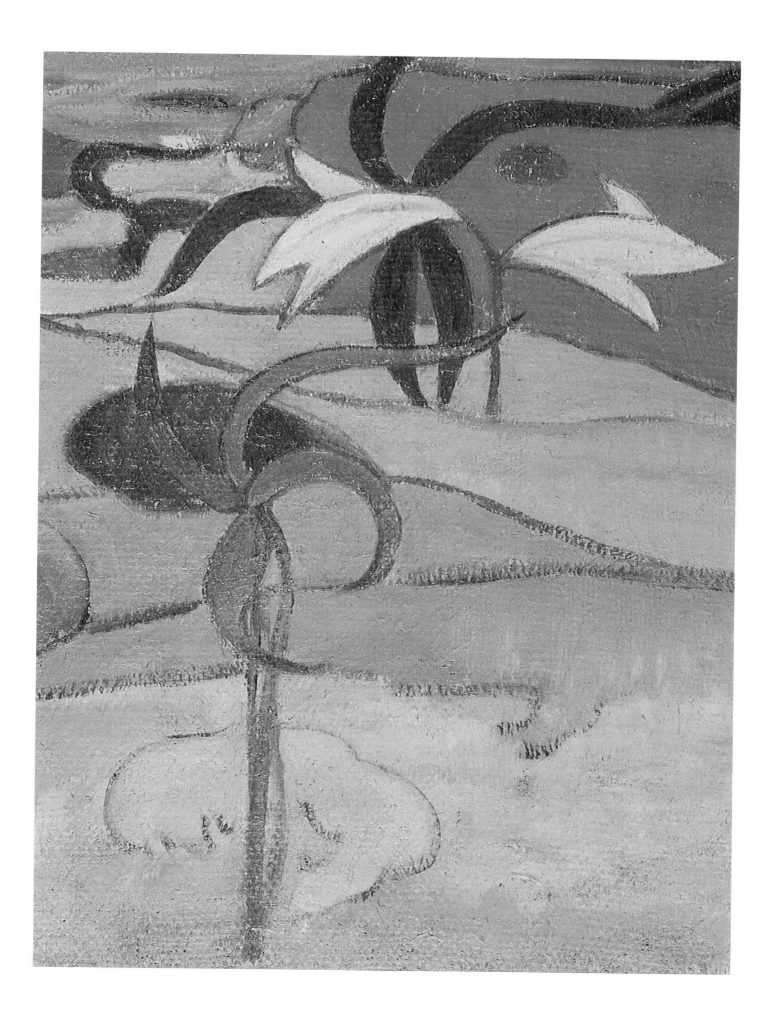

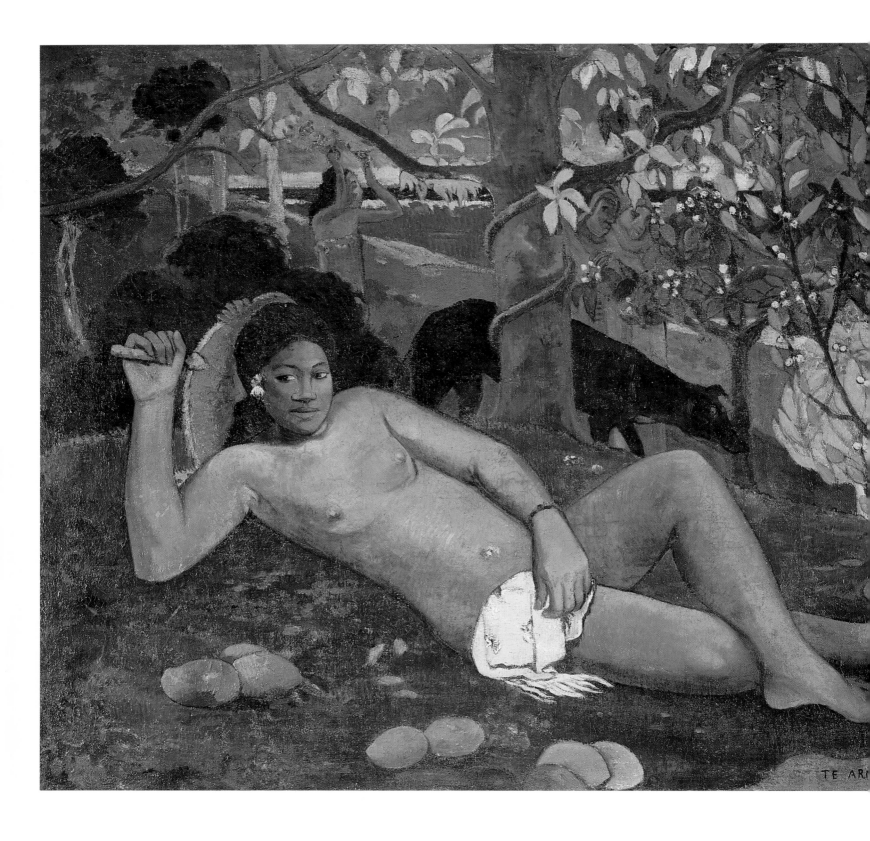

Te arii vahine.
The Queen, or The King's Wife.
The Pushkin Museum of Fine Arts,
Moscow.

13. *TE ARII VAHINE*
THE QUEEN, OR THE KING'S WIFE

1896.
Oil on canvas. 97 x 130 cm.
Signed and dated on a light green zone, bottom right: *P. Gauguin 1896*;
inscribed: *Te arii Vahine*.
The Pushkin Museum of Fine Arts, Moscow. Inv. No. 3265. W. 542.
(as owned by the Hermitage).

The picture belongs to Gauguin's second Tahitian period. The artist described it in a letter to Daniel de Monfreid in April 1896, adding a sketch in Indian ink and watercolour: "I've just made a picture of 130 cm by 1 metre which I think is even better than anything else to date: a naked queen lying on a green carpet, a servant picking fruit, two old men, near the big tree, discussing the tree of knowledge; a beach in the background... I think that in colour I've never before made anything of such a majestic deep sonority. The trees are in flower, the dog is on guard, the two doves on the right are coving. What's the use of sending this canvas, when there are so many others that do not sell and cause such a howl" (Monfreid, pp. 85, 86). None the less, the painting was sent to Monfreid in Paris, but it was not until after Gauguin's death in 1903 that he managed to sell it to Gustave Fayet for 1,100 francs.

As it follows from Gauguin's own words and from the enthusiasm with which this painting was received by Monfreid and later by Fayet, it was classed among Gauguin's best works in his lifetime. In its complicated message and its dual symbolic content *The Queen is* akin to *Her Name Is Vaïraumati.* The "naked queen", like Vaïraumati is shown as a Tahitian *vahine*. According to Perruchot, the model for the queen was Pahura — the thirteen-year-old girl who lived with Gauguin after his second arrival on Tahiti (Perruchot, p. 301). The posture of the queen is evocative of the famous *Olympia* by Edouard Manet which strongly impressed Gauguin. Back in 1890, Gauguin had made a copy of *Olympia,* which was later acquired by Edgar Degas. In his notebook Gauguin also made a caricature on Manet's celebrated canvas. Gauguin's queen, in the guise of a young Tahitian *vahine,* defies the bourgeois prejudices by starting a dialogue with goddesses of a past age. Recently an opinion has been voiced that in the *Queen* Gauguin repeated the composition of the *Sleeping Nymph* by Lucas Cranach.

In a letter to Andre Fontainas of March 1899, the artist wrote that in his new environment he was haunted by ghosts of the ancient past. The red fan which the queen holds in her hand is, according to tradition, the sign of royal descent and at the same time an instrument of temptation. The tree under which she is lying is not an ordinary mango-tree it is the Tree of the Knowledge of Good and Evil. Standing near it are two greybeards whom Gauguin later introduced into his major work *Where Do We Come From? What Are We? Where Are We Going?* According to Field, these shadowy figures in hoods with their eyes fixed on the ground were borrowed from Delacroix's painting *The Dying Seneca* owned by Gustave Arosa, the guardian of Gauguin's sister. The picture was reproduced in the catalogue of

119

Arosa's collection (No. 31). In 1896, that is in the same year he painted the *Queen,* Gauguin made a sketch of the Delacroix canvas in his manuscript of *Noa Noa.* Behind the queen there are peculiar treelike plants reminiscent of either buds or fruits swollen and ready to burst, run to seed or break into blossom. This is how Gauguin explained his principle of representation in answer to August Strindberg's criticism of this picture: "This world which perhaps neither Cuvier nor a botanist would be able to recognize, could be a Paradise only I could have sketched" (Malingue, p. 263). These plants cannot be identified with any actually existing plants, either European or tropical, for they are attributes of Gauguin's 'Paradise'. For the first time they appear in *Exotic Eve* (W. 389). They also occur in *Ruperupe (Gathering Fruit),* in *Faa Iheibe (Preparations for a Feast,* W. 569) and in two Hermitage canvases. The composition of the *Queen* and its symbols of 'Paradise lost' were conceived by Gauguin before his arrival to Tahiti, while still in France. The Ny Carlsberg Glyptothek, Copenhagen, has a wooden relief, *Nude with a Fan,* produced by Gauguin in 1890, which almost exactly repeats the pose of the woman in the Moscow picture. That native Eve is lying under the big tree, the pivot of the whole composition; seen in the distance is the head of a barbaric devil. The title *Te Arii Vahine* is also translated as *Woman with Mangoes, The Queen of Beauty* or *Woman of the Royal Race.*

There is a variant of the Moscow painting also entitled *Te Arii Vahine* or *Woman with Mangoes* (W. 543), and a watercolour on the same subject (Rewald 1958, No. 100). The 'queen' is depicted in the same pose in a pen drawing on page 121 in the manuscript of *Avant et Après* (Rewald 1958, No. 99, in reverse), in a woodcut (Guérin, No. 62, in reverse), in a cover for the review *Le Sourire* (Guérin, No. 80, in reverse) and in the large monotype *The Spirit Watching* (Field, Monotypes, Nos. 60, 66, in reverse). In the monotype, the fan over the *vahine's* head is replaced by a mask of the devil. Gauguin pasted an impression of the woodcut *Te Arii Vahine* into his copy of *Noa Noa.* The female figure in the left distance, picking a fruit, can be seen in a number of Gauguin's paintings, e.g. *Barbaric Tales* (W. 459) and *A Group with the Angel* (W. 622).

Woman with Mangoes.
(Rewald 1958, No. 100).

L. Cranach.
The Sleeping Nymph.

Provenance: 1903-1906, G. Fayet Gallery, Paris; Hotel Drouot (?), Paris; 1910, S. Shchukin collection, Moscow (bought from Fayet for 30,000 francs); 1918, First Museum of Modern Western Painting, Moscow; 1923, Museum of Modern Western Art, Moscow; since 1948, The Pushkin Museum of Fine Arts, Moscow.

120

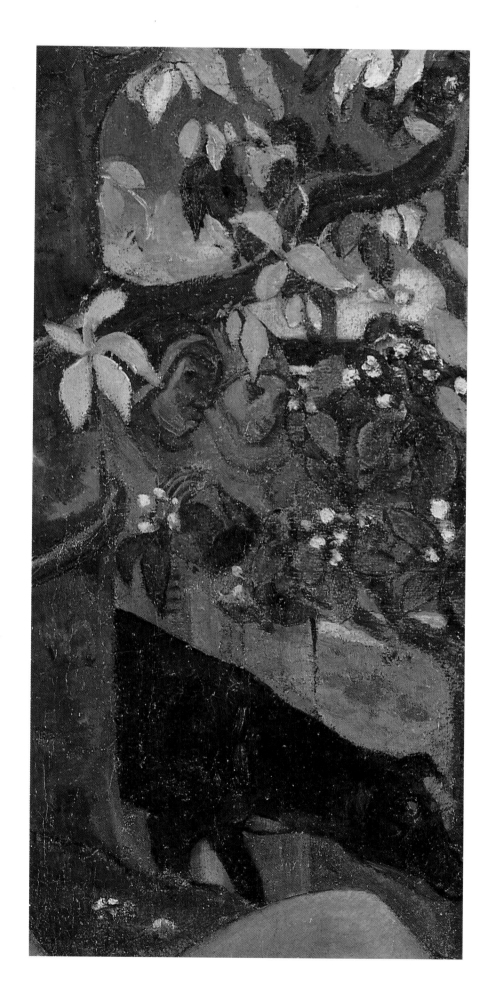

The Queen, or *The King's Wife* (detail).
The Pushkin Museum of Fine Arts,
Moscow.

14. BÉ BÉ
THE NATIVITY

1896.
Oil on canvas. 66 x 75 cm.
Inscribed, signed and dated, bottom left: *Bé Bé Paul Gauguin 96.*
The Hermitage, St. Petersburg. Inv. No. 6568. W. 540.

The title *Bé Bé,* inscribed by Gauguin on the front side of the canvas, is one of the few French words assimilated by the Tahitian language, meaning 'a baby'. According to Bouge, the word has an onomatopoetic origin, being an imitation of the cow's moo. Danielsson and Cachin state that the Hermitage painting, like the thematically similar *Te Tamari no Atua (The Birth of Christ, Son of God,* W. 541) from the Bayerische Staatsgemäldesammlungen, Munich, is connected with a real event in Gauguin's life: on December, 1, 1896 his second Tahitian wife, Pahura, bore him a child. But to a much greater extent these two paintings, treating the Tahitian version of the evangelical legend of the Nativity of Christ, reflect Gauguin's thoughts on the affinity of Christian and oriental myths, including the Maori ones. These ideas, supported by numerous examples, were expounded by him in 1897 in his book *L'Esprit moderne et le Catholicisme* (The Modern Spirit and Catholicism). Both paintings, executed in 1896, are closely related in subject and in the use of motifs. Thus, the entire right-hand part of the Hermitage picture — a group of a woman with the child and an angel — is reproduced in the Munich canvas, but shifted to the left background to become a mere episode accompany-

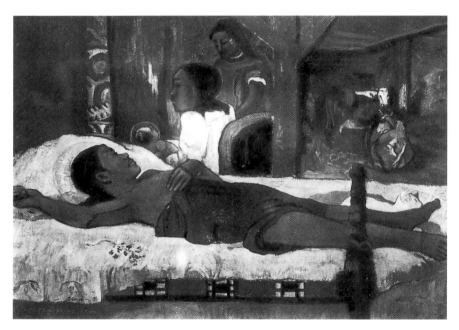

Te tamari no atua.
(The Birth of Christ).
(W. 541).

ing the main scene. The manger also occurs in both paintings, but in *Te Tamari no Atua* it is treated quite realistically, and the figure of the Virgin with the warm glow of light around it is absent. The only feature common to both representations of the manger is the lying cow. Field, however, believes that Gauguin copied both motifs from a photograph of Tassaert's *Inside the Manger* (Field, p. 143). This is true as far as the Munich canvas is concerned. It is interest-

122

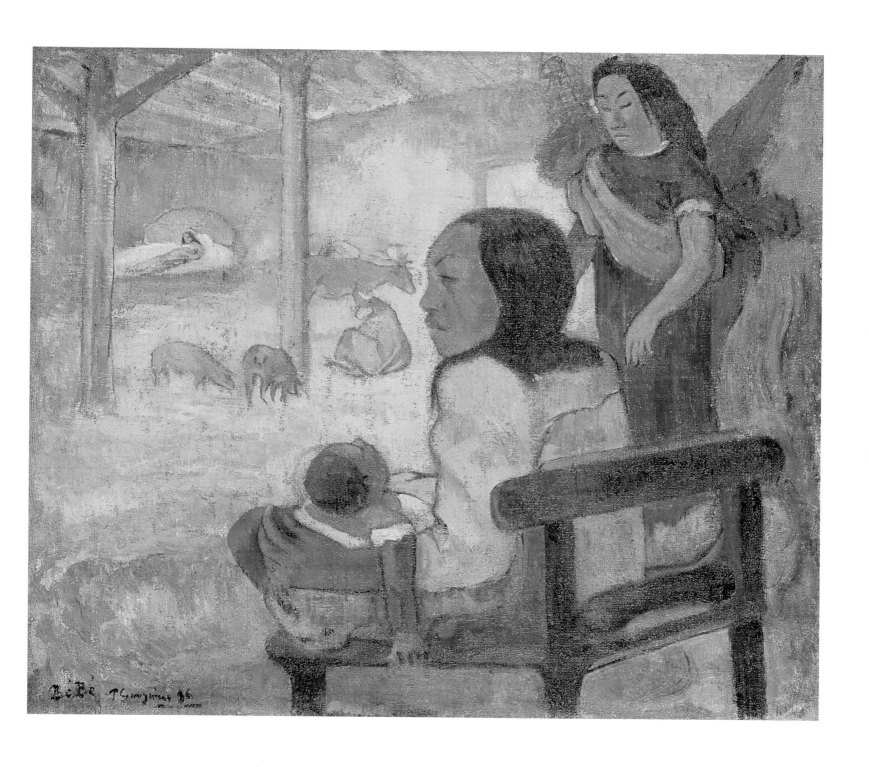

Bé Bé.
The Nativity.
The Hermitage, St. Petersburg.

ing that the silhouette of the ox standing on the right in the Hermitage painting was borrowed by Gauguin from his Breton 1894 picture entitled *The Holy Night* (W. 519) and brought by him to Tahiti in 1895. There is a group of woodcuts indirectly related to *Bé Bé,* in which one can easily trace his idea of the fusion of Christian and oriental religious beliefs. Thus, the woodcut on a Tahitian subject, *Te Atua (The Gods.* Guérin, No. 61) is based on a Lamentation scene from the woodcut *The Breton Calvary* (Guérin, No. 68), in which the ox is identical to that in *Bé Bé.* In 1901 and 1902, Gauguin executed several monotypes with figures of cows and pigs, some of which are borrowed from *Bé Bé* (Field, Monotypes, Nos. 76-78, 80). These representations were probably connected with the concept of another Nativity scene, for which in 1902 Gauguin painted a small multi-figure canvas, *The Nativity* (W. 621), where the story unfolds in a series of successive narrative episodes.

The Nativity (detail).
The Hermitage, St. Petersburg.

Provenance: A. Vollard Gallery, Paris; until 1918, S. Shchukin collection, Moscow; 1918, First Museum of Modern Western Painting, Moscow; 1923, Museum of Modern Western Art, Moscow; since 1931, The Hermitage, St. Petersburg.

The Holy Night.
(W. 519).

Lying Cow and Pigs.
(Field, Monotypes, No. 80).

Cows. Studies.
(Field, Monotypes, No. 77)

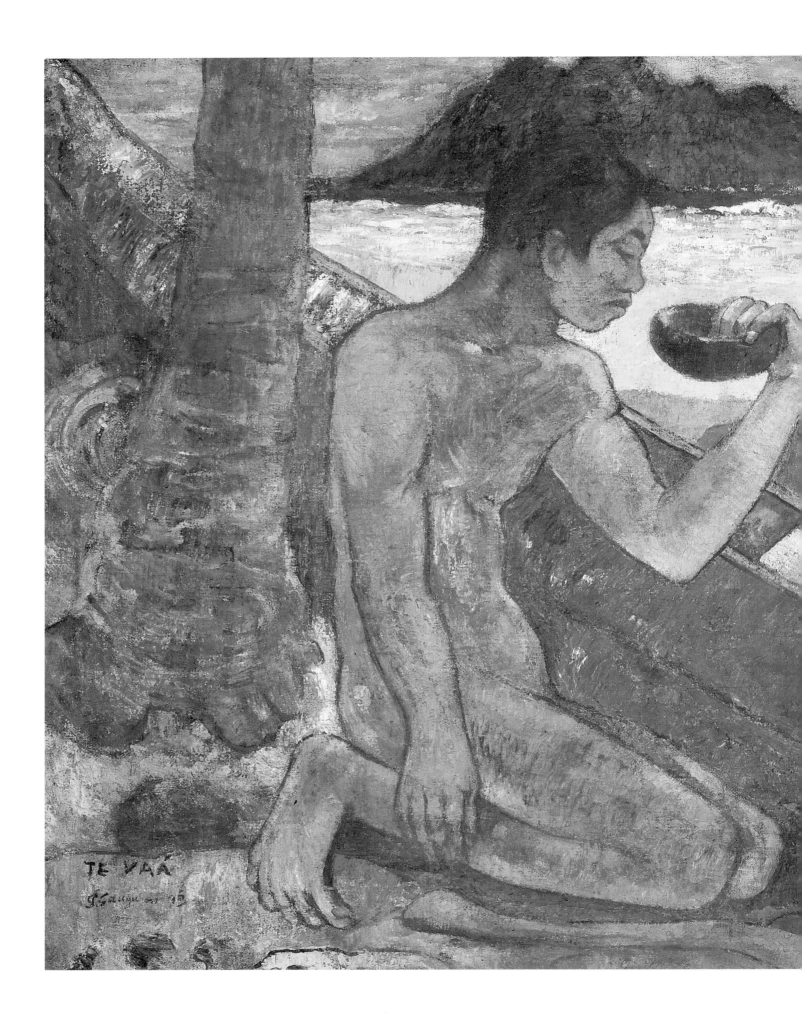

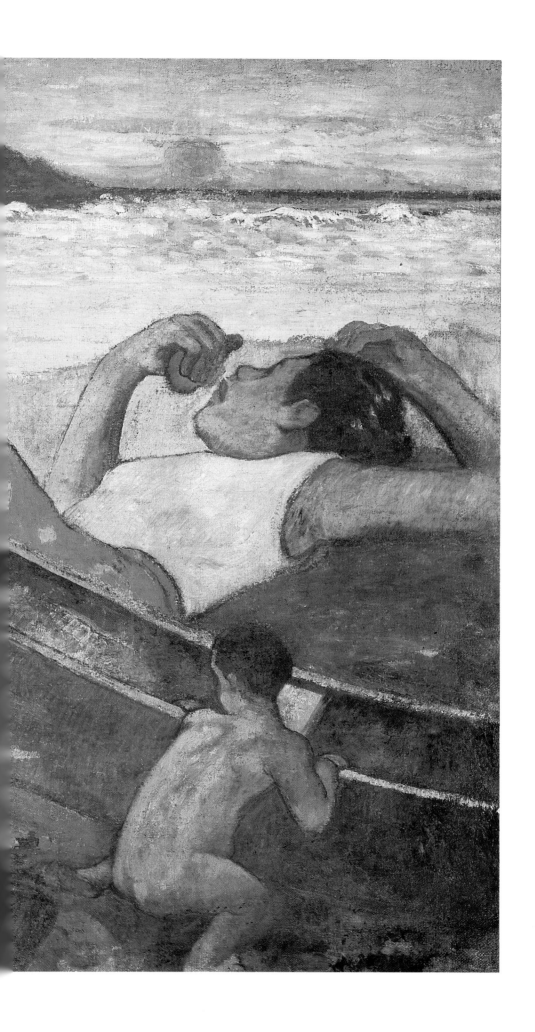

Te vaa.
The Canoe, or A Tahitian Family.
The Hermitage, St. Petersburg

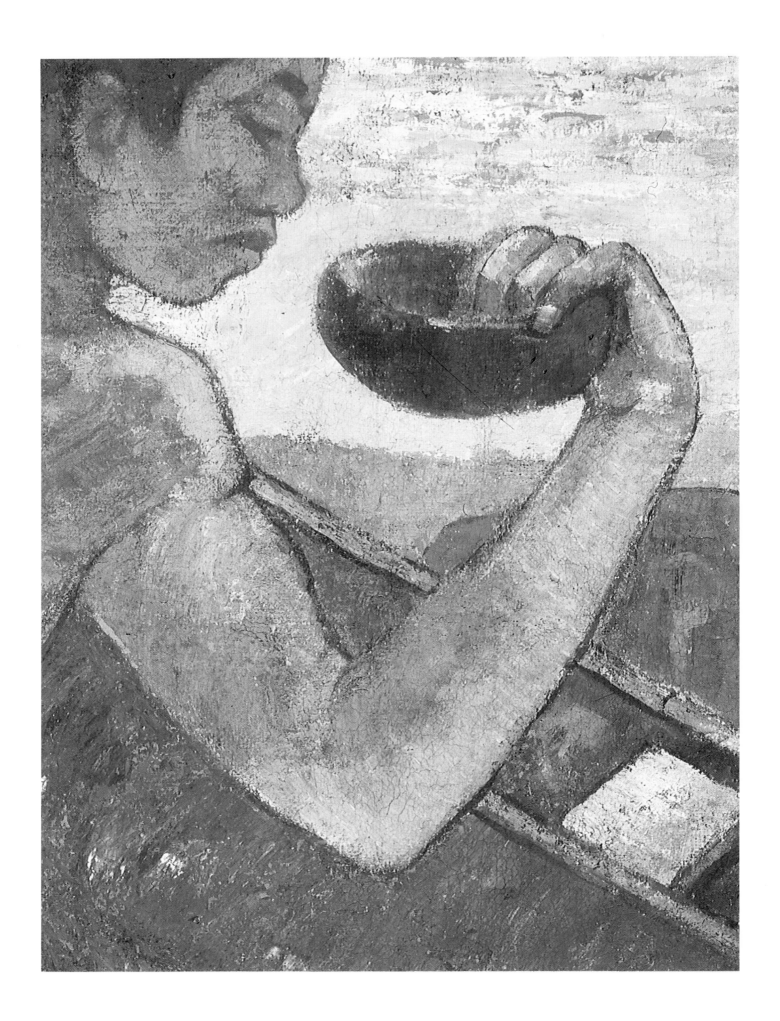

15. *TE VAA*
THE CANOE, OR A TAHITIAN FAMILY

1896.
Oil on canvas. 96 x 130.5 cm.
Inscribed, signed and dated, bottom left: *Te vaa P. Gauguin 96.*
The Hermitage, St. Petersburg. Inv. No. 9122. W. 544.

The Tahitian words *te vaa* on the front side of the canvas are trans-
lated as 'pirogue' or 'canoe'. In the 1917 catalogue of the Tretyakov
Gallery the painting was listed as *A Tahitian Family*, probably in
conformity with the suggestion of M. Morozova, who donated it to
the gallery. Under this title the picture later entered the Museum of
Modern Western Art and then the Hermitage. To avoid confusion
with Gauguin's 1902 picture known as *A Tahitian Family* (W. 618),
the present canvas has two titles.

The motif of a Tahitian fisherman's family on the seashore, as a
theme for a large composition, attracted Gauguin during his first
stay in Tahiti *(Man with an Axe*, 1891, W. 430). In 1896, he pro-
duced two variations on the theme: *The Canoe* (Hermitage) and *Poor
Fisherman* (São Paulo Museu de Arte, W. 545). The representations
of the fisherman and the canoe are identical in these two pictures,
but the landscape settings are different. Moreover, the figures of the
woman and child are absent in the São Paulo version. The title *Poor
Fisherman*, rather unusual for Gauguin, might have been given in
answer to the challenge from August Strindberg who, in a letter of
1895, expressed his admiration for Puvis de Chavannes's painting
of the same name. The painting was then at the Musée de Luxem-
bourg, Paris, and was well known to the Symbolist artists. Judging
by its smaller size (76 x 66 cm) and incomplete elaboration of the
theme, the São Paulo canvas may have been the first version of the
Hermitage composition. Later Gauguin rejected the original title as
incompatible with his understanding of Tahitian life.

The fisherman sitting by his canoe in a slightly different posture (the
right hand raised over his head, and the gesture more dynamic) was
repeated in a woodcut (Guérin, Nos. 45, 46). An impression of it,
touched up with watercolour, Gauguin glued to the Louvre manu-
script of *Noa Noa* (p. 75). On page 124 of the same manuscript
there is a watercolour with a woman, whose reclining attitude is
identical to that of the woman in the *Canoe* (Field, Monotypes,
No. 125). The silhouette of a mountain in the background recurs in
Landscape (W. 546) and in a watercolour on page 175 of the
manuscript of *Noa Noa*.

The Canoe, or A Tahitian Family (detail).
The Hermitage, St. Petersburg.

Provenance: M. Morozov collection, Moscow; 1903, Morozova collection, Moscow;
1910, Tretyakov Gallery, Moscow (gift of M. Morozova); 1925, Museum of Modern
Western Art, Moscow; since 1948, The Hermitage, St. Petersburg.

129

16. SCENE FROM TAHITIAN LIFE

1896.
Oil on canvas. 89 x 125 cm.
Partly obliterated signature, bottom right: *P. Gauguin*. The date, *96*, is not traceable now, but must have been visible when the canvas was catalogued at the First Museum of Modern Western Painting in 1918.
The Hermitage, St. Petersburg. Inv. No. 6517. W. 537.

The painting is thematically related to a group of works on the harvest theme such as *Nave Nave Mahana (Delightful Day,* 1896, W. 548), *Man Picking Fruit from a Tree* and *Ruperupe (Gathering Fruit).* A group of people setting out to gather in the harvest is perceived as a triumphal procession, headed by a man with a stick on his shoulder, and a horseman bringing up the rear. The figure of the man resolutely striding forward first appears in this painting and occurs repeatedly in a number of Gauguin's graphic works, for example, in a woodcut on folio 180 of the Louvre manuscript of *Noa Noa* (Guérin, No. 64), in which the man is depicted in reverse, with a cluster of bananas on his stick; in a brown ink and pencil drawing (Rewald 1958, No. 125); in the monotypes *Return from the Hunt* (Field, Monotypes, Nos. 49 and 96) and *Adam and Eve* (Field, Monotypes, No. 105); and in a reversed monotype on page 153 of the manuscript of *Avant et Après* (Field, Monotypes, No. 107). According to S. Wagstaff and Gray (Ch. Gray, *Sculpture and Ceramics of Paul Gauguin,* Baltimore, 1968, No. 127), this image was borrowed from the figure of a warrior in the relief of Trajan's Column, a photolithograph of which Gauguin had with him in Tahiti. Possibly, the recurrence of this figure in scenes of labour and hunting is connected with Gauguin's ideas of the original sin and expulsion from the Garden of Eden. This assumption, if correct, explains the inclusion of the same image in the monotype *Adam and Eve.* This motif links the Hermitage painting with Gauguin's large symbolic panel of 1897, *Where Do We Come From ? What Are We ? Where Are We Going?* (W. 561). The woman with the raised arm, showing the way to the other participants in the procession, is derived from the Parthenon frieze whose photograph Gauguin possessed (Dorival 1951, pp.118-122). This figure reappears in a monotype on page 165 of the Leipzig manuscript of *Avant et Après* (Field, Monotypes, No. 112) and, in reverse, in *L'Appel (The Call,* 1902, W. 612; Field, Monotypes, No. 101).

Provenance: 1910, S. Shchukin collection, Moscow; 1918, First Museum of Modern Western Painting, Moscow; 1923, Museum of Modern Western Art, Moscow; since 1930, The Hermitage, St. Petersburg.

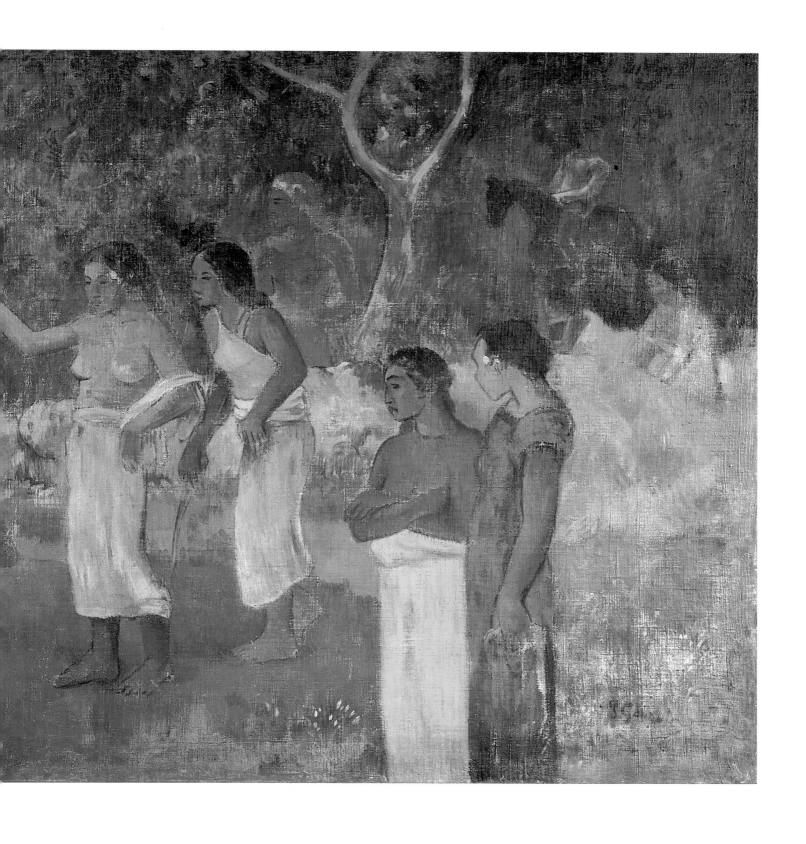

Scene from Tahitian Life.
The Hermitage, St. Petersburg.

Eiaha Ohipa.
Tahitians in a Room.
The Pushkin Museum of Fine Arts,
Moscow.

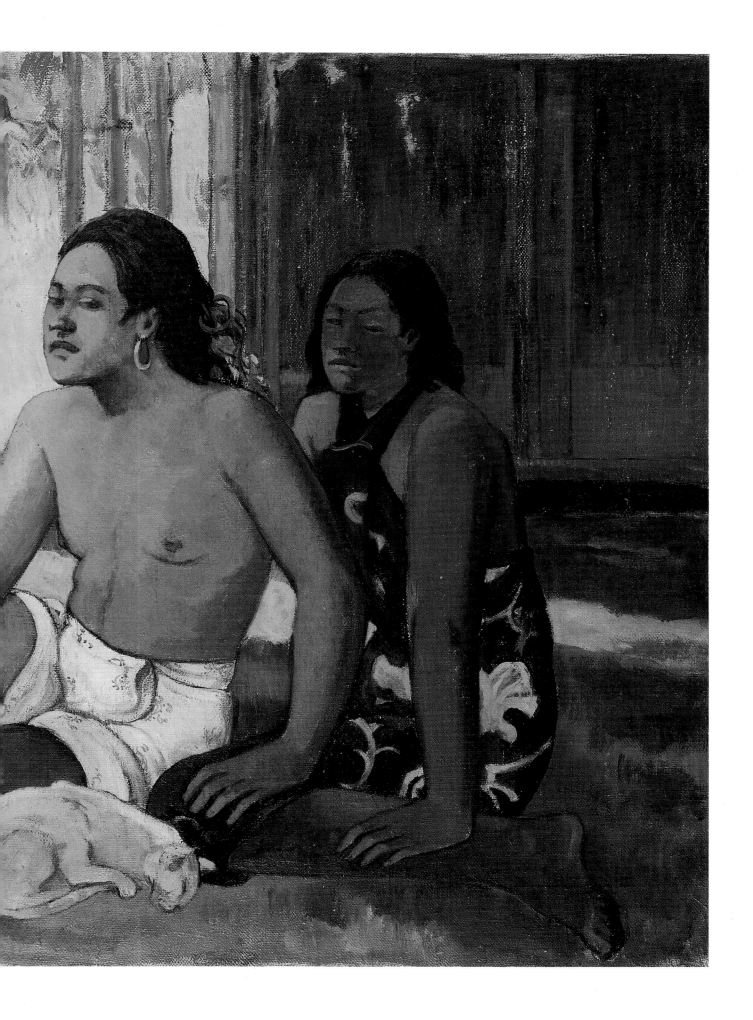

Tahitians in a Room (detail).
The Pushkin Museum of Fine Arts,
Moscow.

17. *EIAHA OHIPA*
TAHITIANS IN A ROOM

1896.
Oil on canvas. 65 x 75 cm.
Inscribed, signed and dated, bottom left: *Eiaha ohipa - P. Gauguin 96.*
The Pushkin Museum of Fine Arts, Moscow. Inv. No. 3267. W. 538.
(as owned by the Hermitage).

The picture was painted during Gauguin's second Tahitian period. The inscription was translated in different ways — as 'Do not do it', 'Do not work' or 'Do not smoke'. The second version seems to be the most reliable, as implying bliss or tranquillity in a certain sacral sense. Cooper suggested another title, *They Do Nothing* (Cooper, p. 576). The figure on the left appears in *Aha oe Feii? (What! Are You Jealous?)*, while the poses of other Tahitians are repeated in *And the Gold of Their Bodies* (W. 596) and prints and monotypes (Field, Monotypes, No. 138; Guérin, No. 59). All these figures were apparently inspired by the frieze of the Buddhist temple of Borobudur, whose photographs Gauguin took with him to Tahiti. The golden yellow tinge in the landscape of this picture was to become one of Gauguin's favourite colours during his second Tahitian period. A juxtaposition of the enclosed world of an interior with the boundless expanse of nature visible through the open door in the background is used in *Te Rerioa (Rêverie,* W. 557), painted in 1897 at Punaauia, and in *Two Women* (W. 626). The bare tree trunks, a scrawny dog and a native in hat, seen in the background, strongly recall the landscape in the well-known painting *Te Faaturuma (The Brooding Woman,* W. 440). In fact, the message of the Moscow composition is the same as that of *Te Faaturuma* — the call to contemplation. Such reiteration of the same motifs was in general very characteristic of Gauguin's works produced during the two Tahitian periods.

Bas-relief of the Buddhist temple of Borobudur (detail).

Provenance: until 1906, A. Vollard Gallery, Paris; after 1906, S. Shchukin collection, Moscow; 1918, First Museum of Modern Western Painting, Moscow; 1923, Museum of Modern Western Art, Moscow; since 1948, The Pushkin Museum of Fine Arts, Moscow.

135

18. *MAN PICKING FRUIT FROM A TREE*

1897.
Oil on canvas. 92 x 72 cm.
Signed and dated, bottom left: *P. Gauguin 97.*
The Hermitage, St. Petersburg. Inv. No. 9118. W. 565.

In the list of works sent by Gauguin to Vollard in Paris on December 9, 1898, a canvas was registered as No. 7 under the title *Man Picking Fruit from a Tree in a Yellow Landscape with Two White Goats* (Monfreid, pp. 137, 211), which, undoubtedly, was the 1897 painting now in the Hermitage collection. The picture belongs to a group of works related to Gauguin's large allegorical panel *Where Do We Come From? What Are We? Where Are We Going?* (Museum of Fine Arts, Boston; W. 561). This link is borne out by a certain similarity between the Tahitian man with raised arms in the Hermitage canvas and the naked youth depicted in reverse at the centre of the Boston panel and also in a study for it (W. 560). In a letter to Charles Morice Gauguin explained the message conveyed by the central figure of his testamentary picture: "...What are we? Day-to-day existence. The man of instinct wonders what all this means?" (Malingue, p. 301). in other words, the artist shows a man on the verge of rejecting the thoughtless enjoyments of existence, extending his hand to the Tree of the Knowledge of Good and Evil. This figure seems to have been haunting the artist's fancy. It appears in a large preliminary drawing for *Where Do We Come From?* (Musée d'Art Moderne, Paris) and in the final version of this subject (done in 1903, this time with a female figure), introduced into the picture (W. 635). The same man's figure occurs in a xylograph for the title-page of Gauguin's review *Le Sourire* and pasted into page 186 of the Louvre manuscript of *Noa Noa* (Field, Monotypes, No. 73) and in a sketch of *Where Do We Come From?* in Gauguin's letter to Monfreid (Monfreid, pl. 8, p. 128). This figure derives from a drawing of a male model by an artist of Rembrandt's circle. The connection between Gauguin's recurrent image and the image created in the seventeenth century is the subject of Field's article *Gauguin: Plagiarist or Creator?* (Field, p. 162). The Hermitage painting is also related to the cycle of harvest scenes, such as *Nave Nave Mahana (Delightful Day,* 1896, W. 548), *Scene from Tahitian Life, Faa Iheihe (Preparations for a Feast,* 1898, W.569) and *Ruperupe (Gathering Fruit).*

In his book *Gauguin in the South Seas,* Bengt Danielsson gave the following, completely unjustified characteristics of the Hermitage painting: "The date is illegible... The brushwork is crude and the colours are dull..." In actual fact, the date put by the artist is perfectly readable, the exquisite colour scale is built upon exceptionally delicate shades of pale yellow, green and violet, and the refined drawing is done with amazing spontaneity. Recently the painting has undergone a thorough restoration, as its condition was rather poor: seeking to achieve a fresco-like quality of the painted surface, Gauguin made use of the coarse, thick-grained canvas almost without priming.

Provenance: 1898, Sent from Tahiti to Vollard in Paris for sale on December 9 (apparently sold shortly thereafter, as it did not appear in the 1903 exhibition of Gauguin's works at the A. Vollard Gallery); S. Shchukin collection, Moscow; 1918, First Museum of Modern Western Painting, Moscow; 1923, Museum of Modern Western Art, Moscow; since 1948, The Hermitage, St. Petersburg.

Man Picking Fruit from a Tree.
The Hermitage, St. Petersburg.

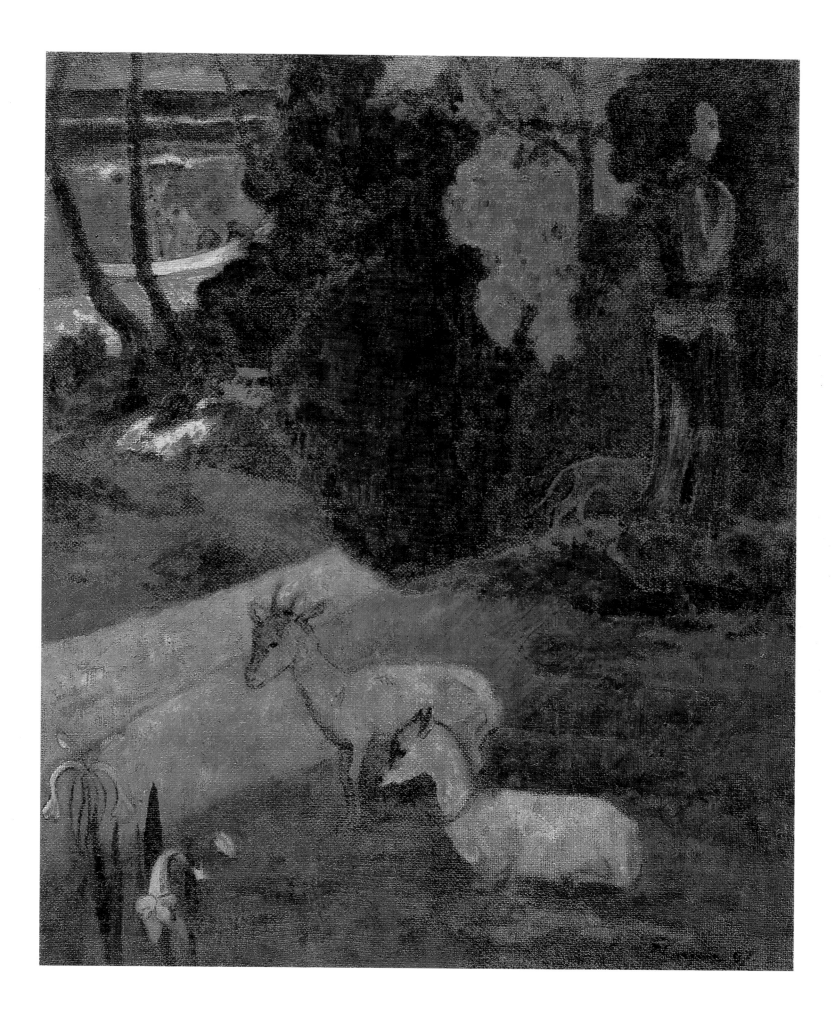

20. *RAVE TE HITI AAMU*
THE IDOL

1898.
Oil on canvas. 73 x 91 cm.
Signed, dated and inscribed, bottom left: *P. Gauguin 98 Rave te hiti aamu.*
The Hermitage, St. Petersburg. Inv. No. 9121. W. 570.

Both in the Hermitage and, before that, in the Museum of Modern Western Art the painting was registered as *The Idol.* In art literature it is usually mentioned as a representation of the Marquesan God Tiki or Takai. However, the subject of this Hermitage canvas looks different from either Tiki or other deities whose wooden or stone effigies are often seen in Gauguin's Tahitian paintings. This monstrous idol with a deadly immobile face and a woman's body is iconographically connected with another image present in many works of the artist's late period. In 1894-1895, during his stay in Paris after the first trip to Tahiti, Gauguin produced a large ceramic sculpture, on the base of which he inscribed the word *Oviri* (Savage). The sculpture depicts a nude female with a mass of hair at the back of her otherwise bald head, clasping a small animal to her breast. Apparently at the same time, the artist portrayed the same image in two monotypes (Field, Monotypes, Nos. 30, 31) and two woodcuts (Guérin, Nos. 48, 49). On the cardboard with two impressions of a woodcut (Guérin, No. 48) is a dedicatory inscription in the artist's hand: *à Stephane Mallarmé cette étrange figure cruelle énigme P Gauguin 1895.*

In April 1897, in a letter to Vollard from Tahiti Gauguin referred to this sculpture as *Murderess* (J. Rewald, "The Genius and the Dealer", *Art News,* 1959, May, p. 64). Later, in 1898, the artist reproduced this image in the picture now in the Hermitage. The inscription on the canvas, incorrectly translated by Bouge as 'the presence of evil spirit', misled art historians and made them think of Tiki and Tupapau, gods who guarded the spirits of the dead. Danielsson, in his turn, offered a more accurate version of translation which conveyed the exact meaning of the Tahitian words *(rave* means 'to seize', *te hiti,* 'monster', and *aamu,* 'glutton'), but failed to clarify the sense of the inscription as a whole. He evidently had not compared the Tahitian title with another inscription accompanying the drawing *Oviri* made by Gauguin in 1899 for his review *Le Sourire* (Louvre, Cabinet des Dessins; Guérin, p. 27): *Et le monstre étreignant sa créature féconde de sa semence les flancs généreux pour engendrer Seraphitus Seraphita.* The symbolism of *Oviri* was discussed by Ch. Gray, M. Bodelsen and B. Landy. According to Gray, Gauguin used for the idol's head the mummy of a Polynesian tribal chief who had died to become a deity. Landy points out that the figure in the posture of Oviri first appeared in 1892 in the Munich version of *Where Are You Going?* (W. 478) and that this posture might go back to the Javanese stone image of a female deity in the Art Museum, Jakarta, or a similar Tahitian sculpture. Bodelsen has traced the origin of the name Seraphita in a Balzac novel in which the main heroine is treated as a creature uniting the characteristics of both sexes (M. Bodelsen, *Gauguin's Ceramics. A Study in the Development of His Art,* London, 1964, p. 149).

140

Rave te hiti aamu.
The Idol.
The Hermitage, St. Petersburg.

Oviri.
(stoneware).

The Idol (detail).
The Hermitage, St. Petersburg.

On the basis of this information, added to Gauguin's own statements in *Noa Noa* and in his letters (Malingue, pp. 138, 262-264), Landy arrives at a fairly convincing interpretation of the Oviri image as a symbolic expression of the simultaneous destruction and revival of the artist's personality. Gauguin repeatedly called himself 'a savage' *(Oviri)*, implying his desire to get assimilated with the people living in blissful ignorance of the vices, perversions and acute contradictions of the civilized world. He hoped to merge into the Maori world, to purge his soul and to achieve harmony and spontaneity of expression both in his life and in his art by consciously destroying his European ego. The inscription on the 1895 Louvre drawing of Oviri and the Tahitian title of the Hermitage painting reveal the essence of this image. This is the monster that brings destruction, death and, at the same time, gives birth to Seraphitus (masculine gender) and Seraphita (feminine gender), that is, a supreme harmonious creature immune to contradictions disrupting the world.

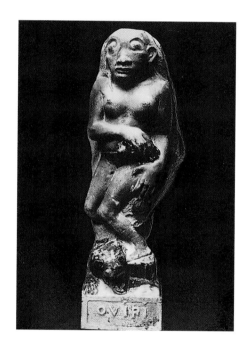

Towards the end of his life, Gauguin, like many people of his generation, constantly meditated on the loss of harmony in the contemporary world and the life of mankind before the Fall. He conveyed his ideas through enigmatic allegorical images in which his own symbolism intertwined with myths and legends of the non-European peoples.

These symbols and ideas inspired, among other things, the composition reproduced here. Gauguin attached special importance to the notion 'oviri', as is testified by his self-portrait in relief where this word is inscribed above the artist's profile or by the fact that in a letter to Daniel de Monfreid (Monfreid, p.165) he asked his friend to send him from Paris the ceramic sculpture *Oviri* which was to decorate his garden and, after his death, his grave.

The Hermitage picture was first mentioned as *The Idol* by Yakov Tugendhold in his 1914 article describing Sergei Shchukin's collection. Before that, in the lot of works sent by Gauguin in 1898 to Ambroise Vollard in Paris, the painting was listed under the title Gauguin inscribed on the canvas: *Rave te hiti aamu*. In the first comprehensive monograph on Gauguin, written by J. Rotonchamp, its prototype — the ceramic sculpture discussed above was called A *Maori Woman* (J. de Rotonchamp, *Paul Gauguin. 1848-1903*, Weimar/Paris, 1906, p. 136). In the 1913 catalogue of the Shchukin collection, where the painting was mentioned for the first time in Russia, it was entitled *Seated Nude Woman*.

Provenance: 1898, Sent from Tahiti to Vollard in Paris for sale on December 9; A. Vollard Gallery, Paris; S. Shchukin collection, Moscow; 1918, First Museum of Modern Western Painting, Moscow; 1923, Museum of Modern Western Art, Moscow; since 1948, The Hermitage, St. Petersburg.

21. *MATERNITY (WOMEN ON THE SEASHORE)*

1899.
Oil on canvas (relined). 94 x 72 cm.
Signed and dated, bottom right: P. Gauguin 99.
The Hermitage, St. Petersburg. Inv. No. 8979. W. 581.

The painting was shown under the title *Women on the Seashore* at the exhibition of Gauguin's works at the Vollard Gallery in Paris in 1903, and was likewise listed in the 1913 catalogue of the S. Shchukin collection, in the 1928 catalogue of the Museum of Modern Western Art, Moscow, and in the 1958 catalogue of the Hermitage collections. Yet, the posthumous auction of Gauguin's works held in Papeete in 1903 included a painting entitled *Maternité* (W. 582), which was almost identical to the Hermitage canvas. That was the reason why the Hermitage canvas received a second title which, incidentally, seems to be more in tune with its message. Danielsson links the subject of the picture to the birth in 1899 of Emile Gauguin, the artist's son by Pahura. The motif of maternity, however, underlies Gauguin's entire work of the Polynesian period from his first year in Oceania up to 1902. The Hermitage picture, like its version, belongs to a group of works in which the images of mother and child at times assume religious overtones (W. 428, W. 541, W. 621) and, at others, are treated in a realistic manner (W. 569, W. 573, W. 583, W. 623, W. 624). But even in genre pictures the composition is interpreted as a sacred ritual scene, evoking associations with the classical theme of offering gifts to a king. Hence the special role assigned to the woman standing in the centre with flowers in her hands, seemingly folded in prayer. This image sometimes accompanied by a Tahitian woman with a basket of fruit, recurs in a number of Gauguin's works related to the motif of gift-offering: in a monotype (Field, Monotypes, No. 106), in *Fa Iheihe (Preparations for a Feast,* 1898, W. 569), *Three Tahitians* (1898, W. 573), *Three Tahitian Women against a Yellow Background, Te Avae no Maria (Woman Carrying Flowers,* or *The Month of Mary), Ruperupe (Gathering Fruit), Changing the Place of Residence* (1902, W. 623), *The Offering* (1902, W. 624), in the drawing *Changing the Place of Residence* pasted into the manuscript of *Avant et Après* (p. 173), in several monotypes of the same title (Field, Monotypes, Nos. 58, 95, 116), in the woodcuts *The Rape of Europa* (Guérin, No. 65) and *Changing the Place of Residence* (Guérin, No. 66), and in the title-page of the review *Le Sourire* (Guérin, No. 81) — impressions of these woodcuts were glued to the Louvre manuscript of *Noa Noa* (pp. 184, 186, 189). A little black dog is reproduced in an impression of a woodcut for the cover of *Le Sourire* (Guérin, No. 76).

Provenance: 1903, Sent from Atuona to Vollard in Paris for sale (as No. 8 in the artist's list); A. Vollard Gallery, Paris; S. Shchukin collection, Moscow (apparently bought from Vollard in 1903 or 1904, as it was not exhibited at Gauguin's retrospective show at the 1906 Salon d'Automne); 1918, Museum of Modern Western Painting, Moscow; 1923, Museum of Modern Western Art, Moscow; since 1948, The Hermitage, St. Petersburg.

Maternity (Women on the Seashore).
The Hermitage, St. Petersburg.

Two Women Conversing in a Landscape.
(Field, Monotypes, No. 106).

144

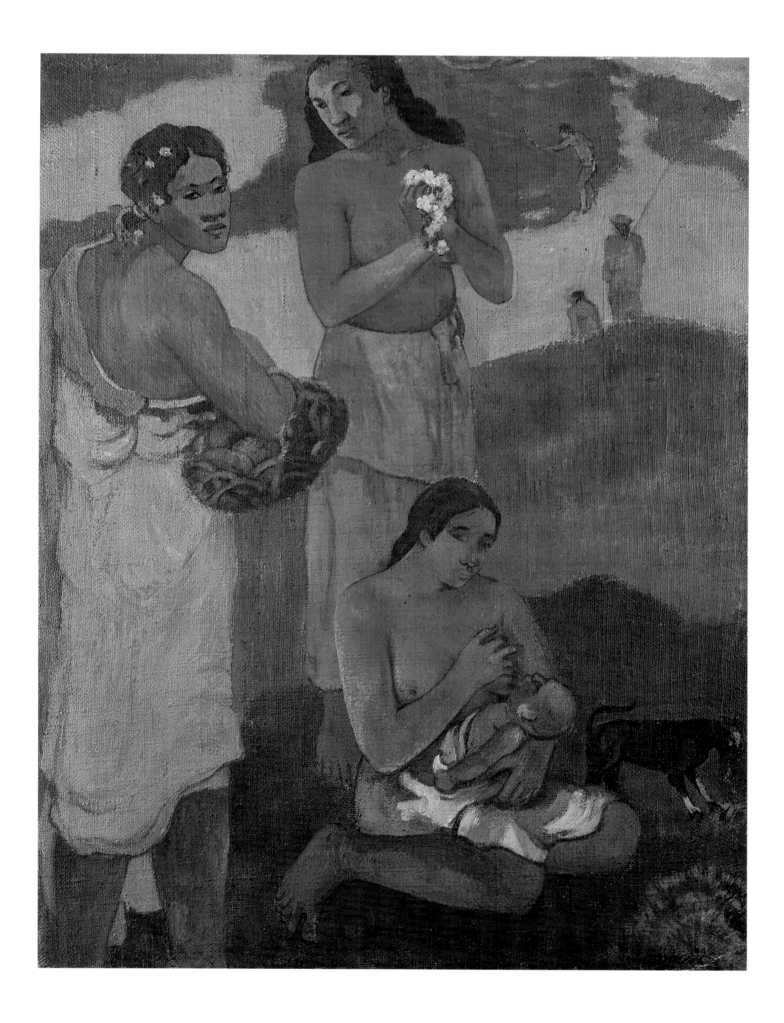

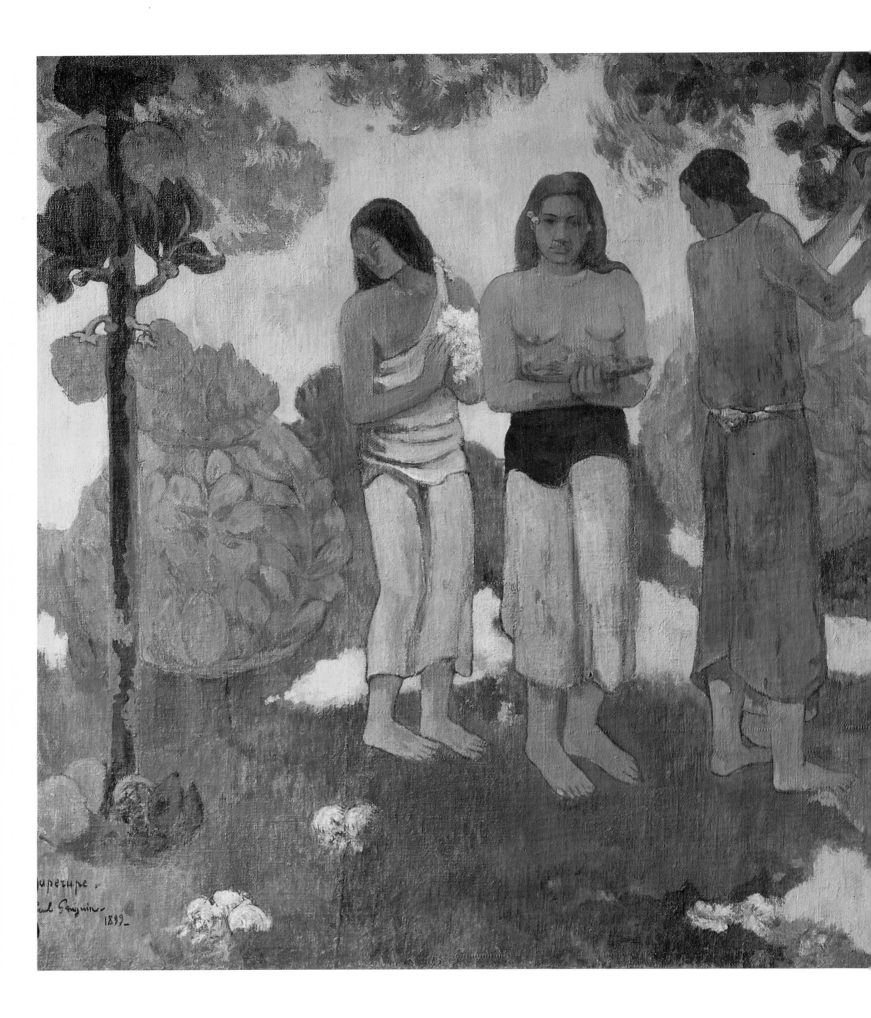

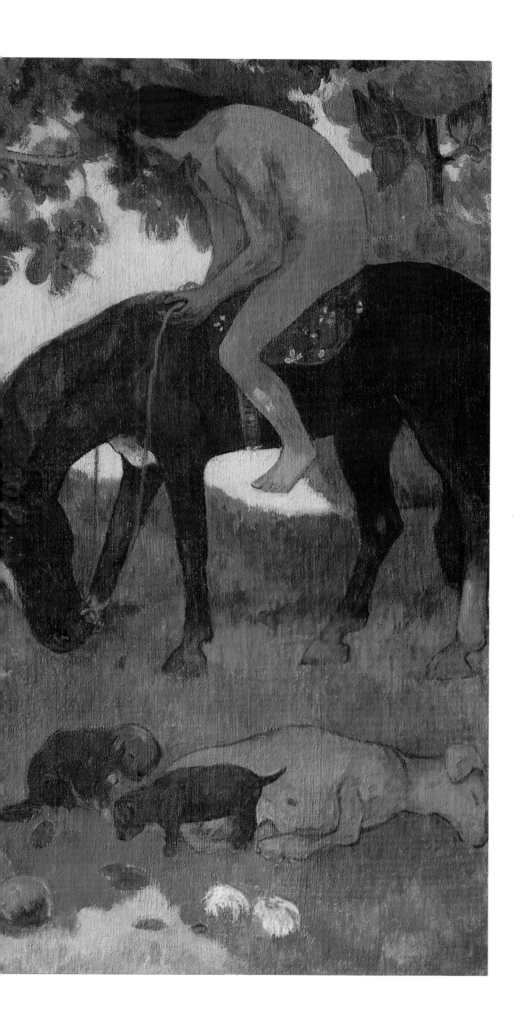

Ruperupe.
Gathering Fruit.
The Pushkin Museum of Fine Arts,
Moscow.

Gathering Fruit (detail).
The Pushkin Museum of Fine Arts,
Moscow.

22. *RUPERUPE*
GATHERING FRUIT

1899.
Oil on canvas. 128 x 190 cm.
Inscribed, bottom left: *Ruperupe*;
signed and dated under the inscription: *Paul Gauguin 1899*.
The Pushkin Museum of Fine Arts, Moscow. Inv. No. 3268. W. 585.
(as owned by the Hermitage).

Together with *Faa Iheihe* (W. 569) and *Where Do We Come From?* (W. 561), this painting belongs among the programmatic works, produced towards the end of Gauguin's life. It manifests all characteristic features of the artist's synthetic style. The yellow background — that foundation of Gauguin's world — is central to both composition and colour scale. The yellow colour creates a gleaming wall behind the figures and suffuses the lower part of the composition, showing through the soil and forming the flowing patches reminiscent of golden clouds or pools of water. Like Gauguin's cloissonist works, the picture is not divided into optically distinct planes. All habitual structural and conceptual relationships seem to be reversed. The puppies in the lower right corner with the fruits scattered around, bring to mind Gauguin's first still life painted at Pont-Aven (W. 293). Rendered by decorative patches of colour, these young animals are perceived as unripe fruits. In this way Gauguin breaks the boundary between animate and inanimate nature, flattening the living creatures and turning them into ornamental patterns. The ornament, in turn, loses its static quality, assuming configurations of a live body. The picture seems to be cut out of a larger composition developing in two directions — rightward, from where the horse comes, and leftward, beyond the slender tree with red fruit. In other words, it looks like a fragment of a large frieze, which enhances its monumental and decorative effect.

The two female figures in the left-hand part of the canvas, one of which is a replica of Mary from the Hermitage picture, appear like saints on icons, standing out against the golden background in a conventional, paradise-like landscape. They are portrayed in poses modelled on the postures of Buddhist monks in the friezes of the Buddhist temple of Borobudur, photographs at which, taken at the World Fair of 1889 in Paris, Gauguin brought with him to Tahiti. The left-hand part of the Moscow picture is identical to that of *Faa Iheihe* in the Tate Gallery, London (W. 569). The tempter in the centre is also a borrowing from the London painting, but the scene of Eve's temptation is absent. The man in a long *pareo is* picking a fruit, looking at the two women on the left. In contrast to these, he and the horse are creatures of flesh and blood, not 'saints'.

The right-hand part of the Moscow painting (with a horse, a rider and puppies) symbolizes the Earth on which birth and death triumph by turns, and also repeats the corresponding part of *Faa Iheihe*. As in other pictures by Gauguin, the horse personifies death. The left-hand part is an allegory of the Garden of Eden before the Fall. On the whole, the painting, like *Where Do We Come From?* and *Faa Iheihe* symbolizes the history and destiny of the human race. But

149

this profoundly allegorical picture reveals still another aspect, which is devoid of any philosophic implication.

Bengt Danielsson states that the word *Ruperupe* written by Gauguin on the canvas should not be translated as 'gathering fruit' or 'luxuriant vegetation'. He established that this is the beginning of a song, *O Ruperupe Tahiti* ('Oh, Tahiti the blessed land'), which was popular among the colonists and native residents in Gauguin's lifetime. The artist painted *Ruperupe* during one of his recurrent crises which eventually ended in his decision to move to the Marquesas. The world of Tahiti as a source of inspiration, as a 'promised land', had already waned for him. In this context *Ruperupe is* a kind of picture postcard inviting to visit the delectable islands and, at the same time, an expression of the artist's bitter irony.

In April 1903, shortly before his death, Gauguin sent *Ruperupe,* along with several other pictures, to Daniel de Monfreid in Paris. Monfreid

Gathering Fruit (detail). The Pushkin Museum of Fine Arts, Moscow.

wrote him a letter, mentioning Fayet's offer of 1,100 francs for the canvas — a fairly small sum in those days. The letter remained unanswered... For his manuscript of *Avant et Après* Gauguin did two drawings from this painting, *On the Way to the Feast* and *Changing the Place of Residence*. An impression from the woodcut *Changing the Place of Residence* was pasted into the manuscript of *Noa Noa* (Guérin, No.66). One of the covers of *Le Sourire* presents the extreme left female from *Ruperupe* (Guérin, No. 81). It also appears in two versions of the *Maternity* (W. 581, pl. 50; W. 582). Two other figures also repeatedly occur in Gauguin's works, e.g. *Two Tahitian Women with Red Flowers* (W. 583), *Nave Nave Mahana* (Delightful Day, W. 548), *The Great Buddha, Changing the Place of Residence* (W. 623), a monotype (Field, Monotypes, No. 109) and an engraving *(Noa Noa).*

Provenance: 1903, Sent from Atuona to G. Fayet in Paris; G. Fayet collection, Paris; S. Shchukin collection, Moscow; 1918, First Museum of Modern Western Painting, Moscow; 1923, Museum of Modern Western Art, Moscow; since 1948, The Pushkin Museum of Fine Arts, Moscow.

Faa Iheihe (Preparations for a Feast).
(W. 569).

The White Horse.
(W. 571).

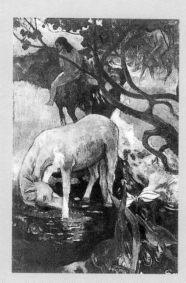

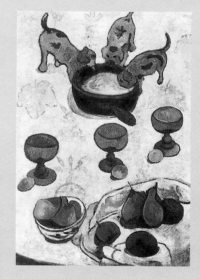

Three Little Dogs.
(W. 393).

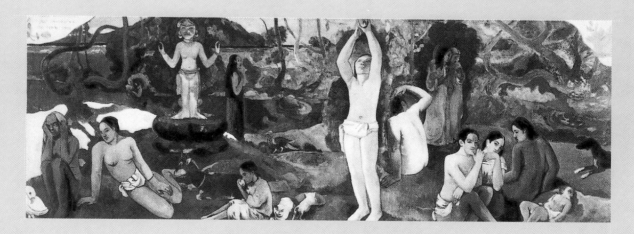

Where Do We Come From? What Are We? Where Are We Going?
(W. 561).

23. THE GREAT BUDDHA (THE IDOL)

1899.
Oil on canvas. 134 x 95 cm.
Signed and dated, bottom left: *P. Gauguin 99.*
The Pushkin Museum of Fine Arts, Moscow. Inv. No. 3368. W. 579.

Placed on a pedestal at the centre is the dark statue of the idol, its front decorated with two carved figurines of Tahitian deities facing each other. Such a representation was typical of traditional Tahitian reliefs depicting the dialogue between Hina and Tefatou about the destiny of mankind doomed to death. It is probable that Gauguin used that ancient Maori myth as the subject for his picture. The left-hand figure seated in the foreground might be taken for Hina, the Goddess of the Moon and Eternity, and the figure on the right for Tefatou, the God of the Earth and Death. The sleeping dog with puppies at Tefatou's feet is a symbol of life on earth, whose tragic fate is predetermined. A similar dog with puppies also appears in the

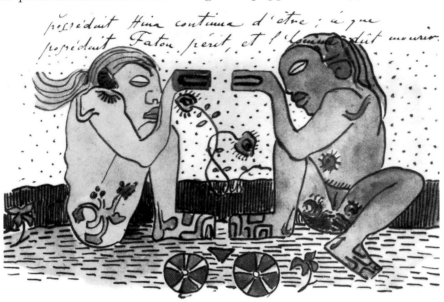

Ancient Maori cult (detail).

right-hand part of *Faa Iheihe* (W. 569), in *Ruperupe* and in *Women Bathing* (W. 572). According to local beliefs, sleep is close, almost identical, to death. The word *matamoe*, for example, means 'sleeping head', but its other meaning is 'death'. Thus, various symbolic motifs and elements pass from one Gauguin picture to another. A parallel representation of characters from old Maori legends as ancient stone or wooden images in the background and as real people in the foreground was the artist's favourite device. This device is used in *Her Name Is Vaïraumati*, which gives us reason for extending such interpretation to *The Great Buddha*. In the distance, against the wall, in the Moscow canvas, we also see the scene of the Last Supper: a long table lit by a mysterious greenish light and covered with a white cloth, the figure of Christ with a halo, and the dark figure of Judas standing in front of the table. This painting was certainly of great significance in Gauguin's art, asserting his ideas of the inner kinship of great religions in the world.
The figure seated at right occurs in *Te Rerioa (Rêverie,* W. 557),

The Great Buddha (detail).
The Pushkin Museum of Fine Arts,
Moscow.

152

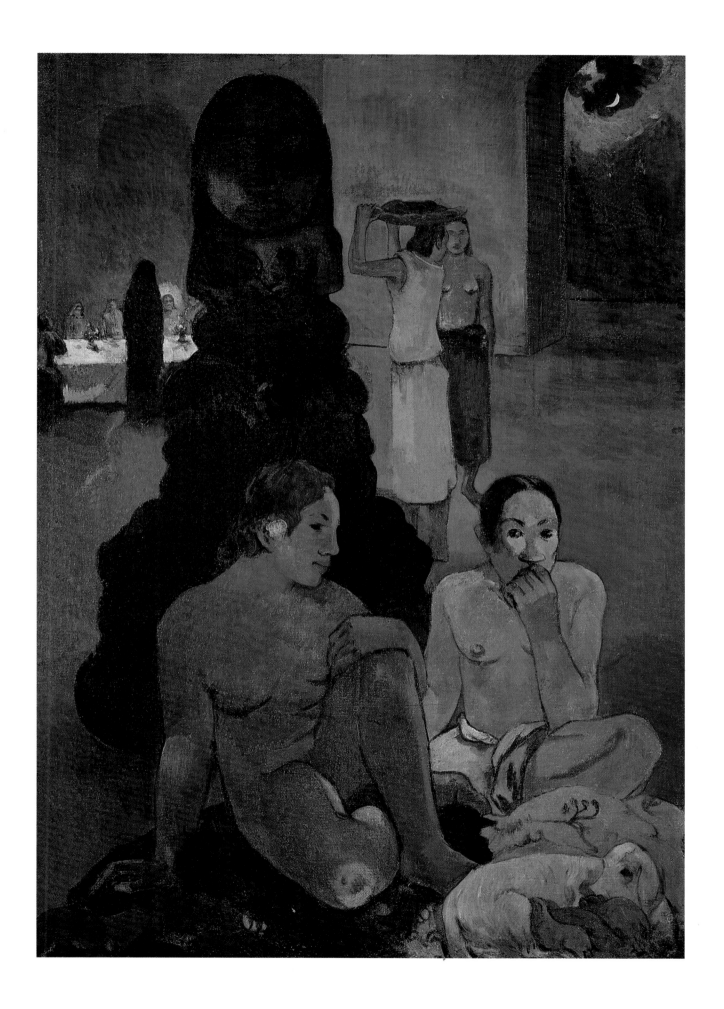

The Great Buddha (detail).
The Pushkin Museum of Fine Arts,
Moscow.

24. THREE TAHITIAN WOMEN AGAINST A YELLOW BACKGROUND

1899.
Oil on canvas (relined). 68 x 74 cm.
Signed and dated, bottom right: *Paul Gauguin 99.*
The Hermitage, St. Petersburg. Inv. No. 7708. W. 584.

Three Tahitian Women against a Yellow Background is one of the four pictures executed in 1898-99 and displaying three features in common: the presentation of the subject against a yellow background recalling medieval icon painting; the variation of an identical landscape motif — the dwarf tree with a round top — which is not seen in any other of Gauguin's works; and the portrayal of a woman carrying flowers in her hands folded as if in prayer. In three of these paintings, *Faa Iheihe* (W. 569), *Ruperupe* and the present picture, this figure flanks the composition on the left, whereas in *Te Avae no Maria* it is the main and only character of the composition. Thanks to these common features, all four paintings could form a single decorative cycle despite their different size. The disposition of the figures in the Hermitage canvas to a certain extent resembles the compositional scheme of Courbet's painting *Bonjour, Monsieur Courbet,* which was certainly familiar to Gauguin, for in 1889 he produced his version of the same subject entitled *Bonjour, Monsieur Gauguin* (W. 322). The painting *Three Tahitian Women against a Yellow Background* was the last Gauguin purchased by Morozov.

Three Tahitians Women against a Yellow Background (detail). The Hermitage, St. Petersburg.

Provenance: 1903, Sent from Atuona to Vollard in Paris for sale (as No. 10 in the artist's list: "Three standing women against a golden-yellow background touched with green"); A. Vollard Gallery, Paris; ca. 1905 G. Stein collection, Paris; once again A. Vollard Gallery (selected for purchase by the well-known Hungarian collector M. Nemes but not acquired); 1910, I. Morozov collection, Moscow (bought from Vollard for 10,000 francs); 1919, Second Museum of Modern Western Painting, Moscow; 1923, Museum of Modern Western Art, Moscow; since 1934, The Hermitage, St. Petersburg.

157

25. TE AVAE NO MARIA
THE MONTH OF MARY,
OR WOMAN CARRYING FLOWERS

1899.
Oil on canvas. 97 x 72 cm.
Inscribed, signed and dated, bottom left: *Te Avae no Maria Paul Gauguin 1899.*
The Hermitage, St. Petersburg. Inv. No. 6515. W. 586.

This painting is related to three other of Gauguin's later works: *Faa Iheihe* (W. 569), *Ruperupe* and *Three Tahitian Women against a Yellow Background*. These four pictures are united by the yellow background, by the identical female figure and the dwarf tree with a round top. The inscription made by Gauguin on the front side of the canvas, *Te Avae no Maria*, was translated by Danielsson as the 'month of Mary'. In Catholic countries May is the month of worshipping the Virgin Mary and, at the same time, the month when nature is in full bloom. This picture is iconographically connected with a number of Gauguin's woodcuts (Guérin, Nos. 65, 81 etc.) and drawings executed for the book *Avant et Après* (pp. 151, 173).

*The Month of Mary,
or Woman Carrying Flowers.
The Hermitage, St. Petersburg.*

Provenance: 1903, Sent from Atuona to Vollard in Paris for sale (as No. 9 in the artist's list: "Woman carrying flowers, in white dress, against a golden-yellow background. At right, a fruit-tree and an exotic plant"); A. Vollard Gallery, Paris; 1918, First Museum of Modern Western Painting, Moscow; 1923, Museum of Modern Western Art, Moscow; since 1930, The Hermitage, St. Petersburg.

*Te avae no Maria.
The Month of Mary,
or Woman Carrying Flowers.
The Hermitage, St. Petersburg.*

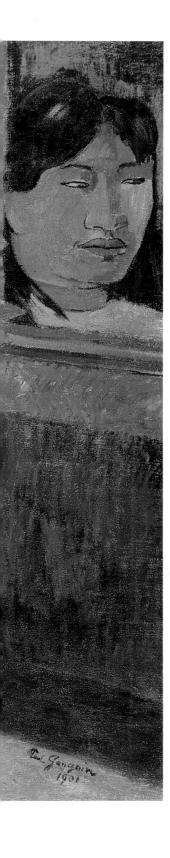

27. *SUNFLOWERS*

1901.
Oil on canvas. 72 x 91 cm.
Signed and dated, bottom right: *Paul Gauguin 1901*.
The Hermitage, St. Petersburg. Inv. No. 6516. W. 603.

In his letter of October 1898, Gauguin asked Daniel de Monfreid to send him some flower seeds and bulbs: dahlias, nasturtiums and different sunflowers which would stand the hot climate. He added that he adored flowers and wanted to embellish his small plantation. This letter, although indirectly, points to the fact that *Sunflowers* was painted not at Atuona, as is generally believed, but in Tahiti, since, having moved to the Marquesas in August 1901, Gauguin settled at Atuona only in September and could not have had the time to grow a garden there. One more circumstance supports the view that this work was executed before Gauguin's departure for Atuona. As is known, the Hermitage canvas is one of the four still lifes with sunflowers painted by the artist. Both in composition and in the set of objects (the armchair and the vase), it is most closely related to *Sunflowers in an Armchair* (W. 602). Earlier in his career, in 1880, Gauguin used a similar compositional pattern — the cut flowers on a chair — in the still life *To Make a Bouquet* (W. 49). The distinctive feature of the Hermitage picture is its mystic atmosphere, created by a strange object in the background, resembling a solar disk or a flower, with the 'All-Seeing Eye' in the centre. The idea of this flower-symbol was undoubtedly borrowed from Odilon Redon, to whom Gauguin devoted a chapter in *Avant et Après*. The sunflowers — a traditional symbol of worship of supernatural power — are encircling the 'All-Seeing Eye'. This image might have been introduced to create a metaphor: flowers — human eyes. The fact that this symbolic element was not accidental is supported by its appearance in *Sunflowers and Pears* (W. 606) and by the still life (W. 604) where Gauguin reproduced the same flowers and Puvis de Chavannes's *Hope*, as if expressing in each of the canvases his faith in a better future in the Marquesas.
The girl's head occurs, in reverse, in a pencil drawing of a girl seated in an armchair in the Leipzig manuscript of *Avant et Après* (fol. 125).

Provenance: S. Shchukin collection, Moscow; 1918, First Museum of Modern Western Painting, Moscow; 1923, Museum of Modern Western Art, Moscow; since 1931, The Hermitage, St. Petersburg.

163

The Ford (The Flight).
The Pushkin Museum of Fine Arts,
Moscow.

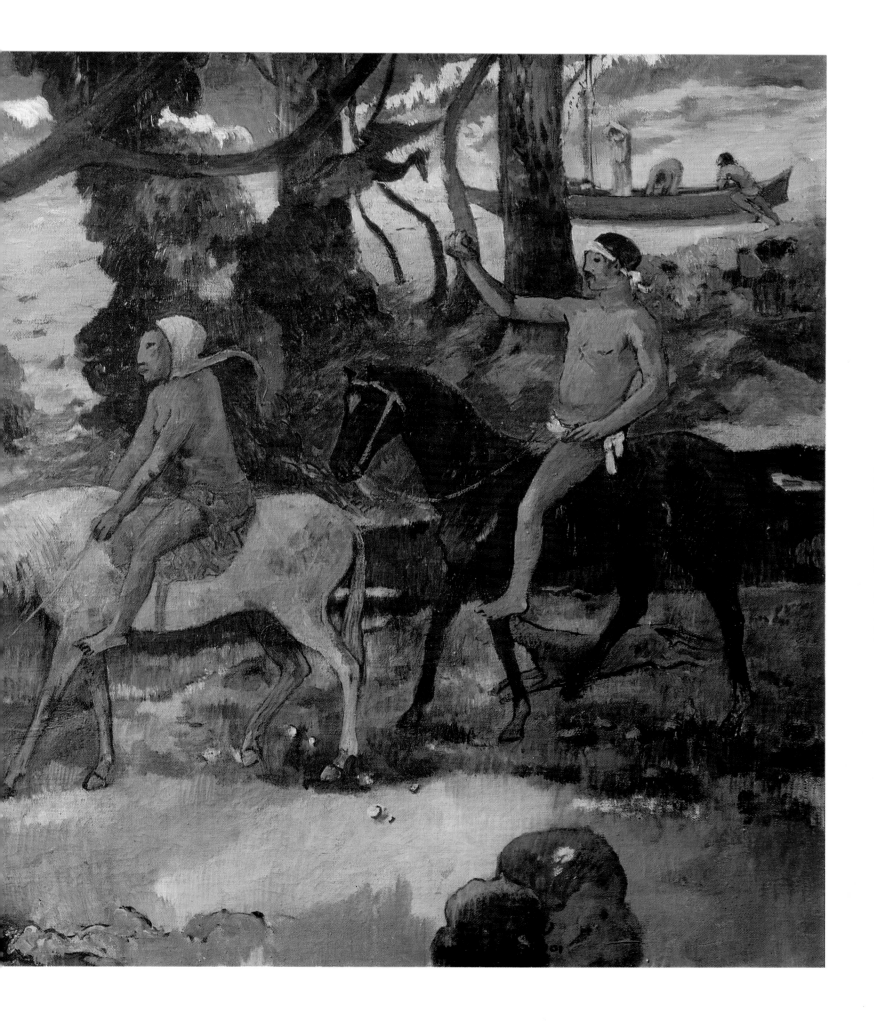

The Ford (The Flight), detail.
The Pushkin Museum of Fine Arts,
Moscow.

29. *STILL LIFE WITH PARROTS*

1902.
Oil on canvas. 62 x 76 cm.
Signed and dated in a cartouche, on the tablecloth, bottom left: *Paul Gauguin 1902.*
The Pushkin Museum of Fine Arts, Moscow. Inv. No. 3371.
W. 629 (as owned by the Hermitage).

The picture was painted in 1902 at Atuona, on the island of La Dominica. It is one of Gauguin's best works produced at the end of his artistic career. The presence of separate strokes testifies to the artist's more spontaneous perception of nature.

The E. von der Heydt collection owns a version of this painting (W. 630) which, judging by its incompleteness, may have preceded the Moscow picture. According to Charles Morice, the terracotta idol depicted in the background (repr. Morice, p. 198) represents Hina, the Goddess of the Moon and Eternity, whose dialogue with Tefatou on the destinies of mankind was the subject of many Gauguin paintings, drawings, sculptures and woodcuts (e.g. Guérin, No. 31). The inclusion of this image in the present still life reveals its symbolic meaning. The vivid, radiant colours, succulent modelling and the flickering, separate strokes 'clash' with the implicit sombre symbolism of the picture. The dead game, the flowers falling from the tablecloth, and the gourd water-bottle are perceived as symbols of approaching departure for the other world, of the transience of life. It should not be forgotten that this still life was painted shortly before the artist's death, preceded by a long and grave illness and a chain of various troubles and misfortunes, which caused him to leave Tahiti and settle on La Dominica. The tablecloth with all the objects on it, including the statuette of Hina, seems to cover not a table but a travelling-trunk. A still life (W. 631) and *Bouquet of Flowers* (W. 594), painted at the same period, portray a similar trunk-like object. *Bouquet of Flowers* also echoes the present still life in its purport. On top of a large travelling-trunk, we see a water-bottle and a ceramic vase of flowers, made by Gauguin. The vase is decorated with relief representations of Hina and Tefatou; hanging on the wall is a skull-like mask with the face of the artist Meyer de Haan. *Bouquet of Flowers is* not dated, but it must have been painted around the same time as the Moscow canvas (Wildenstein, without any reason, assigns it to 1899). Thus, this picture is not simply a still life with parrots, but a kind of travelling-altar of the perpetual wanderer Gauguin.

Provenance: G. Fayet Gallery, Paris (Oiseaux morts); E. Druet Gallery, Paris (Le perroquet vert); 1910, I. Morozov collection, Moscow; 1919, Second Museum of Modern Western Painting, Moscow; 1923, Museum of Modern Western Art, Moscow; since 1948, The Pushkin Museum of Fine Arts, Moscow.

BIOGRAPHY

1848
Paul Gauguin born in Paris, on June 7.

1849
The family left France for Peru; his father died at sea.

1855-1861
Returned to France after a five-year stay in Lima. Lived in Orleans, his father's native town. Studied at the Petit Seminaire.

1861 (?)-1865
Moved with his mother to Paris. Attended a Lycée.

1865
Entered the merchant marine as a cabin-boy.

1868-1871
Served in the navy; after the disbandment of the French army and navy settled in Paris.

1871-1873
Worked as a stockbrocker in the banking office of Bertin. In the house of his sister's guardian, Gustave Arosa, began to take interest in art. Became acquainted with Camille Pissarro and Emile Schuffenecker. First amateur efforts at painting.

1873-1875
Married Mette Sophie Gad, a Dane from Copenhagen. Attended the Atelier Colarossi, acquired a collection of Impressionist pictures. *The Seine by the Pont d'Iena.*

1876
Exhibited a landscape at the official Salon.

1877
Took lessons from the sculptor Jules Ernest Bouillot and produced his first sculptures.

1880
Exhibited in the 5th Impressionist exhibition (seven paintings and a marble bust).

1881
Participated in the 6th Impressionist exhibition (eight paintings and two sculptures); spent the summer holidays in Pontoise with Pissarro who introduced him to Cézanne.

1882
Took part in the 7th Impressionist exhibition (twelve oils and pastels, one sculpture).

1883
Resigned his job at Bertin's and devoted himself entirely to painting. With Pissarro at Osny to spend the holidays and make some studies.

1884-1885
Moved with his family first to Rouen, and then to Copenhagen, where he executed a number of paintings and wooden sculptures. Displayed interest in the Symbolist theories. Short show at the Society of the Friends of Art, Copenhagen. Left his wife and four children in the Danish capital and returned to Paris with his six-year-old son Clovis. Went to London for three weeks, later lived in Dieppe, where he made friends with Edgar Degas.

1886
Lived by turns in Pont-Aven (Brittany) and Paris; made ceramics at Ernest Chaplet's workshop. Represented in the 8th Impressionist exhibition (nineteen paintings).

1887
In April, with Charles Laval, left for Panama, then moved to Martinique. Back in Paris in November, where he met Van Gogh. Organized his first one-man show at Boussod and Valadon, which included ceramics as well as Brittany and Martinique paintings. Became acquainted with Daniel de Monfreid.

1888
Lived at Pont-Aven; produced pictures in his new synthetist and cloisonne manner; gave 'lessons' in synthetic painting to Paul Sérusier. Painted *The Vision after the Sermon, Wrestling Boys, Self-Portrait* (with a profile of Bernard): *"Les Misérables", Fruit.* etc. Stayed, from October to December, with Van Gogh at Arles, where he painted *Café at Arles, The Alyscamps, Old Women of Arles* and other works.

1889

Exhibited with his friends at the Cafe Volpini as 'Groupe Impressioniste et Synthétiste', where he showed seventeen of his paintings and a number of zincographs. Lived, alternatively, in Paris, Pont-Aven and Le Pouldu (Brittany). Painted *Portrait of Meyer de Haan, The Yellow Christ, La Belle Angèle* and *The Schuffenecker Family;* carved the wooden relief *Soyez amoureuses et vous serez heureuses* (Be in love and you will be happy). Wrote two articles for the magazine *Le Moderniste*. Met Albert Aurier and Charles Morice; frequented the Symbolist group at their meetings at the Cafe Voltaire.

1891

On February 23, auctioned thirty of his paintings at the Hotel Drouot. On April 4, left for Tahiti.

1891-1893

The first Tahitian period. He settled first in Papeete, then at Mataeia. During these years he produced over ninety paintings (eight of them are now divided between the Hermitage, St. Petersburg, and the Pushkin Museum of Fine Arts, Moscow). Sent a number of pictures for two exhibitions in Copenhagen, one held in March 1892 (thirteen canvases), and the other in March 1893 at the Society of Free Arts (about fifty works).

1893

Returned to France on August 30. In November arranged a show of his works at the Galerie Durand-Ruel (two sculptures and forty-four paintings, among them *Landscape with Peacocks, Pastorales Tahitiennes, Her Name is Vaïraumati, What! Are You Jealous?* and *At the Foot of a Mountain*. Wrote *Noa Noa* and prepared a series of illustrations for it.

1894

Contributed to La Libre Esthétique exhibition in Brussels (January-February). Visited his family in Copenhagen. Lived alternatively in Paris and Brittany.

1895

On February 18, a sale of his works was held at the Hotel Drouot (forty-nine paintings, drawings and prints). On July 3, he sailed to Tahiti, leaving France for good.

1895-1901

The second Tahitian period. The output of these years amounted to more than sixty paintings, numerous drawings, watercolours, woodcuts and sculptures. Rewrote the manuscript of *Noa Noa* and wrote a series of articles on the Catholic church.

1897

Exhibited with the group of La Libre Esthétique in Brussels *(Bé Bé, Tahitians in a Room, etc.).* Learned of the death of his daughter Aline.

1898

Physical suffering and despair reaching a sort of climax. On February 11 attempted suicide, after having painted *Where Do We Come From?...* as a testamentary picture. In April, having no money at all, took a post as a draughtsman and a copyist of official papers in the Bureau of Public Works at Papeete.

1899-1900

Contributed articles to the local journal *Les Guêpes* (The Wasps) and published the first issue of his own satirical periodical *Le Sourire* (The Smile). Painted two versions of *Maternity, Three Tahitian Women against a Yellow Background* and *The Great Buddha*. Birth of his son Emile, later a self-taught artist.

1901

In August Gauguin moved to Atuona (on the island of Hivaoa, or La Dominica in the Marquesas group). Experienced a new surge of creative energy, painted *And the Gold of Their Bodies, The Ford,* still lifes with sunflowers and a number of landscapes.

1902

Wrote *Racontars de Rapin*. Painted *Young Girl with a Fan,* a series of still lifes with parrots and landscapes with horsemen on the beach.

1903

Worked on his memoirs *Avant et Après* (Before and After). Sentenced to a fine and three-months' imprisonment for protesting at the authorities' scandalous treatment of the natives. His illness prevented him from going to Tahiti to appeal against the sentence. On May 8, a month before his fifty-fifth birthday, Gauguin died. He was buried in a small cemetery near Atuona.

BIBLIOGRAPHY

WORKS (IN RUSSIAN)

CATALOGUE SHCHUKIN
Catalogue of the S. Shchukin Collection. Moscow, 1913.

CATALOGUE 1928
The Museum of Modern Western Art. Moscow. Illustrated Catalogue, Moscow, 1928.

CATALOGUE 1957
The Pushkin Museum of Fine Ants. Moscow. Catalogue of the Picture Gallery. Painting. Sculpture. Moscow, 1957.

CATALOGUE 1958
The Hermitage. Westem European Painting. Catalogue. Vol. 1 (Italy, France, Spain, Switzerland), Leningrad, 1958.

CATALOGUE 1961
The Pushkin Museum of Fine Arts, Moscow. Catalogue of the Picture Gallery. Painting. Sculpture. Moscow, 1961.

CATALOGUE 1976
The Hermitage. Westem European Painting. Catalogue. Vol. 1 (Italy, France, Spain, Switzerland), Leningrad, 1976.

BESSONOVA 1986
M. Bessonova, *"Gathering Fruit" by Paul Gauguin. Studies of the Masterpieces in the Pushkin Museum of Fine Arts,* Moscow, 1986.

GAUGUIN 1969
The *Pushkin Museum of Fine Arts, Moscow. Paul Gauguin (Image and Colour)*, 1969, Vol. 3.

KANTOR-GUKOVSKAYA. 1965
A. Kantor-Gukovskaya, *Paul Gauguin. His Life and Work.* Leningrad-Moscow, 1965.

MAKOVSKY 1912
S. Makovski, "French Painters in the I. Morozov Collection", *Apollon,* 1912, No. 3-4.

MAKOVSKY 1913
S. Makovski, *Pages of Art Criticism.* 3 vols., Moscow, 1913. Vol. 3: *Exhibitions and Reviews.*

MURATOV 1908
P. Muratov, "The S. Shchukin Gallery", *Russkaya Mysl* (Russian Thought), 1908, No. 8.

PERTSOV 1921
P. Pertsov, *The S. Shchukin Collection of French Painting.* The Museum of Modern Western Painting, Moscow, 1921.

TERNOVETZ 1934
Artists on Art. Edited by B. Ternovetz. 4 vols., Moscow, 1934, vol. 3.

TUGENDHOLD 1914
Y. Tugendhold, "The French Collection of S. Shchukin", *Apollon* 1914, Nos.1-2.

TUGENDHOLD 1923
Y. Tugendhold, *The First Museum of Modern Western Painting (the former S. Shchukin collection),* Moscow-Petrograd, 1923.

ZELENINA 1926
K. Zelenina, *Paul Gauguin.* Moscow, 1926.

WORKS (IN OTHER LANGUAGES)

BARSKAYA, BESSONOVA
Impressionist and Post-Impressionist Paintings in Soviet Museums. Leningrad, 1985.

BESSONOVA, WILLIAMS
Impressionnist and Post-impressionnist. The Hermitage, Leningrad; The Pushkin Museum of Fine Arts, Moscow; National Gallery of Art, Washington. Leningrad, 1986.

BECKER
J. Becker, "The Museum of Modern Western Painting in Moscow", *Creative Art,* 1932, March-April.

BOUDAILLE
G. Boudaille, *Gauguin.* Paris, 1963.

BOUGE
Traduction et interprétation des titres en langue tahitienne inscrits sur les œuvres océaniennes de Paul Gauguin revues par L. J. Bouge, ancien gouverneur de Tahiti. "Gazette des Beaux-Arts", 1956, janvier-avril.

CACHIN
F. Cachin, *Gauguin.* Paris, 1968.

CAHIERS D'ART
Art moderne français dans les collections des musées étrangers. Le Musée d'Art Moderne Occidental à Moscou. "Cahiers d'art", 1950.

CHASSÉ
Ch. Chassé, *Gauguin sans légendes.* Paris, 1965.

COOPER
D. Cooper, *Lugano. French Painting from Russia.* "The Burlington Magazine", 1983, Décember.

DANIELSSON
B. Danielsson, *Gauguin's Tahitians Titles,* "The Burlington Magazine", 1967, April.

DORIVAL 1951
B. Dorival, "Sources of the art of Gauguin from Java, Egypt and Ancient Greece", *The Burlington Magazine,* 1951, April.

DORIVAL 1954
B. Dorival, *Carnet de Tahiti de Paul Gauguin,* Paris, 1954.

DORIVAL 1960
B. Dorival, *Le Milieu, la peinture dans son siècle. Gauguin.* Collection "Génies et Réalités", Paris, 1960.

ELGAR
F. Elgar, *Gauguin,* Paris, 1949.

FEZZI
E. Fezzi, *Paul Gauguin. Das Gesamtwerk,* 2 vols., Frankfort,1979.

FIELD
R. S. Field, *Gauguin: plagiaire ou créateur?, Gauguin.* Collection "Génies et Réalités", Paris, 1960.

FIELD, MONOTYPES
R. S. Field, *Paul Gauguin. Monotypes* (published on the occasion of the Philadelphia Museum of Art), Philadelphie, 1973.

FRENCH 19TH CENTURY MASTERS
The Hermitage, Leningrad. French 19th Century Masters (introduction and notes by A. N. Izerghina and the Staff of the State Hermitage, Leningrad), Prague-Leningrad, 1968.

GAUGUIN, NOA NOA
P. Gauguin, *Noa Noa,* Paris, 1924 (édition définitive).

GAUGUIN, AVANT ET APRÈS
P. Gauguin, *Avant et Après.* Edition fac-similé, publiée par Scripta, Paris, 1951.

GAUGUIN, DOCUMENTS
Gauguin: sa vie, son œuvre. Réunion de 90 textes d'études, de documents sous la direction et avec la collaboration de G. Wildenstein, Paris, 1958.

GAUGUIN, 45 LETTRES
P. Gauguin, 45 *lettres à Vincent, Théo et Io Van Gogh.* Introduction et annotations par D. Cooper, Lausanne, 1983.

GORSKY
B. Gorsky, *Trois tombes au soleil (Robert Louis Stevenson, Paul Gauguin, Alain Gerbault),* Paris, 1976.

GEORGIEVSKAYA, KUZNETSOVA
French Painting from the Pushkin Museum. 17th to 20th Century, Leningrad, 1980.

GRAY
Ch. Gray, *Sculpture and Ceramics of Paul Gauguin,* Baltimore, 1963.

GUÉRIN
M. Guérin, *L'œuvre gravé de Gauguin,* Paris, 1927.

HUYGHE
R. Huyghe, *Le Carnet de Paul Gauguin,* Paris, 1952 (fac-similé).

IZERGHINA, BARSKAYA
French Painting. Second Half of the 19th to Early 20th Century. The Hermitage, Leningrad, Leningrad, 1975 (2nd ed., 1982)

KANTOR-GUKOVSKAYA 1977
Paul Gauguin (compiled and introduced by A. Kantor-Gukovskaya), Leningrad, 1977.

LANGER
A. Langer, *Paul Gauguin,* Leipzig, 1963.

LEE VAN DOVSKI
L. Van Dovski, *Paul Gauguin oder die Flucht vor der Zivilisation,* Olten-Bern, 1950.

LEYMARIE
J. Leymarie, *Gauguin. Orangerie des Tuileries. Exposition du Centenaire.* Catalogue, Paris, 1949.

L'OPERA COMPLETA
L'Opera completa di Gauguin (introdotta da scritti del pittore e coordinata da C. N. Sugana), Milan, 1972.

MALINGUE
Lettres de Gauguin à sa femme et à ses amis. Recueillies, annotées et préfacées par M. Malingue, Paris, 1946.

MONFREID
Lettres de Gauguin à Daniel de Monfreid. Précédées d'un hommage à Gauguin par Victor Segalen, édition établie et annotée par Joly Segalen, Paris, 1950

MORICE
Ch. Morice, *Paul Gauguin,* Paris, 1920.

PERRUCHOT
P. Perruchot, *Paul Gauguin,* Paris, 1961.

RÉAU
L. Réau, *Catalogue de l'art français dans les musées russes,* Paris, 1929.

REWALD 1938
J. Rewald, *Gauguin,* Paris, 1938.

REWALD 1956
J. Rewald, *Post-Impressionism from Van Gogh to Gauguin,* New York, 1956.

REWALD 1958
J. Rewald, *Gauguin. Drawings,* New York, 1958.

REWALD 1961
J. Rewald, *Post-Impressionism from Van Gogh to Gauguin,* New York, 1961.

REWALD 1962
J. Rewald, *Paul Gauguin. Carnet de croquis. 1884-1888.* Edition fac-similé, New York-Paris, 1962.

REY
R. Rey, *Gauguin,* Paris, 1924.

ROTONCHAMP
J. de Rotonchamp, *Paul Gauguin. 1848-1903,* Paris, 1925.

STERLING
Ch. Sterling, *Musée de l'Ermitage. La peinture française de Poussin à nos jours,* Paris, 1957.

TERNOVETZ
B. Ternovetz, *Musée d'Art Moderne de Moscou,* «L'Amour de l'art» 1925, décembre.

WIESE
E. Wiese, *Paul Gauguin. Zwei Jahrzehnte nach seinem Tode,* «Junge Kunst», Leipzig, 1923, vol.5-6.

W. G. WILDENSTEIN
Gauguin. Catalogue, Paris, 1964.

guin.